For all the anonymous craftsmen that
over the centuries have fashioned the
man-made wonders of the world.

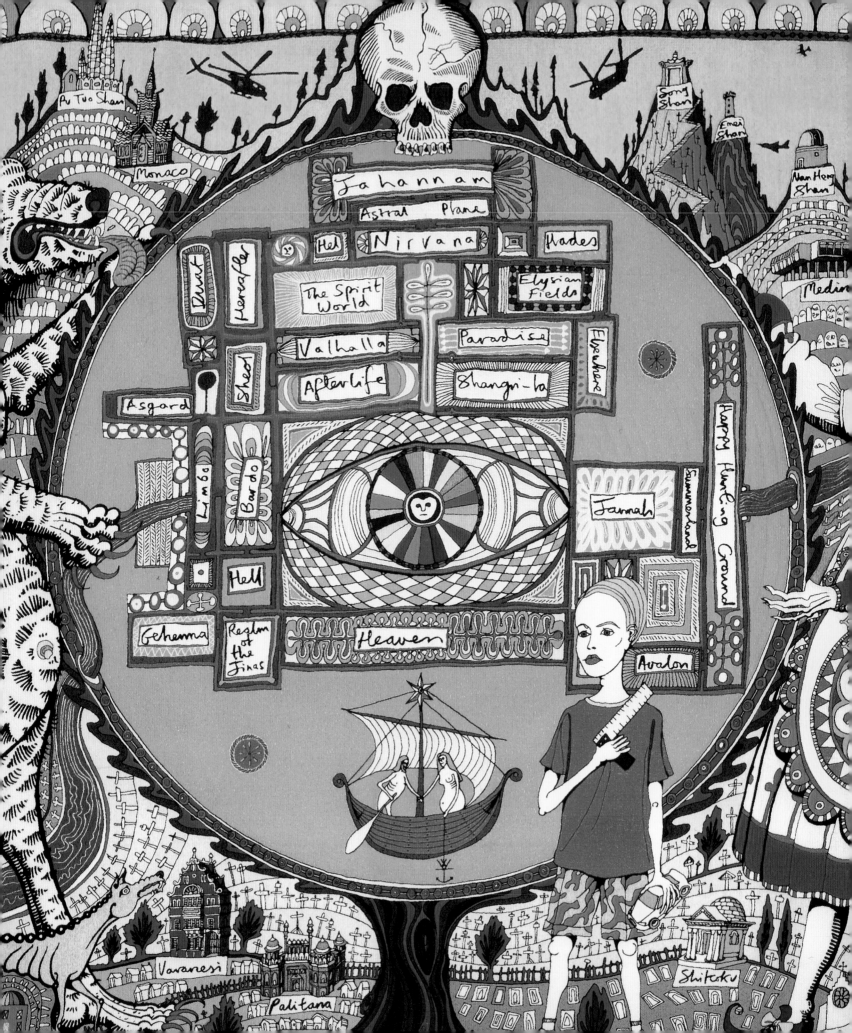

THE TOMB OF THE UNKNOWN CRAFTSMAN
GRAYSON PERRY

THE BRITISH MUSEUM PRESS

Published to accompany the exhibition
The Tomb of the Unknown Craftsman
at the British Museum 6 October 2011–19 February 2012

Supported by

With

LOUIS VUITTON

First published in 2011 by The British Museum Press
A division of The British Museum Company Ltd
38 Russell Square, London WC1B 3QQ
britishmuseum.org

A catalogue record for this book is available from the British Library

ISBN 978-0-7141-1820-8

Designed by Will Webb Design
Printed in Italy by Printer Trento

Frontispiece: Grayson Perry, *Map of Truths and Beliefs* (detail), 2011

The registration numbers for the British Museum objects illustrated in this book are listed on pp. 200–201.
Further information about the objects and the collection can be found at britishmuseum.org.

Papers used in this book are natural, recyclable products made from wood
grown in sustainable forests. The manufacturing processes conform to the
environmental regulations of the country of origin.

CONTENTS

SPONSOR'S FOREWORD

In this *Year of Corporate Philanthropy*, when the UK government is calling out to the private sector to get involved in culture and the arts, AlixPartners is pleased to support the British Museum and Grayson Perry in this highly innovative partnership.

The Tomb of the Unknown Craftsman is an example of how a successful museum and a thriving artist have taken note of changing times, realizing that cultural bodies, not just businesses, need to think broadly and imaginatively to ensure their continuing relevance and long-term sustainability.

For three decades AlixPartners has been developing innovative and creative ideas that have helped businesses around the world realize that there are options available to them that will allow them to flourish for generations to come.

In a similar vein, this project is about the development of new ideas within the arts and the importance of collaboration. Grayson Perry has worked together with curators from the British Museum's permanent collections to identify and celebrate amazing and intriguing pieces of craftsmanship created over the centuries. He has also added his own exciting new work to these man-made wonders of the world.

We hope the exhibition will inspire creative thinking for all and encourage the development of future generations of craftspeople.

Pippa Wicks
Managing Director
AlixPartners

DIRECTOR'S FOREWORD

Well known across the world for its collections documenting the great civilizations of the past, the British Museum also engages constantly with the present.

Fundamental to the Museum's thinking ever since its foundation in the mid-eighteenth century has been the notion that its unrivalled collections offer an ideal starting point for an understanding of the modern world. However, objects, like words, are of limited value without the mediation of skilled individuals able to interpret them. The Museum's expert scholars include anthropologists, archaeologists, art historians and many others, but it has long been recognized that practising artists are also particularly well placed to develop our understanding of the Museum's collections and the societies that produced them. The list of those who have been inspired by and worked with the British Museum and its collection ranges from sculptors Henry Moore and Eduardo Paolozzi (whose 1985 British Museum exhibition Grayson Perry acknowledges below) to contemporary artists Julian Opie and Hoshino Yukinobu.

For *The Tomb of the Unknown Craftsman*, Grayson Perry has combined an extraordinary group of new works specially created for this exhibition with pieces selected from all parts of the Museum's collection. The resulting juxtapositions are something that none of those of us working in the Museum ever would – or could – have brought into being. On one level, this is a uniquely personal installation conceived out of the artist's imagination, experience and 'lightly held' beliefs; on another, it brings into being an imaginary civilization that offers a mirror to the world and hints in various ways at the links that bind humanity together. The exhibition also acts as a celebration of the millions of people who, over a period of more than one million years, have been making (and continue to make) the millions of objects that are preserved for posterity in the British Museum; a celebration, too, of the archaeologists who rediscover many of these objects and of the museums that care for them.

It is thanks to the generosity of AlixPartners and Louis Vuitton that the British Museum is able to present this new perspective on one of the world's oldest and most celebrated museum collections.

Neil MacGregor
Director
The British Museum

INTRODUCTION

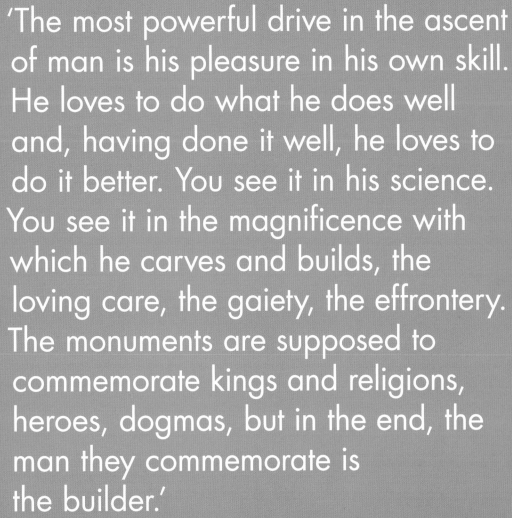

'The most powerful drive in the ascent of man is his pleasure in his own skill. He loves to do what he does well and, having done it well, he loves to do it better. You see it in his science. You see it in the magnificence with which he carves and builds, the loving care, the gaiety, the effrontery. The monuments are supposed to commemorate kings and religions, heroes, dogmas, but in the end, the man they commemorate is the builder.'

JACOB BRONOWSKI

I first visited the British Museum when I was six years old. I was with my mother, my aunt and my sister. We had come up to London from Chelmsford for the day to see the sights. My father had recently moved out. We arrived at the Museum via the North Entrance. The lift attendant asked where we wanted to go. We did not know. He asked me what I liked. I said I liked model cars and aeroplanes. He said there were some model boats in the Egyptian rooms so we went there. I thought if these models are on display in the famous British Museum they must be fantastic. I was disappointed. The ancient Egyptian model boats, compared to the plastic and metal toys I played with at home to me seemed dull and basic. This feeling of supposedly wondrous things often not living up to my imagination has dogged me all my life.

Now forty-five years later I am staging an exhibition in the British Museum with an exhibit centred on a detailed model ship. Is my unconscious leading me to play out some elaborate act of catharsis using an institution? If so, is it significant that it is a ship dedicated to craftsmen? In my personal cosmology the archetypal craftsman is my father.

Model of a funeral barge
Egypt, 12th Dynasty
(c.1985–1795 BC)
Sycomore fig wood
13.4 x 77.5 x 6 cm
British Museum

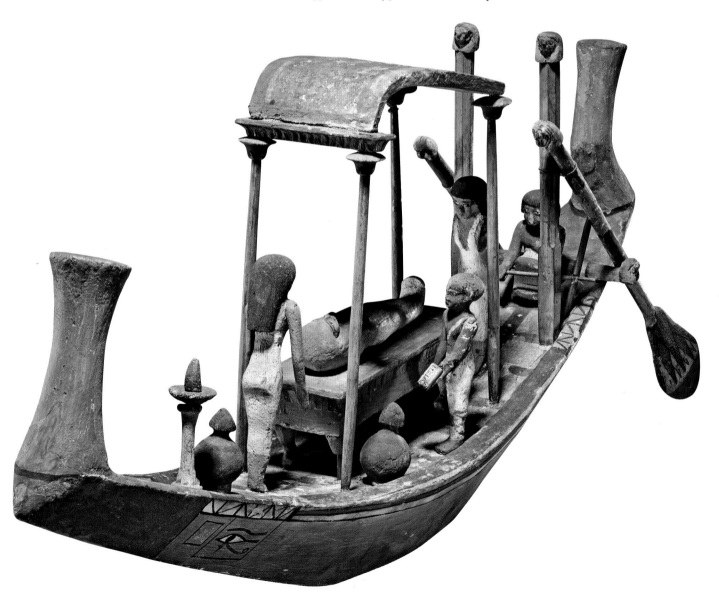

I tell this story of my first visit to the Museum to illustrate the fact that this exhibition *The Tomb of the Unknown Craftsman* is not just about history, at least in the grander sense, nor is it meant to be didactic. It is intended as an artwork in itself and one that comprises several themes. The BM is famously a place 'where the world meets the world'. If the world were to put its camera-phone away for a moment and use its eyes it might take away a more profound image of itself. One of the main themes of the exhibition is the idea of finding oneself in the collections of the BM. By this I do not mean being actually in the storerooms, though that can be a marvellous experience. What I mean is seeing oneself, one's personal concerns as a human being, reflected back in the objects made long ago by fellow men and women with similar, equally human, concerns.

It has become common practice in recent years for contemporary artists to make an 'intervention' into a historic museum. For example, a direct forebear of this exhibition might be Eduardo Paolozzi's show *Lost Magic Kingdoms and Six Paper Moons from Nahuatl,* which I visited in 1985. It was staged at The Museum of Mankind in Burlington Gardens, which once housed the BM's ethnographic collections (since returned to the BM). Paolozzi made sculptural collages with objects from the American, Oceanic and African collections, his own artworks and other artefacts selected from modern popular culture. When an artist is invited to 'respond' to the collection it is an artificially induced version of the process that has powered world culture forever. Makers of artefacts have been 'responding' to objects made by earlier generations since the beginning of craft. I think of the history of culture as an infinitely complex game of 'Chinese whispers', where images and ideas are changed by passing through the hands of various craftsmen. Filtering them through a series of personal experiences, each idea becomes something new, not necessarily because of some revolutionary inspiration but because creativity is often a series of innocent mistakes.

When I began working with the British Museum, I thought: why not reverse this process of response? The BM holds eight million objects from every age and corner of the globe. Why not, I thought, make the works I am inspired to create, and find objects in this vast collection that respond to them? Somewhere in its endless storerooms there must be objects that echo my concerns and style. I have spent my entire career under the influence of the past. I wondered what I would learn from reversing the process. An object throughout its history will probably be subject to different readings. I invite you to view these artefacts by reading them through my lens. I am not a historian, an archaeologist or an ethnographer. I am an artist, and this is principally an art exhibition. I have made my choices of objects from the BM stores because of their connections with each other and with my own work. Sometimes the connection is in their function, sometimes in their subject and often in their form. One thing that connects all my choices is my delight in them.

My intuitive approach to curating is perhaps unsettling for some at an institution famed for deep and arcane knowledge and rigorous research. During the course of my travels through the

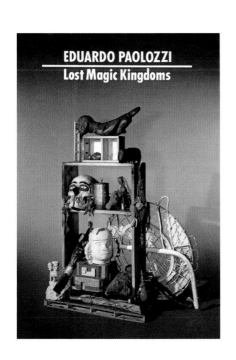

Exhibition catalogue
Lost Magic Kingdoms
by Eduardo Paolozzi
British Museum, 1985

collection I have felt an impostor in the presence of my expert guides. I feared they would view me as an ignorant fantasist making spurious connections, an arty farty Erich von Daniken or Thor Heyerdahl. I found myself choosing objects not just because of their historical or cultural significance but because I felt they fitted into the world that produced *The Tomb of the Unknown Craftsman*. I have no facts to bolster my choices, only the hope that others enjoy the poem I have woven with them.

How did this exhibition come about? In 2008 I was approaching fifty years old, and I was experiencing some success in the art world. I was regularly being offered the chance to exhibit in some fantastic venues. I took up some of these offers but realized, as fine as they were, there was a drawback. These were chances to show in great places but they were not necessarily the exhibitions I would choose to put on if I had carte blanche. I was getting older and exhibitions take me a long time to prepare. I make small intricate works. I am aware of a finite number left in me. So why did I particularly want a show at the British Museum?

It is because it is a place where art and artefacts are usually displayed as the products of distinct civilizations. The world I have worked in all my adult life, the world of contemporary art, is in many ways a distinct civilization. Viewed with an ethnographer's eye, it has its white cube temples, its own esoteric value system, its priests and saints, its festivals and rituals. I wanted to have an exhibition that somehow stepped outside, at least with one foot, from the contemporary art world. In the Museum, amongst the objects from the collection, my works might be viewed as examples of the material culture of a bohemian diaspora, a global tribe whose merchants and witch doctors bartered with a wider population by selling artefacts invested with a special quality, the quality of art. I knew the British Museum has long had an occasional programme of installations and shows featuring contemporary art. I put together my proposal and sent it to Neil MacGregor.

Perhaps the first seeds of *The Tomb of the Unknown Craftsman* lay in a slightly mouldy edition of Arthur Mee's *Children's Encyclopaedia*. Produced in the 1920s the pages were peppered with indistinct photographs of foreign lands and customs, log-jams in the Canadian Rockies or Greek monasteries on spiky pinnacles, colour plates classifying shells or flags. They gave me a window onto a world already gone, of medieval German cities before the allied bombs or whole countries untouched by the internal combustion engine let alone the Kalashnikov or the mobile phone.

Throughout my childhood until the age of fourteen or so all my games took place in a single imaginary scenario where I unconsciously played out a metaphor of my emotional life. This structure of a fantasy world laid down in my mind during my early years I think forms the basic architecture of my imagination. The phrase 'fantasy world' has perhaps become hijacked by the pseudo-medieval subculture of sword and sorcery, *Lord of the Rings* and online games. My imagined civilization was never hermetically sealed from other cultures or from the reality of my own present life. I see my art made in partnership between two parts of my personality

whom I have nicknamed the *hobbit* and the *punk*. I always try to balance my love of intricate historic detail (the hobbit) with social comment on my own time (the punk). I still cling on, though, to the notion that somewhere, somehow, all my work belongs not to here and now but to some other particular place and time.

The term 'fantasy world' also crops up a lot in another of my interests, Outsider art. This art, sometimes called Art Brut or folk art, is made spontaneously by people often with no formal art training and with no intention of exhibiting it. These artists often spend lifetimes creating an elaborate mythology or narrative that binds together many works in several media or an entire environment. I see these sorts of artists as embodying the pure spirit of creativity and I try to tap that unselfconscious spirit within myself. At the same time, as a contemporary artist, part of my job is to be all too aware of the world around us and I have to balance my primal need to create with an adult fascination with contemporary society.

The most direct ancestor of *The Tomb of the Unknown Craftsman* is my final degree show at art college in 1982. I made a collection of artefacts including a crumbling miniature mausoleum, a corroded bronze crown and a great book with a bronze cover inlaid with broken glass. I

Grayson Perry preparing his degree show at Portsmouth Polytechnic, 1982

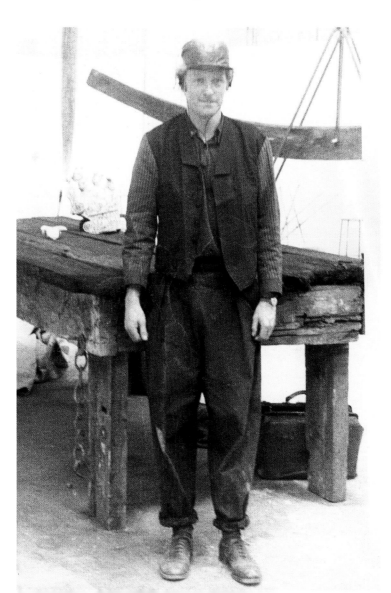

presented them as pseudo-archaeology on a giant table made of decaying railway sleepers. I like the idea that, in this present show, alongside ancient artefacts from world history are a few objects from earlier eras of my career, so I have included the vaguely Romano-British motorcycle helmet from that long-ago degree show. In 1982 I wanted the imprint of the history I loved and I was also rebelling against the neophilia of modern art. I was a postmodernist and proud. In retrospect it was a time when 'the hobbit' was unhealthily dominant in my art.

Despite the mockery and mischief making of 'the punk', a strong thread of overt historical reference survives as one of the constants in my art. I go to a museum or see a photograph in an art book and I think, 'I like that, I will make my own version'. My appetite for borrowing from the past and a fascination for the culture of museums has led me to working directly with the source material. In the last decade I have curated two exhibitions where I have responded to and chosen from public collections. In *The Charms of Lincolnshire* (2004) and *Unpopular Culture* (2008) I made selections from collections of Victorian social history and British twentieth century art and made works in response. Though keenly aware of the nag and pulse of our present hi-tech culture it is old art, whether a Rococo church, a Breugel or a seventeenth-century Norwegian farmhouse that moves me the deepest. *The Tomb of the Unknown Craftsman* is the culmination of a love affair with the artefacts of the past.

A theme that has been central to my work and which constitutes a significant thread to this show is religion. I have always been envious of olden-days artists. They had an all consuming belief system and narrative to make art about. We with our secular liberal freedoms have to think stuff up to make art about. One aspect of religion I have long been particularly interested in is pilgrimage. In 1988 I visited the biggest Christian shrine in the western hemisphere, the Guadalupe shrine in Mexico City. The pilgrims crawling across the concrete towards the basilica, the airport-style moving walkway to prevent crowding in front of the holy relic, the small votive paintings thanking the Madonna covering the walls of the numerous chapels, I found moving and inspiring. I think the performing of the sacred journey is a powerful ritual to go through, even if one does not believe in a god. The journey itself can be transformative and encourages reflection on the lifelong voyage we are all embarked upon.

I have had a modest personal experience of pilgrimage, cycling to Santiago de Compostela in 2003 and Lourdes in 2007. One thing I learned was that the motivation for pilgrimage in the twenty-first century remains in many ways unchanged but modern tourism and popular culture mean it manifests itself in new ways. On the road to Santiago I had a feeling that Paolo Coelho's novel *The Alchemist* was more of an inspiration for the thousands of young backpackers than the Bible. I joked with my companions that we might find marijuana-smoking equipment for sale in Santiago bearing the scallop shell symbol of St James. I was depressingly correct.

Museums and galleries have become the pilgrimage sites of modern global tourism. Art and culture are the secular 'good things'. The British Museum is the prime civic temple to history

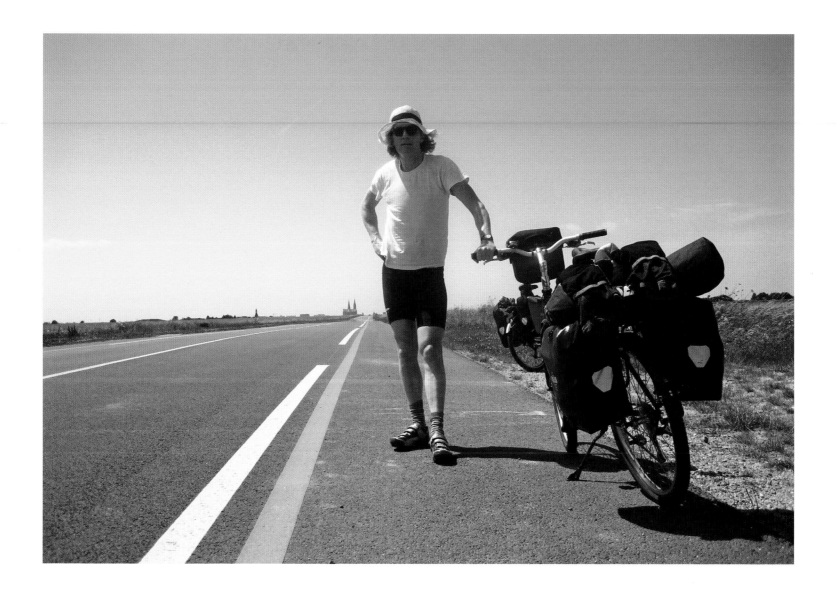

Grayson Perry approaching
Chartres en route to Lourdes,
2007

and art in Britain, preaching the virtues of education and tolerance and housing many famous relics. Almost six million pilgrims visited in 2010.

I wanted to create a site of pilgrimage to play with the idea of sacred journeys, holy relics and their relationship to contemporary art and the museum. The pilgrimage I have created has multiple versions. There is the real pilgrimage of the visitors to the British Museum and thence to my show. There is my actual journey to Germany with Alan Measles in his 'popemobile' the AM1. There is an imagined journey to an implied sacred space, which once may have housed the 'Tomb of the Unknown Craftsman', and there are objects from the BM collection that speak of various pilgrimages, holy and secular, throughout the ages.

All pilgrimage sites have a deity or saint. This show is no different and has both.

I called my large survey exhibition in Japan in 2007 *My Civilisation*. If I were to stage a show hinting at the idea there was a cohesive culture behind my work I felt I needed a distinct

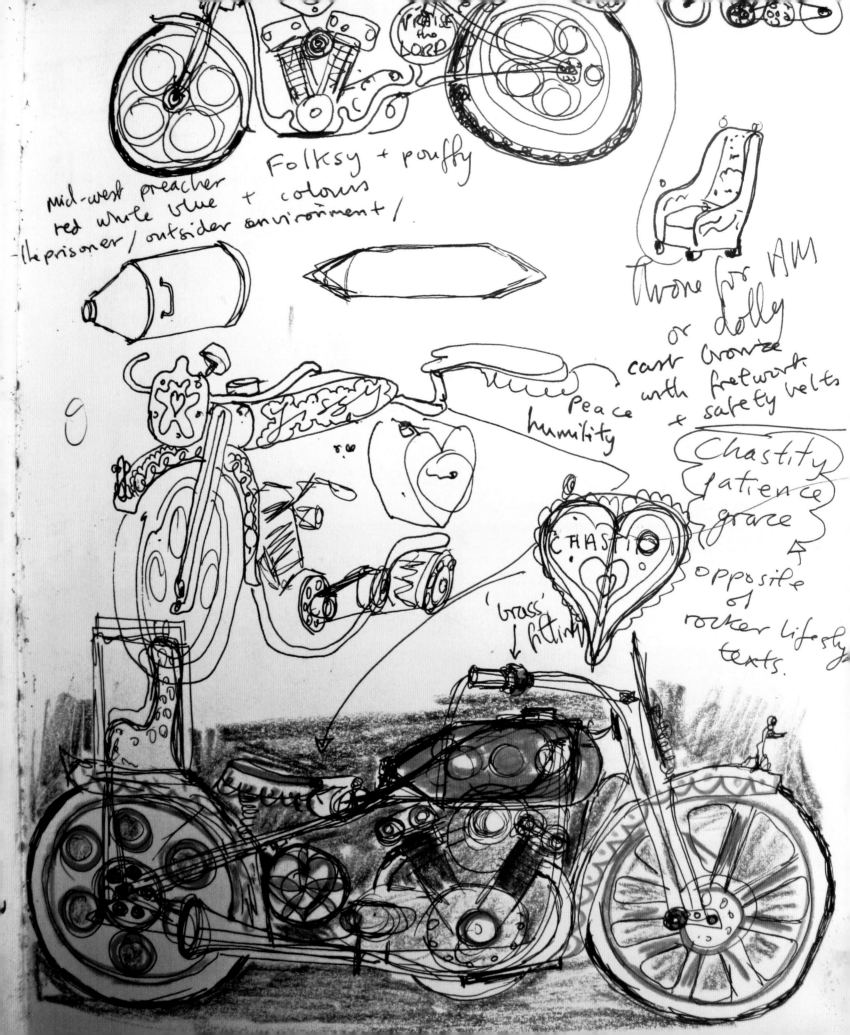

Folksy + pouffy

Mid-west preacher
red white blue + colours
- the prisoner / outsider environment!

Throne for AM
or dolly
cast bronze
with fretwork
Peace + safety belts
humility

Chastity
patience
grace
opposite
of
rocker lifestyle
texts.

'brass' fitting

CHASTI

Early sketch for AM1 motorcycle (opposite)
Grayson Perry, 2008
Ink on paper
29.7 x 21 cm

Untitled (below)
Grayson Perry, 2009
Ink, crayon, watercolour and collage on paper
42 x 59.4 cm

religion. There was no question in my mind as to whom this religion would worship. It had to be Alan Measles, my childhood teddy bear. He was the benign dictator of my fantasy world. He was an unbeaten motor racing driver, a military pilot and leader of the resistance against the occupying Germans. He was my prime candidate for deification and I set about making works that celebrated his heroism (*AM on horseback*, *Vote AM for God*) and his holy qualities (*Shrine to AM*, *Wise Alan*). The idea of Alan as a god, like so many of my ideas, began as a joke. But now I see him as a kind of test bed on which to run the idea of inventing a cult. Most of the art I love is in some ways religious yet I am not a believer in any traditional way, so in order to motivate myself I have had to make my own god. Soft toys, particularly those that become a child's special favourite, their 'transitional object', have much in common with traditional gods. They are both inanimate objects and carriers of ideas onto which we project our human qualities. I often think that if you are an angry person then you tend to have an angry god.

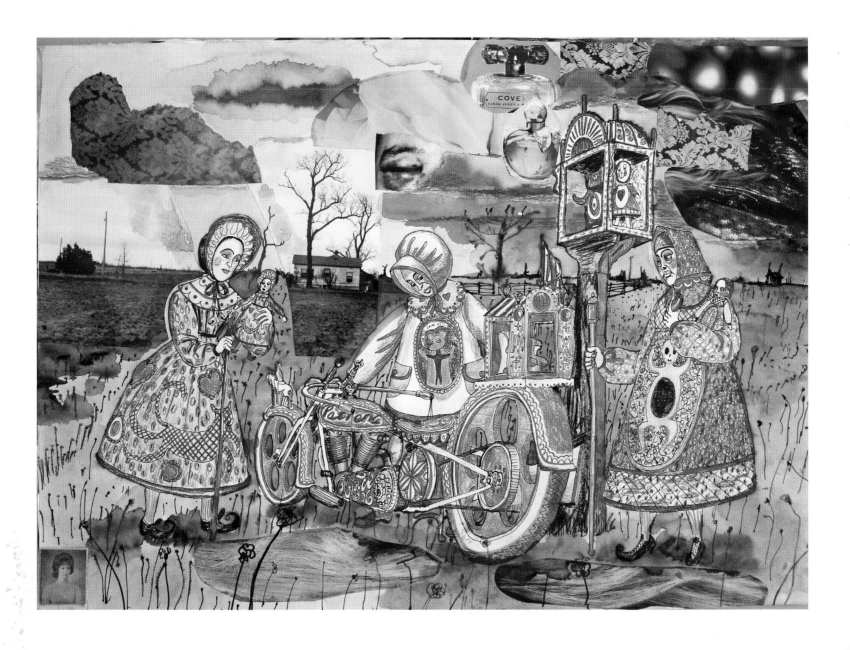

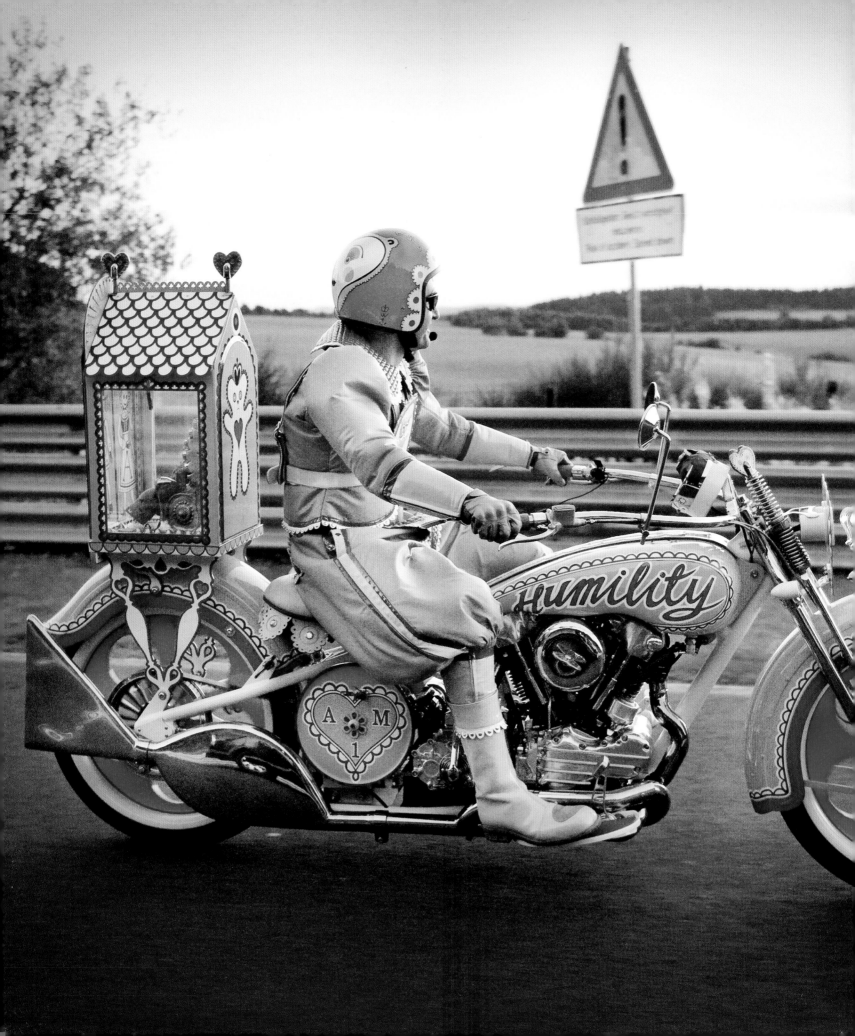

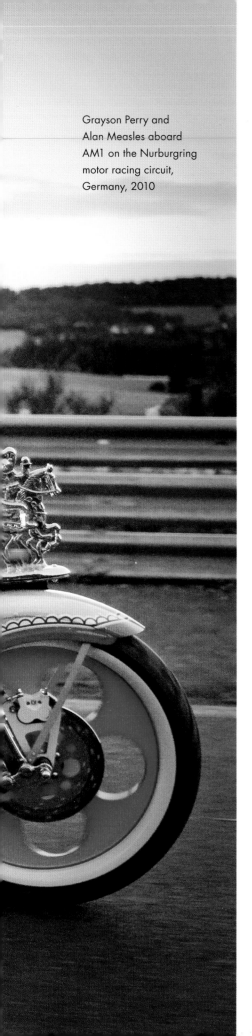

Grayson Perry and
Alan Measles aboard
AM1 on the Nurburgring
motor racing circuit,
Germany, 2010

In the course of visiting a psychotherapist I was to discover that Alan was of course more to me than a mere cuddly toy or even a fantasy leader, he was my surrogate father. Onto him I projected all the positive male characteristics that I found lacking in my real world. As a child when playing I took on the role of his bodyguard, so precious was he as a spiritual receptacle of a significant part of my own personality. It was a role I reprised in 2010 when I rode him to Germany aboard the AM1. The revelations about Alan I experienced during psychotherapy were reflected in his change of role from hot-headed military hero in a psychic war to grumpy sage. A change I can only hope is reflected in my own demeanour.

Why did I take him to Germany on a motorcycle? My parents grew up through the Second World War and the Germans were the default enemy when I was a child, and so they became the metaphor for all that was bad in my experience. Alan and I needed to make peace with our old imagined adversary. Also I took Alan on a trip in his motorised shrine as he is not yet well enough known to inspire pilgrimage. The god had to go to the people. It was a kind of pilgrimage in reverse.

Alan the god manifests in several styles as befits an upcoming cult in a globalised culture. I have always been fascinated by the artistic conversations that cultures have had over the centuries and the way a misinterpreted or misremembered image leads to a fresh vision. It is a visual version of the aforementioned game 'Chinese whispers', sometimes literally. Cathay was the mythical China that inspired the Europe-wide style of Chinoiserie in the seventeenth and eighteenth centuries. For the previous two centuries China had been an almost closed country and one of the main European reference works had been a medieval bestseller called *The Travels of Sir John Mandeville*, a work about a fictional journey written by a man who had never been to China. Even when China reopened to the west in the mid-seventeenth century it was a place as inaccessible to Europeans as outer space is to us today and consequently ripe for misinterpretation by designers. Before the end of the century English versions of the Tree of Life, a Chinese pattern, on fabric made by Indian craftsmen was being sold back to the Chinese without them recognising the pattern as of their own origin.

I have always loved artefacts where the influence of a foreign or colonial culture is clearly adapted and where beliefs and styles blend, such as Afghan war rugs, Asafo flags or export porcelain. As Alan Measles's interpreter and communicator I find myself having artistic dialogues on his behalf with older cultures such as Christianity, Islam and Buddhism. Alan, whose central message is one of doubt and holding one's beliefs lightly, sidles into our consciousness by co-opting the iconography and ritual of more ancient religions as many cults have done before him.

If Alan is the god behind this site of pilgrimage, the saint must be the Unknown Craftsman. The idea of the anonymous individual representing all his dead peers is of course inspired by the Tomb of the Unknown Warrior just inside the door of Westminster Abbey. It contains the remains of an anonymous soldier who died on the battlefields of the Western Front in the First

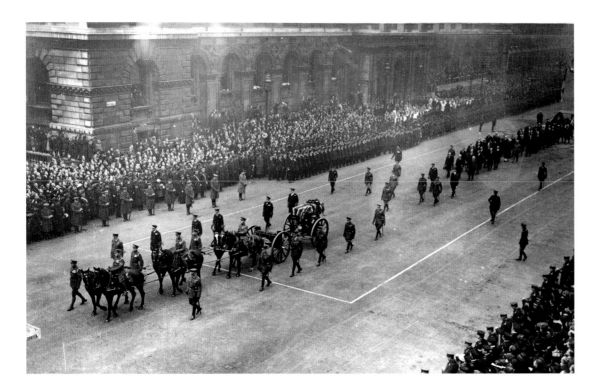

The funeral procession of the unknown soldier passes along Whitehall, 11 November 1920

World War. A plain coffin containing his remains was placed inside a more elaborate one made of oak from trees that had grown on the Hampton Court estate. It was banded with iron and a medieval crusader's sword personally chosen by the king from the Royal Collection was affixed to the top. The casket was carried with elaborate ceremony through the streets of London lined with silent crowds to be buried in the Abbey on the 11 November 1920. The guests of honour were a group of about one hundred women. They had been chosen because they had each lost their husband and all their sons in the war. 'Every woman so bereft who applied for a place got it.' It was a beautifully constructed ritual and an event of momentous national catharsis. In my own modest way I offer *The Tomb of the Unknown Craftsman* as an example of devising a ritual to satisfy a set of emotional needs, conscious or otherwise, that might be shared with others.

The Tomb of the Unknown Craftsman is a memorial to makers and builders, all those countless un-named skilled individuals who have made the beautiful man-made wonders of history. The Unknown Craftsman is an artist in the service of his religion, his master, his tribe, his tradition.

He is all craftsmen and women. It is he who has worked with great skill and dedication on most of the objects at which pilgrims to the British Museum come to marvel. Polymath Jacob Bronowski said: 'The most powerful drive in the ascent of man is his pleasure in his own skill. He loves to do what he does well and, having done it well, he loves to do it better. You see it in his science. You see it in the magnificence with which he carves and builds, the loving care, the gaiety, the effrontery. The monuments are supposed to commemorate kings and religions, heroes, dogmas, but in the end, the man they commemorate is the builder.'

Pilgrimage to the British Museum (detail)
Grayson Perry, 2011
Ink and graphite
60 x 60 cm

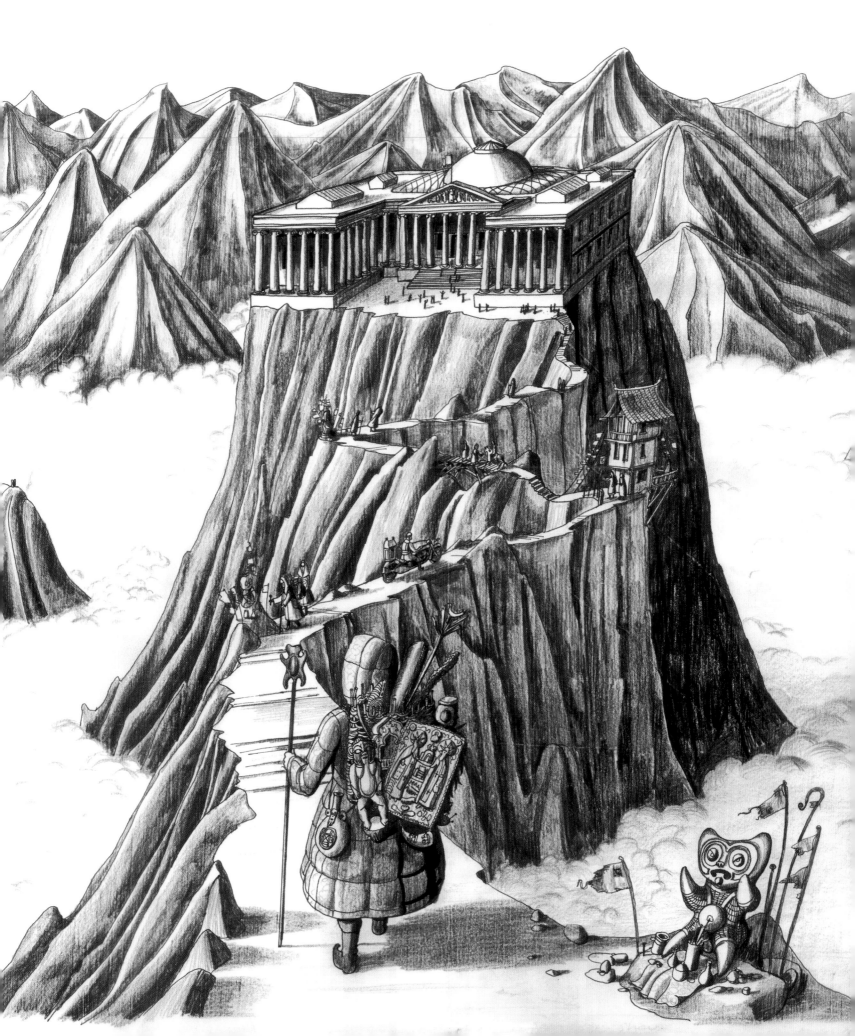

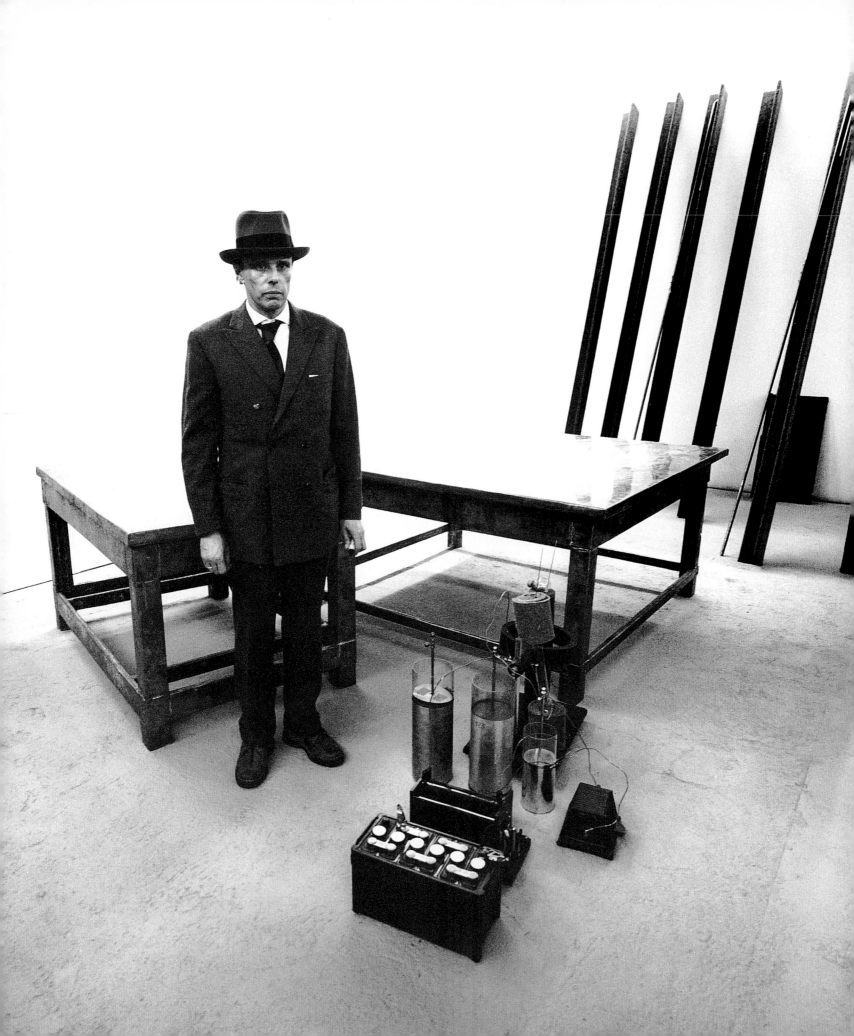

The craftsman is a man perhaps more of action than of contemplation. He grasps the world with skill and intuition. His is not an idea of the world but an experience of it. His prayer is walking the pilgrim trail. He works within a tradition and has become so at ease with his material world that his works have a relaxed fluency won through long, hard apprenticeship. At various times in recent history technical skill has been seen as somehow less than academic attainment or raw aesthetic sensitivity. The result is a population that sends a high proportion of its young people to university to study theory and design but has to recruit technicians from abroad. A craftsman does a job well. Whether the job is building a boat, programming a computer or parenting a child.

In my personal cosmology the idealized craftsman is the shadow burnt by unreliable memories of my father before he left. I equate him with what feminist writer Susan Faludi calls 'Utility Man'. These are men from the golden age of manufacturing, men who worked by making and mending things with their hands. At home they could fix the house, the car, the washing machine and tend an allotment. His temple was the workshop, his shrine the shed.

There is also a mystical resonance to the word craftsman. He is crafty. A trickster, a sorcerer, an androgynous shaman communing with the spirit world, a member of a secretive guild holding his alchemical secrets close to his chest.

Though I subscribe to few superstitions, I enjoy the charms, talismans, shrines that are made by those that do. The very idea of the relic, of an object imbued with spiritual or mystical power, seems a close kin to contemporary art. One of my twentieth-century artistic heroes, Joseph Beuys, saw himself very much as a shaman, an artist who mythologized his own life. He often worked with materials such as fat, felt or copper, substances, he felt, that stored, conducted or insulated spiritual energy. His central myth was that when a gunner in a Stuka dive bomber fighting on the Russian front in the Second World War he crashed in Crimea and was rescued from the wreckage by Tartar tribesmen who smothered him in fat and wrapped him in felt to keep him alive.

If I had a material that conducted spiritual energy it would be iron. Iron for me is the material symbolic of Utility Man and of traditional heavy industry. My father worked at one point in Hoffmans ball bearing factory in Chelmsford. He brought me home a large ball bearing, a perfect shiny cannonball. It rolled into a patch of mint in the garden and was lost. I found it some time after he left, pitted and rusty. When I was a little older I roamed the countryside and was always enchanted when I came across an obsolete piece of farm machinery rusting and overgrown in the corner of a field. Those flaking traction engines and threshing machines themselves were monuments to a past age of skilled labour.

And so we come to the form of the tomb itself, an iron ship sailing into the afterlife. An image perhaps inspired by those original Egyptian models or the magnificent ship burials like those

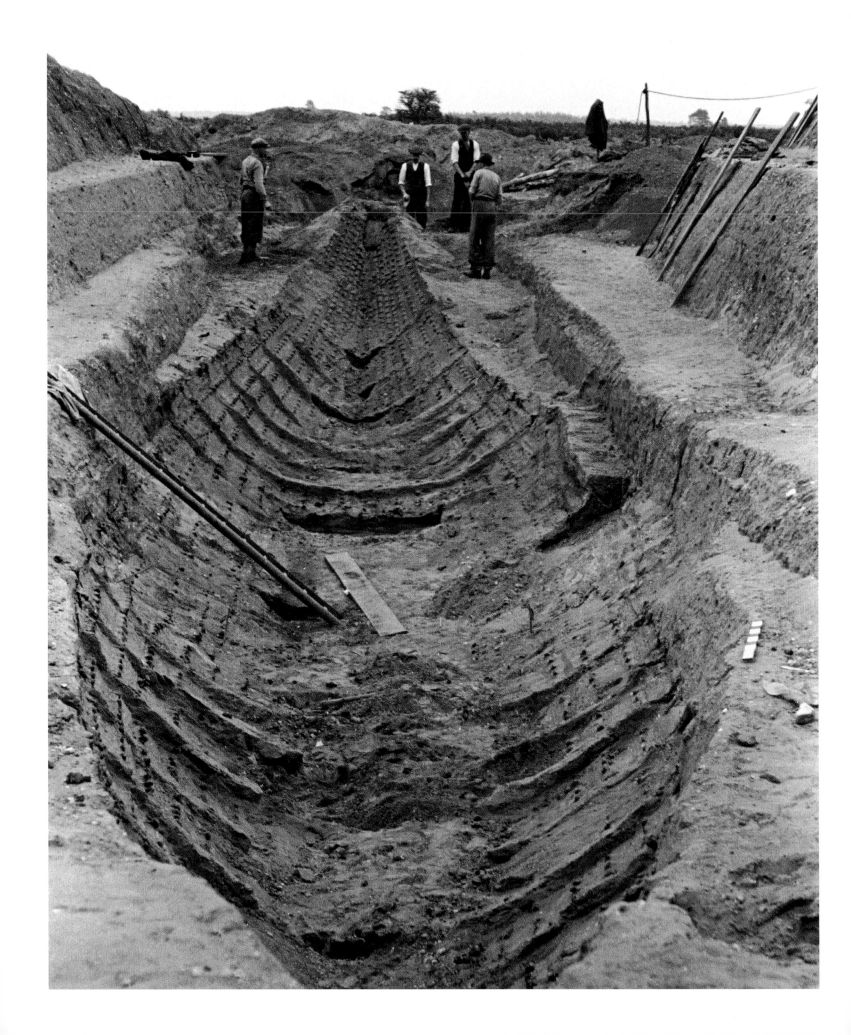

uncovered near Tonsberg in Norway in 1904–5 or Sutton Hoo in Suffolk in 1939. The ship is also a pun, a craft for the craftsman. It is hung with casts of the fruits of his labours and carries a cargo of blood, sweat and tears. In the central reliquary is an example of the original tool which begat all tools, a flint axe 250,000 years old. A flint hand axe is not a masterwork made for some king but a common tool that was used over most of the human world for most of mankind's history. Holding such a tool in my hand and feeling its fit was my most moving memory of my pilgrimage through the stores of this great institution. This whole exhibition rotates around this humble stone.

We are dying, we are dying, so all we can do
is now be willing to die, and to build a ship
of death to carry the soul on the longest journey.

A little ship, with oars and food
and little dishes, and all accoutrements
fitting and ready for the departing soul.

Now launch the small ship, now as the body dies
and life departs, launch out, the fragile soul
in the fragile ship of courage, the ark of faith
with its store of food and little cooking pans
and change of clothes,
upon the flood's black waste
upon the waters of the end
upon the sea of death, where still we sail
darkly, for we cannot steer, and have no port.

There is no port, there is nowhere to go
only the deepening black darkening still
blacker upon the soundless, ungurgling flood
darkness at one with darkness, up and down
and sideways utterly dark, so there is no direction any more
and the little ship is there; yet she is gone.
She is not seen, for there is nothing to see her by.
She is gone! gone! and yet
somewhere she is there.
Nowhere!

D.H. Lawrence

PILGRIMAGE TO THE BRITISH MUSEUM

The relationship between my personal themes and obsessions and the vastness of world culture as represented by the British Museum is like a narrow pilgrimage trail across an infinite plain. With the curators as my guides I have laid out a path. It has led me to *The Tomb of the Unknown Craftsman.*

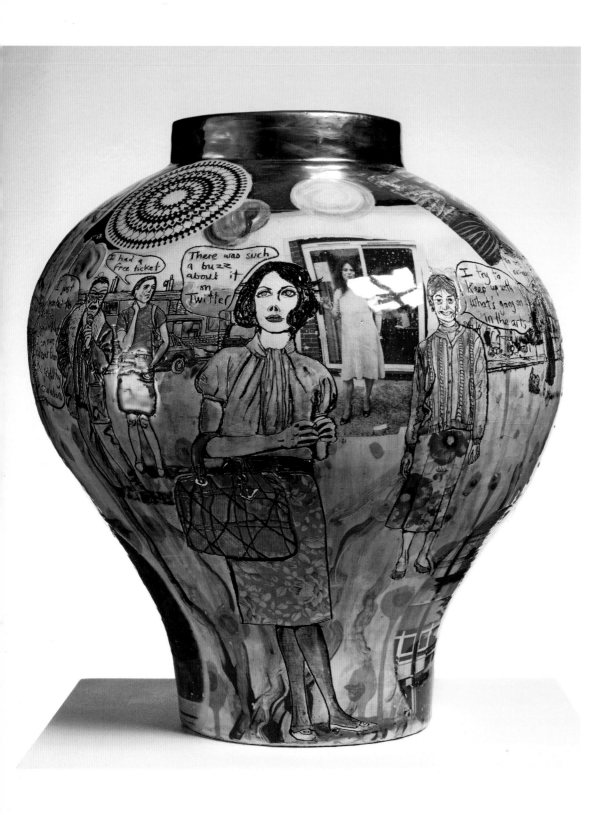

This is the pot equivalent of a reality TV show. It is a busy collage featuring characters saying why they have come to this exhibition. This is an exhibition about sacred sites, the audience are contemporary cultural pilgrims who come here for a variety of reasons.

You Are Here
Grayson Perry, 2011
Glazed ceramic
43.5 x 39.2 cm

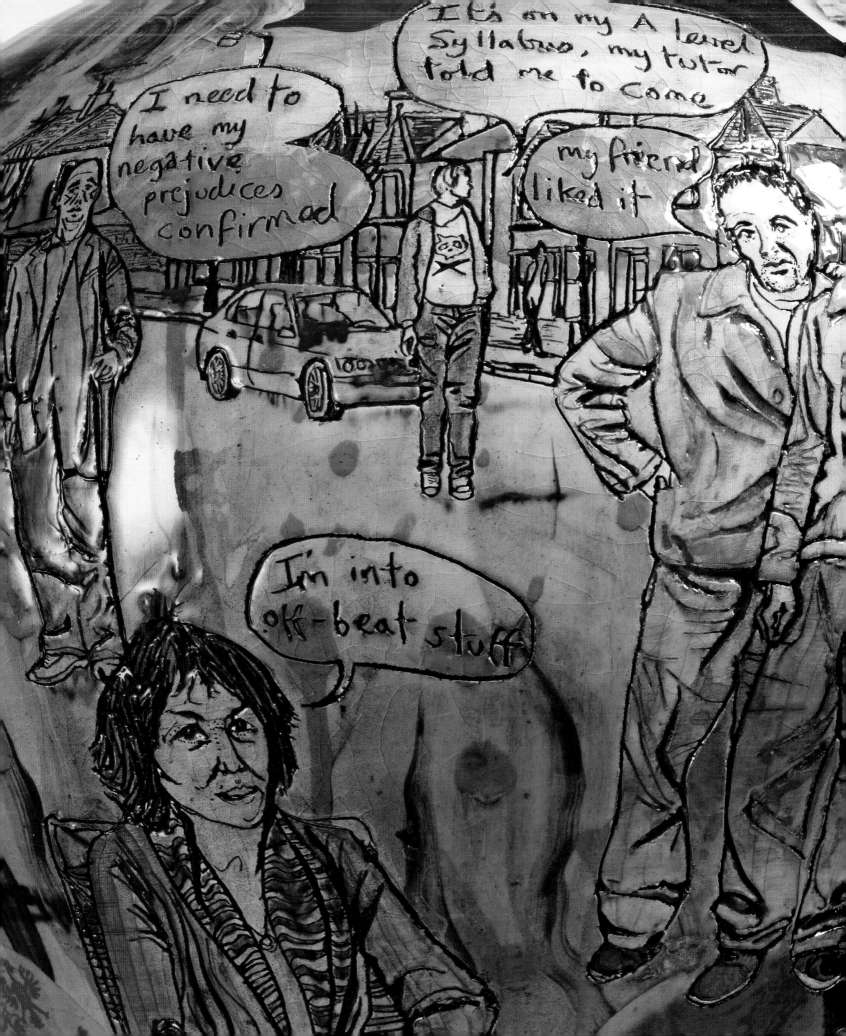

WHO IS ALAN MEASLES?

Alan Measles is my fifty-year-old teddy bear. He was the benign dictator of my childhood imaginary world, where his roles included surrogate father, rebel leader, fighter pilot and undefeated racing driver. I was his bodyguard for he was very precious to me because I had given him all my male qualities of leadership and rebellion. Now he is a guru and living god in my personal cosmology.

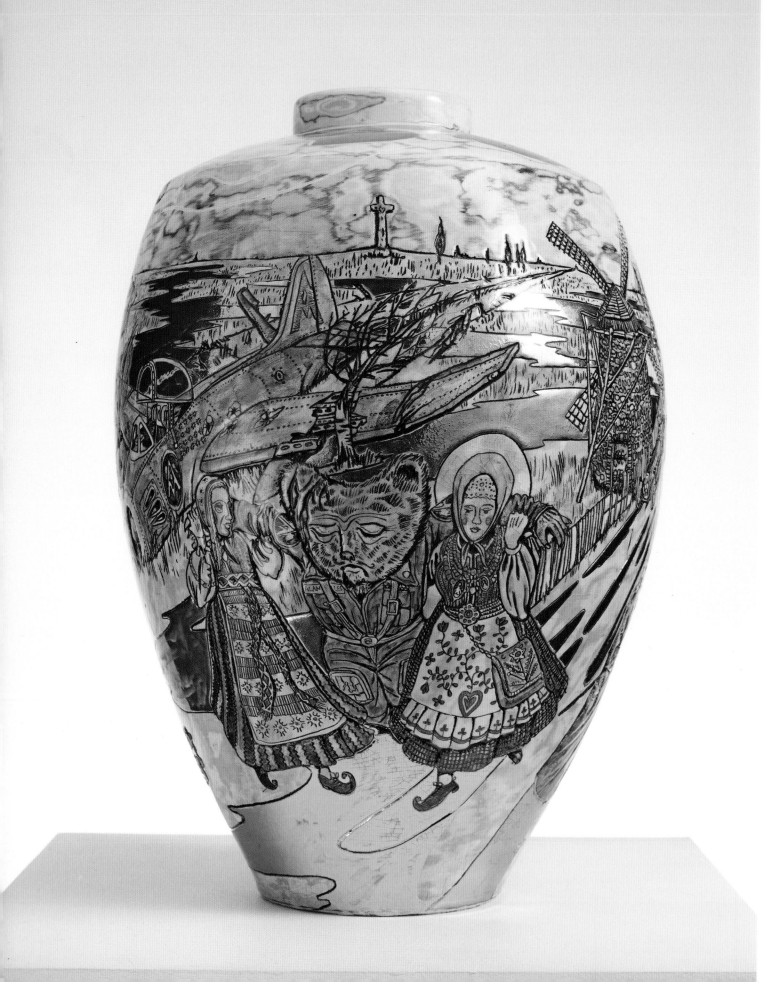

While serving as a jet fighter pilot in the great psychic war 1965–75, Alan Measles was shot down over Latvia. He was dragged out of the crashed plane by local village women including Klara (later known as Claire) and nursed back to health using traditional medicine. Under the tutelage of a shaman Alan abandons his role as a warrior and sets out on a thirty-year journey as a wandering holy man.

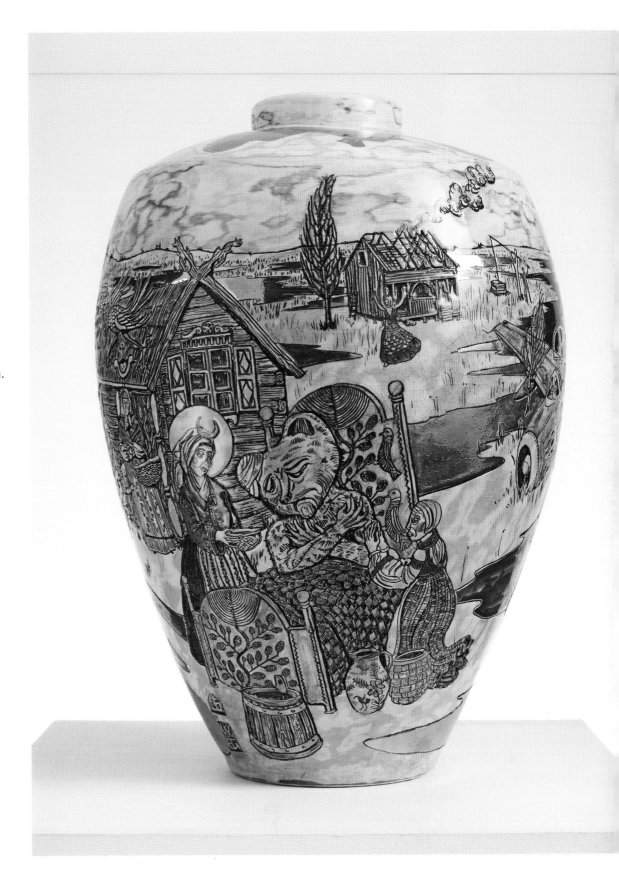

The Near Death and Enlightenment of Alan Measles
Grayson Perry, 2011
Glazed ceramic
42 x 31 cm

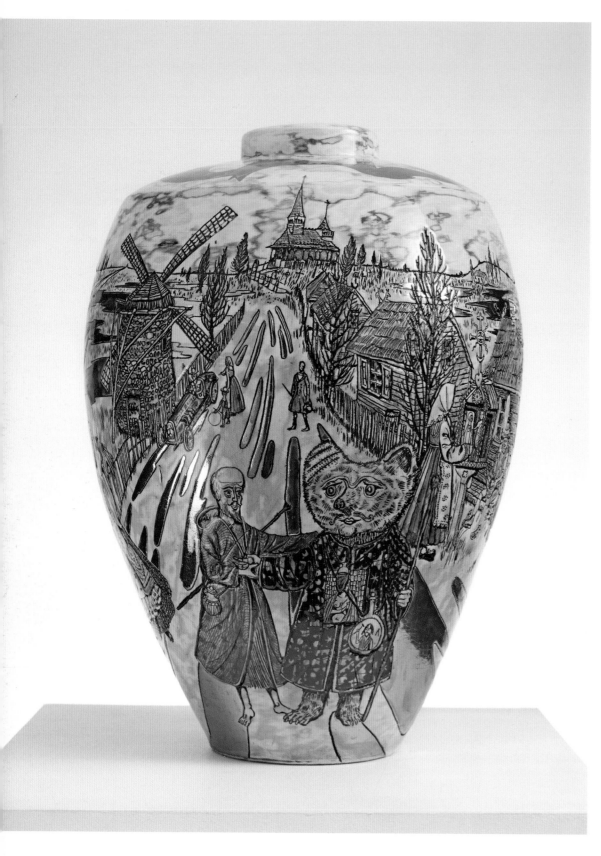

The Near Death and Enlightenment of Alan Measles
Grayson Perry, 2011
Glazed ceramic
42 x 31 cm

(Right) In reward for the man's kindness, the bear seeks to kill a fly on his face with a stone. The inscription reads: 'A clever enemy is better than a stupid friend.'

The Gardener and the Bear (right)
Page from a manuscript of the *Anvar-i Suhayli* (The Lights of Canopus) by al-Kashifi (detail)
Iran, c.1550–75
Ink and opaque watercolour on paper
18.5 x 11 cm
British Museum

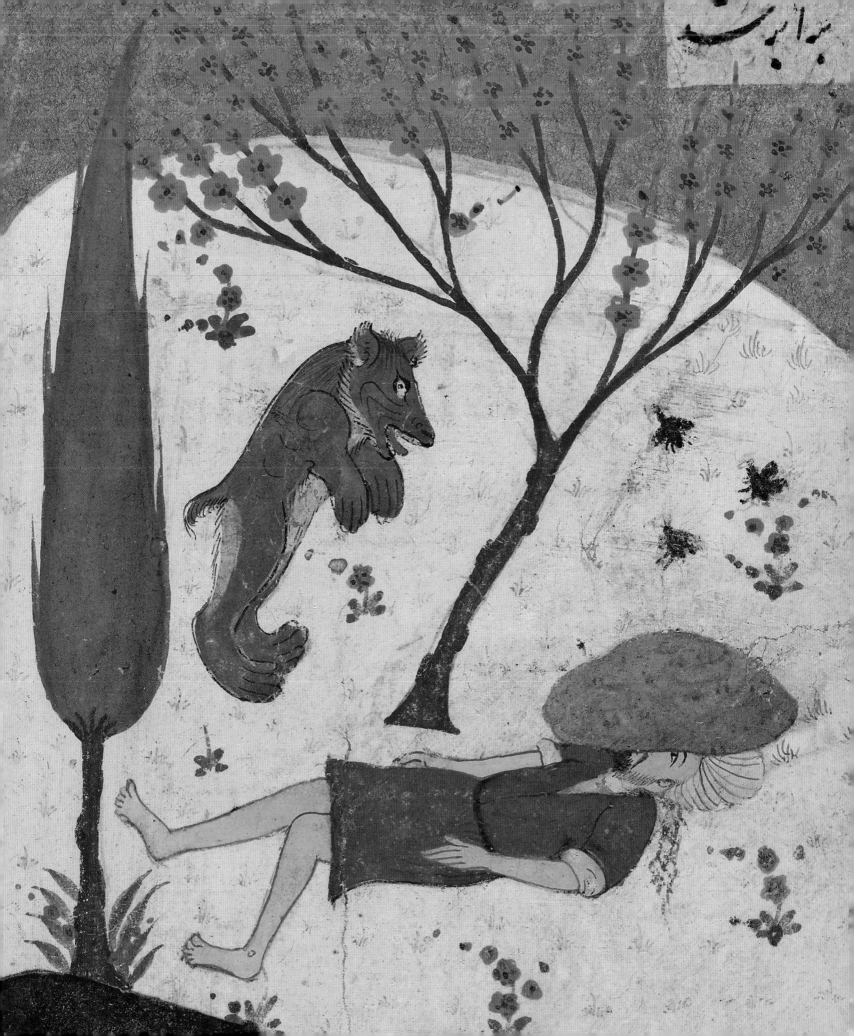

To me, ancient Egypt is to the British Museum what dinosaurs are to the Natural History Museum. It is what children think of when they imagine what they will see in a museum. The ancient Egyptians are the generators of merchandising and cliché. For this reason when I started this project I dreaded entering the Egyptian department as it might look to me like the crumbling stage sets of the popular imagination. Then I saw this small statue of the god Bes (right). For a start he does not look like a typical Egyptian artefact as he is always depicted face on instead of the usual profile. Then he is a household god, the protector of children and childbirth. He became associated with good things: music, dance, sexual pleasure. If Alan Measles had been around in ancient Egypt he would have hung out with Bes.

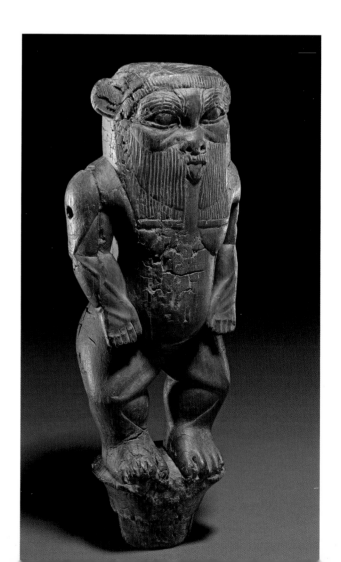

Prehistoric Gold Pubic Alan Dogu
Grayson Perry, 2007
Glazed ceramic
left: 12.5 x 10.5 x 5.5 cm
right: 12.8 x 10 x 4.8 cm

Furniture fitting carved in the form of the god Bes
Egypt, 1550–1069 BC
Wood
27 x 10.5 cm
British Museum

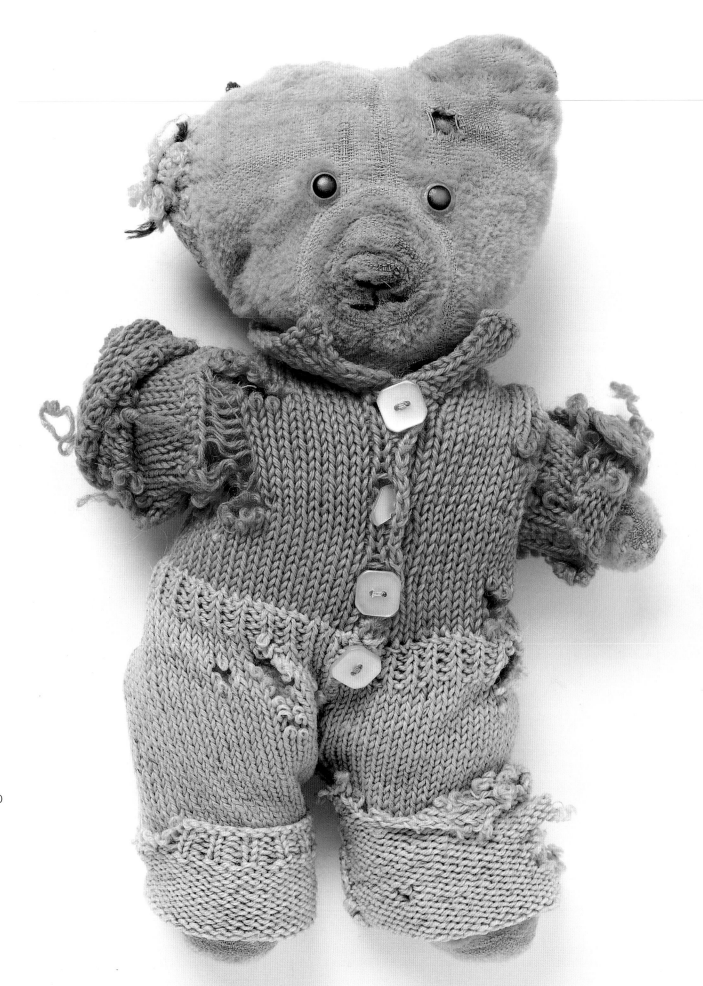

Alan Measles, 1960

Medal
Germany, 1914
Copper alloy
Diam. 6.5 cm
British Museum

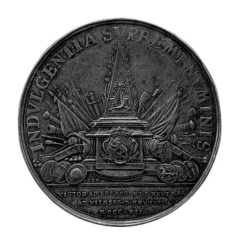

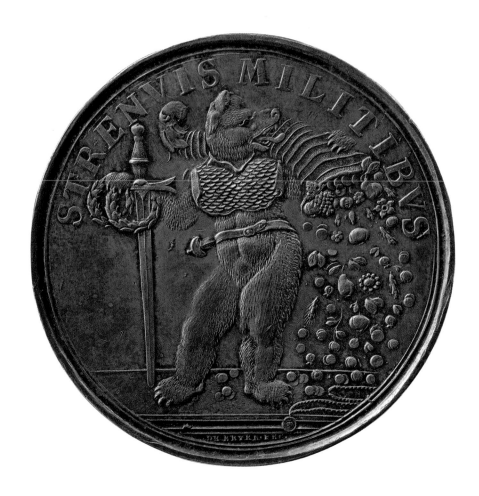

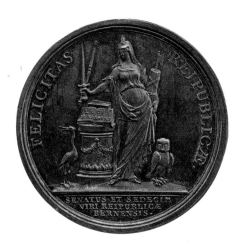

Medal
Switzerland, *c.*1780
Silver
Diam. 5.8 cm
British Museum

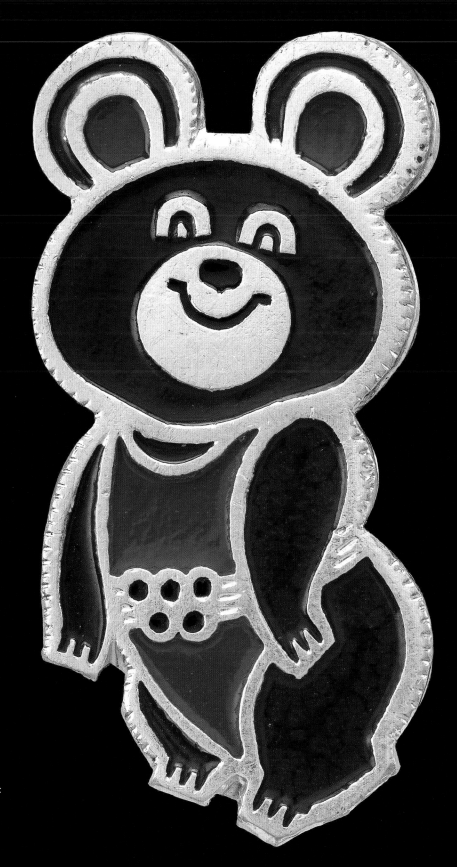

Badge
Russia, 1980
Aluminium and plastic
3 x 1.5 cm
British Museum

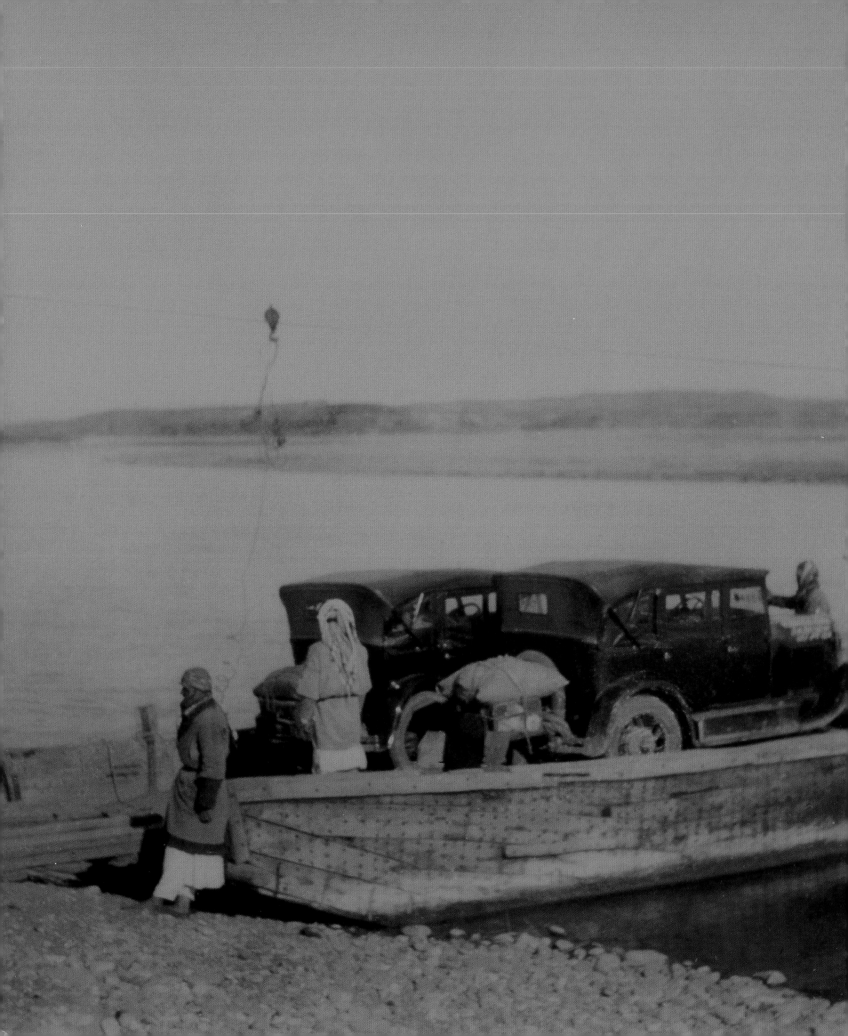

THE TEN DAYS OF ALAN

Why take Alan to Germany?

I wanted Alan to meet the world.
He is not yet famous enough to inspire
pilgrimage so I took him amongst the
people in the AM1, like the Pope in
his 'popemobile'. We chose Germany
as long ago he fought the Germans in
many imaginary battles. We wanted
to make peace.

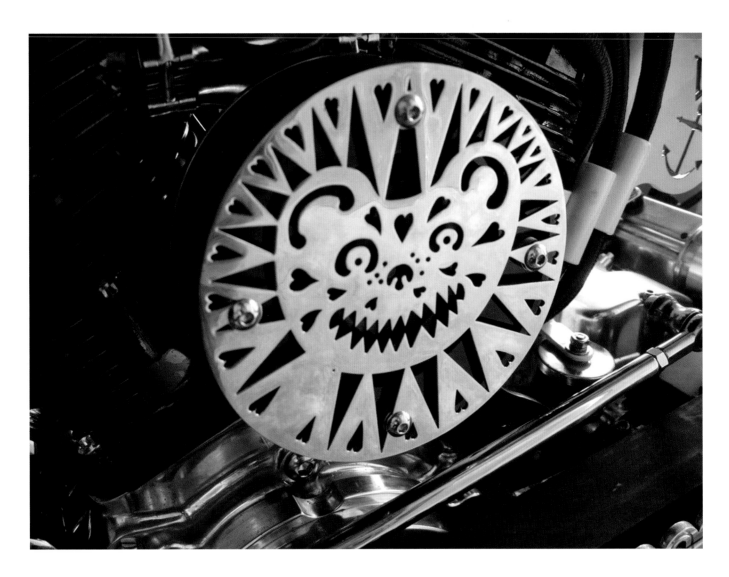

Detail of Kenilworth AM1
horn cover

Bodyguard's jacket (detail)
Grayson Perry, 2010
Leather
77 x 60 cm

Overleaf
Kenilworth AM1
Grayson Perry, 2010
159 x 275 x 126 cm

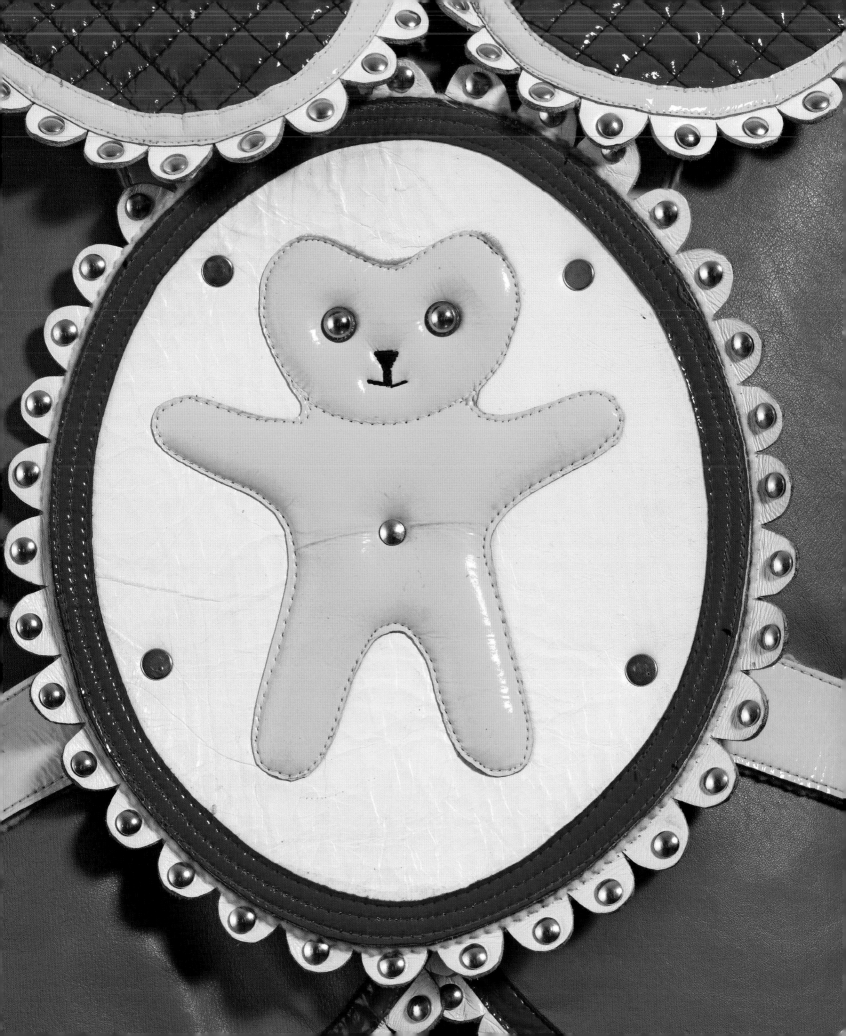

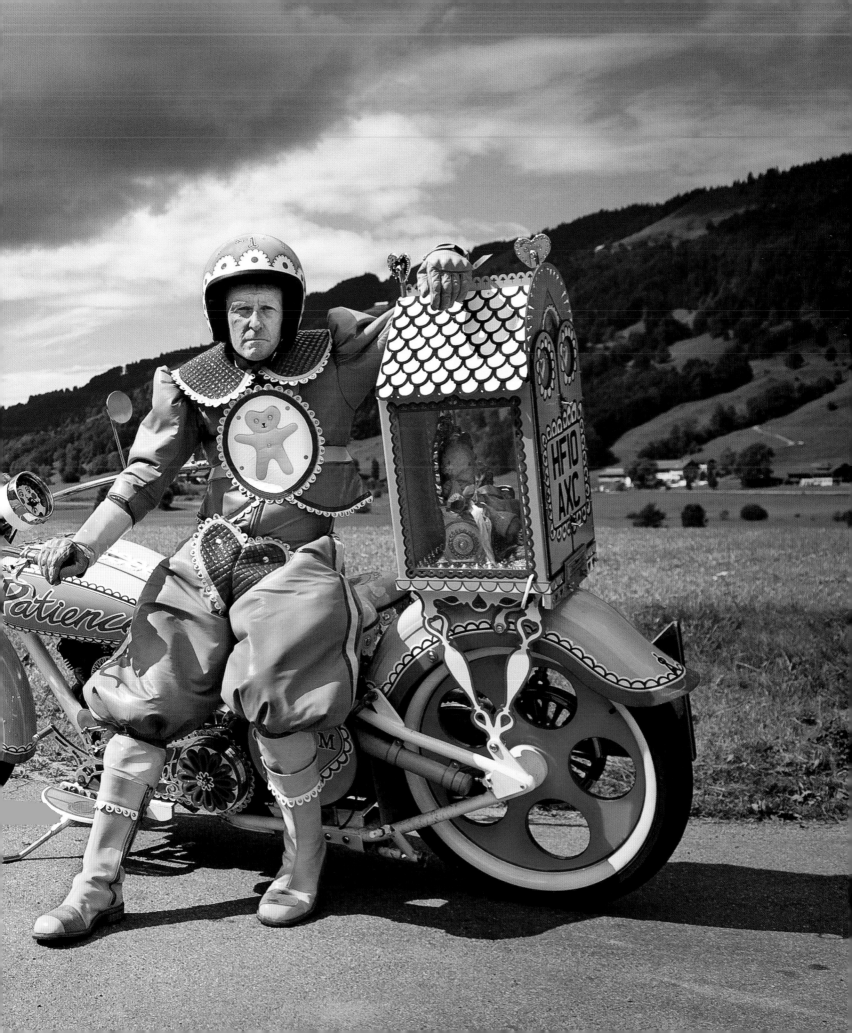

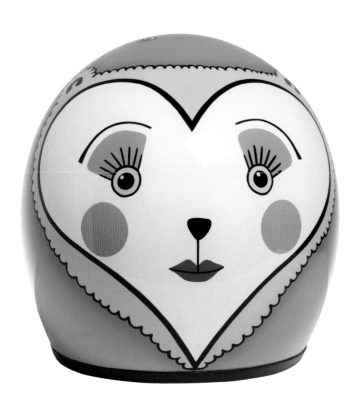
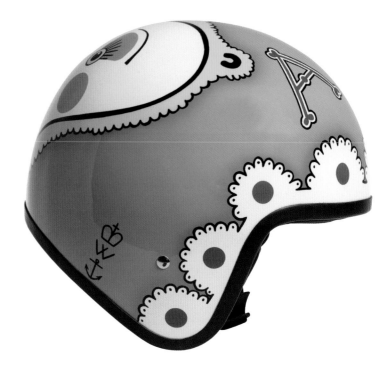

Bodyguard's Helmet
Grayson Perry, 2010
Polycarbonate, metal and textile
29 x 26 x 27 cm

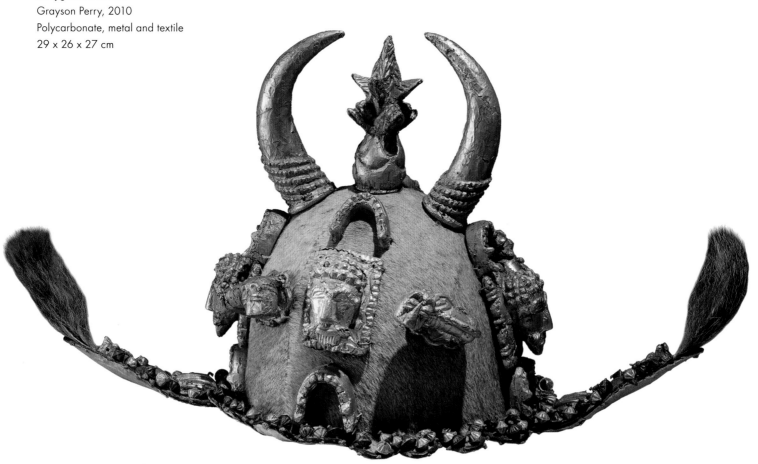

Early English Motorcycle Helmet
Grayson Perry, 1981
Aluminium
32 x 22 x 26 cm

Ceremonial headdress (opposite)
Asante, Ghana
Shell, gold, deer skin, silver
and hair
24 x 46 cm
British Museum

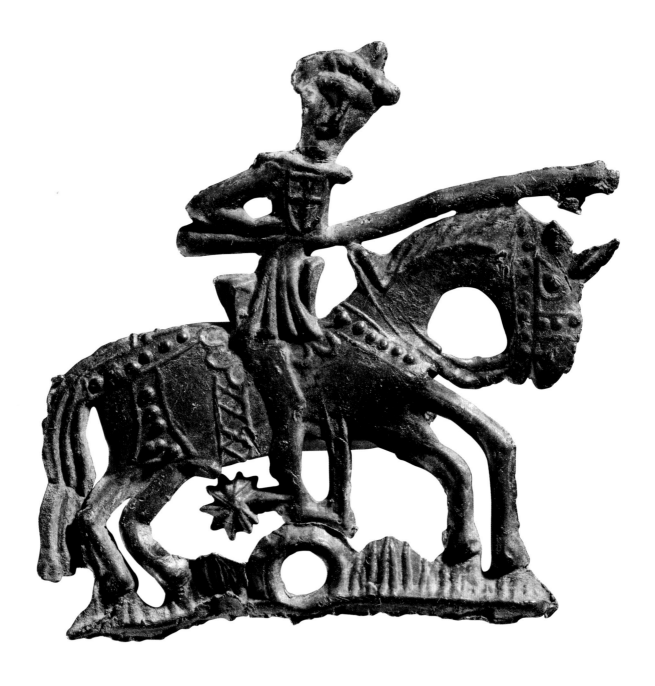

Pilgrim badge
Britain, medieval
Lead alloy
3.7 x 4.2 cm
British Museum

Alan Measles on Horseback
Grayson Perry, 2007
Cast iron
86 x 69 x 20 cm

Play is often a time when children process difficult emotional situations through metaphorical games.
This is my teddy bear Alan as military hero, victor in the imaginary battles of childhood. He was the embodiment of my male rebelliousness and leadership qualities that I suppressed in childhood. It is a monument to all our helpful imaginary friends in the form of a large old-fashioned toy soldier.

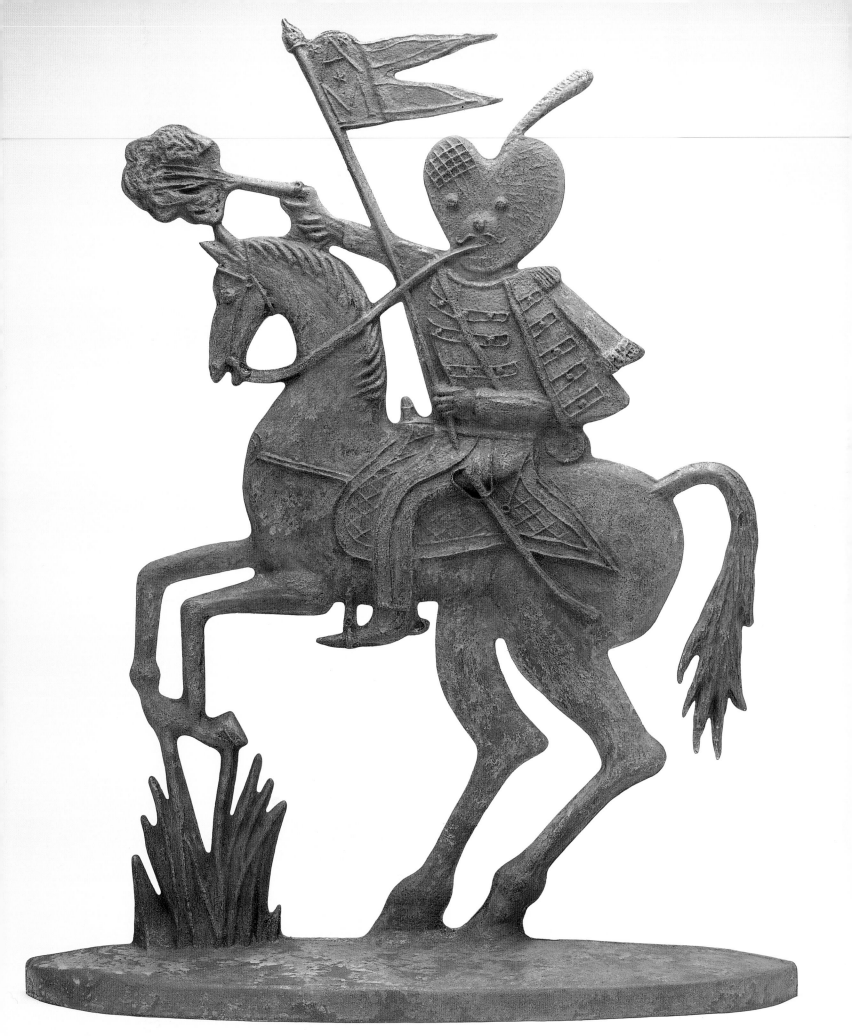

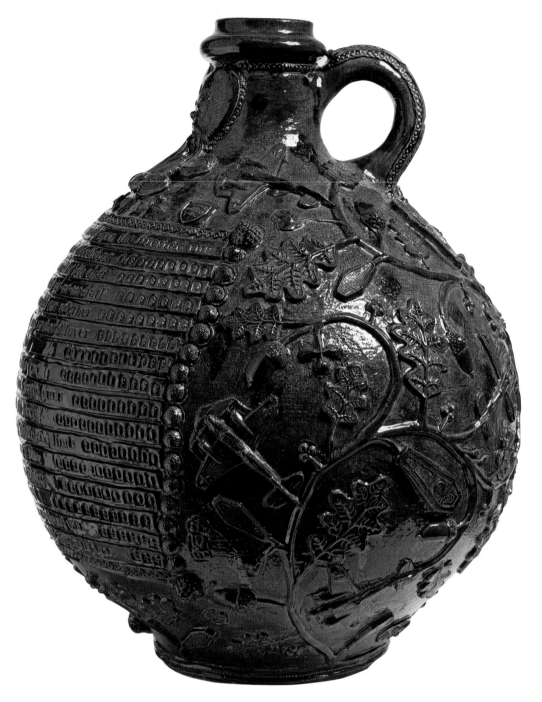

A Family Tradition
Grayson Perry, 2010
Glazed ceramic
53 x 42 cm

When I was small and played with bricks upon the fireside rug
I heard the tales of rationing and dreaded doodlebug
suffering and death in world war two were stuff of idle chat
So I played at killing German swine, 'Take that rat-tat-tat-tat!'

Once more our family went to war, this time with one another
The Germans marched into my head led by my mother's lover
I bunkered down in fantasy, my room a rebel lair
I gave the role of Churchill to my sacred Teddy Bear

We played a war a decade long with sulks and plastic guns
Across the dining table we skirmished with the huns
Through a thousand dogfight duels Ted risked his life and limb
He survived the playtime war, so did I, because of him

Now my childhood hero's reached his golden jubilee
I see him as a keeper for a braver part of me
Peace to the blameless German folk, caught in my inner war
For they were nothing bad to me, just a childish metaphor.

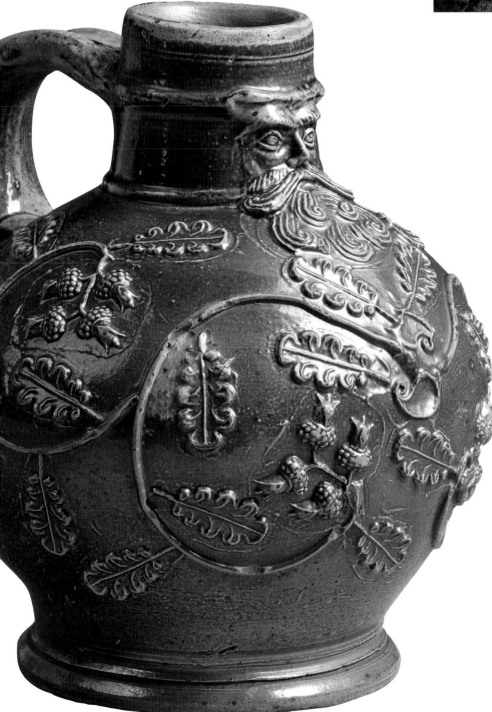

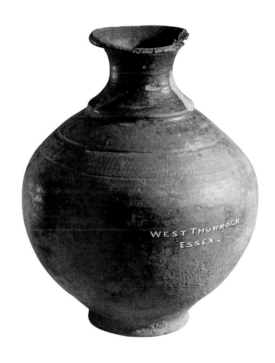

Flask (above)
Roman Britain, *c.* AD 1–50
Pottery
16 x 12 cm
British Museum

Jug (left)
Germany, Rhineland, Cologne,
c.1520–45
Stoneware, salt-glazed, applied
moulded ornament
14 x 12 cm
British Museum

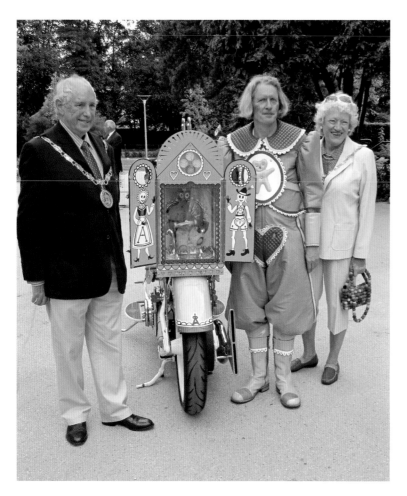

As luck would have it our birthplace, Chelmsford in Essex, is twinned with Backnang near Stuttgart.

(left) Grayson Perry with the mayor and mayoress of Chelmsford
(below) With Oberbürgermeister of Backnang and his wife
(opposite, top) In Colmar to see the Isenheim Altarpiece
(opposite, below left) Outside Neuschwanstein Castle
(opposite, below right) At the Steiff Museum

Badges (above and opposite)
Britain, 1980s–1990s
Plastic, metal and paper
Diam. 2.4–5.4 cm
British Museum

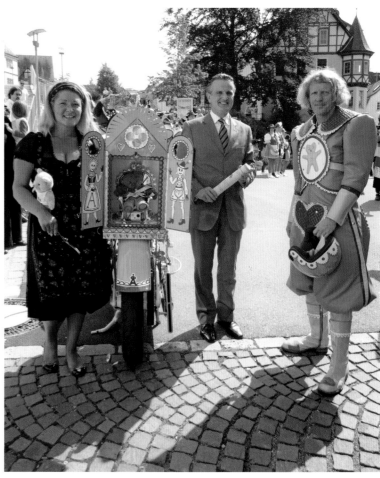

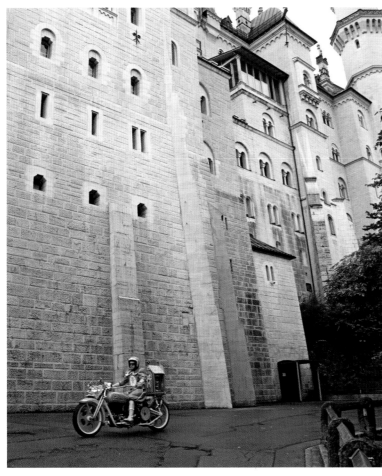

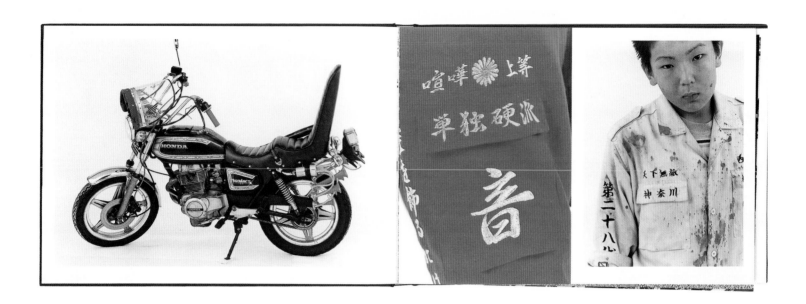

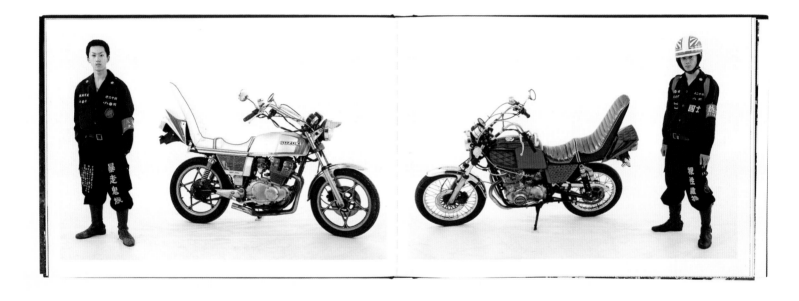

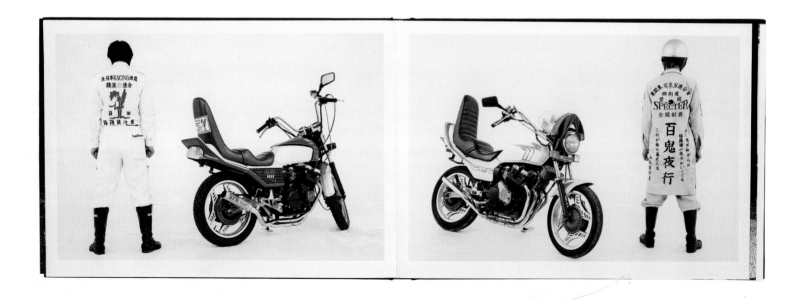

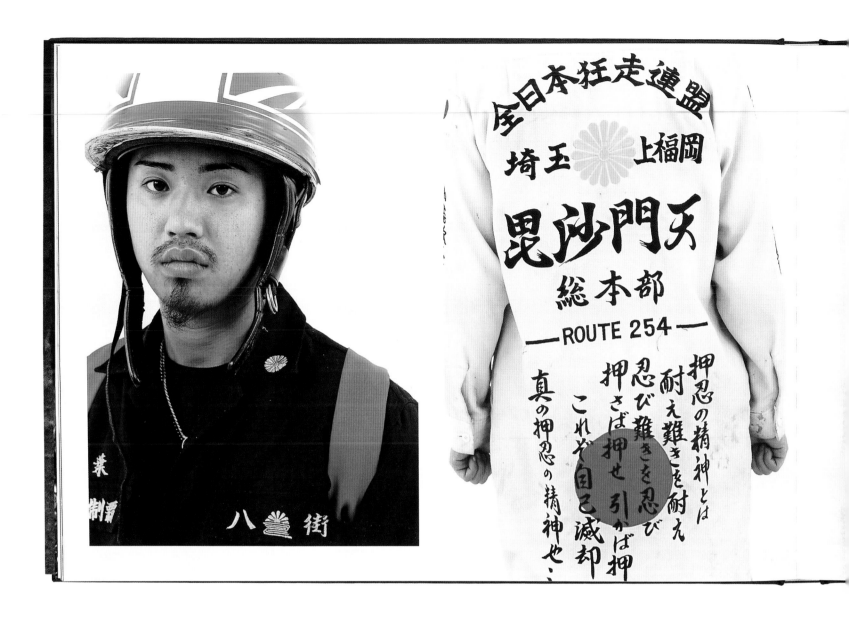

Zoku (Tribes) photobook
by Yoshinaga Masayuki (born 1964)
Japan, 2003
Paper with silk-covered covers
26 x 37 cm (closed)
British Museum

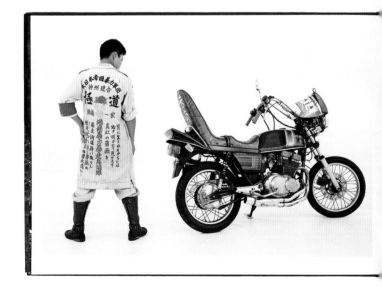

CULTURAL CONVERSATIONS

Few civilizations spring up spontaneously or develop in isolation. Cultures borrow and adapt. I enjoy artefacts where this give and take is more obvious and dissonant. New religions try to recruit by using the sites and symbols of the belief system they are trying to replace. Craftsmen make artefacts they think will appeal to visitors from abroad. Sometimes they get it wrong in a charming way. Creativity is often just mistakes.

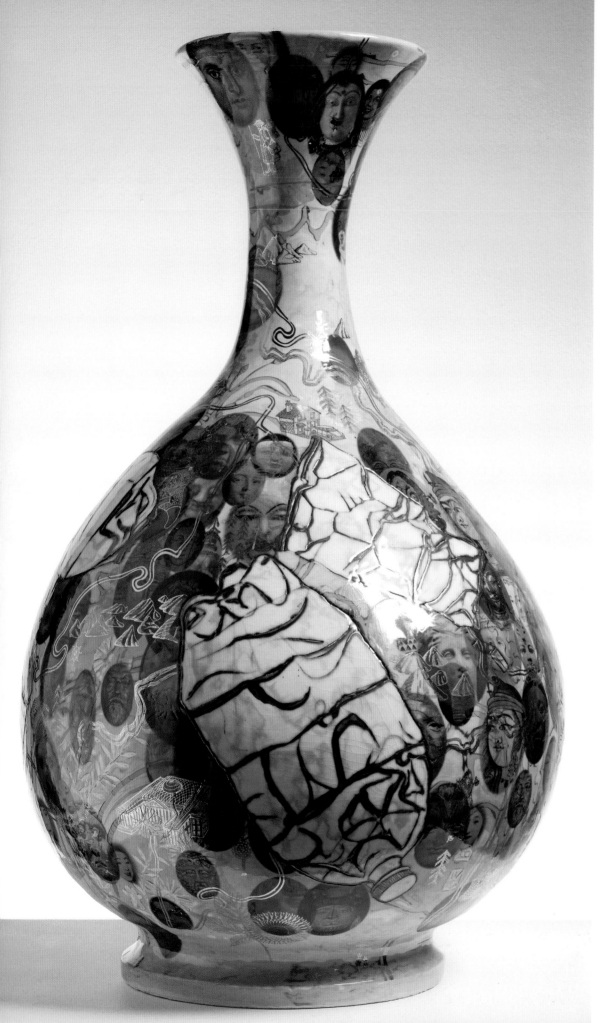

A Walk in Bloomsbury
Grayson Perry, 2010
Glazed ceramic
76 x 47 cm

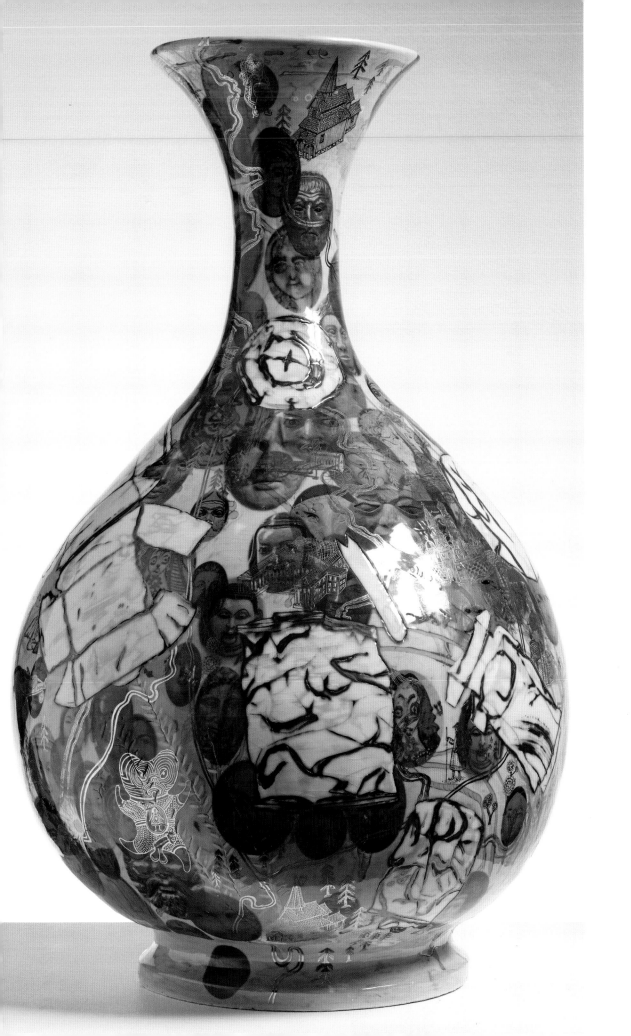

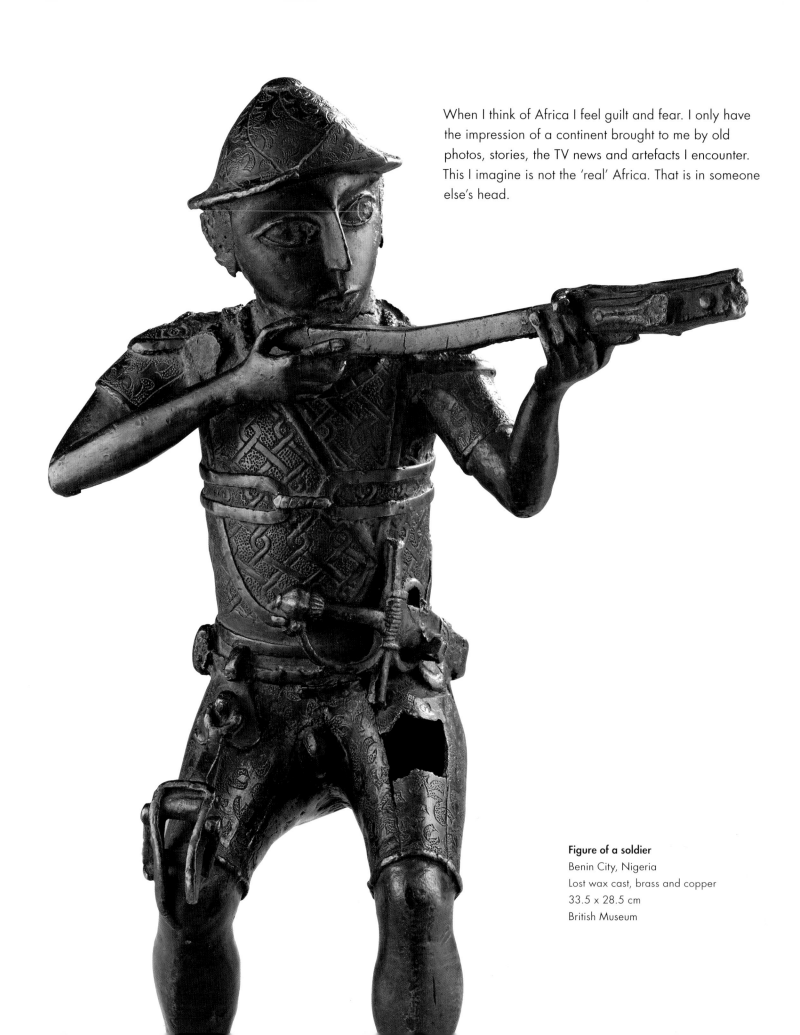

When I think of Africa I feel guilt and fear. I only have the impression of a continent brought to me by old photos, stories, the TV news and artefacts I encounter. This I imagine is not the 'real' Africa. That is in someone else's head.

Figure of a soldier
Benin City, Nigeria
Lost wax cast, brass and copper
33.5 x 28.5 cm
British Museum

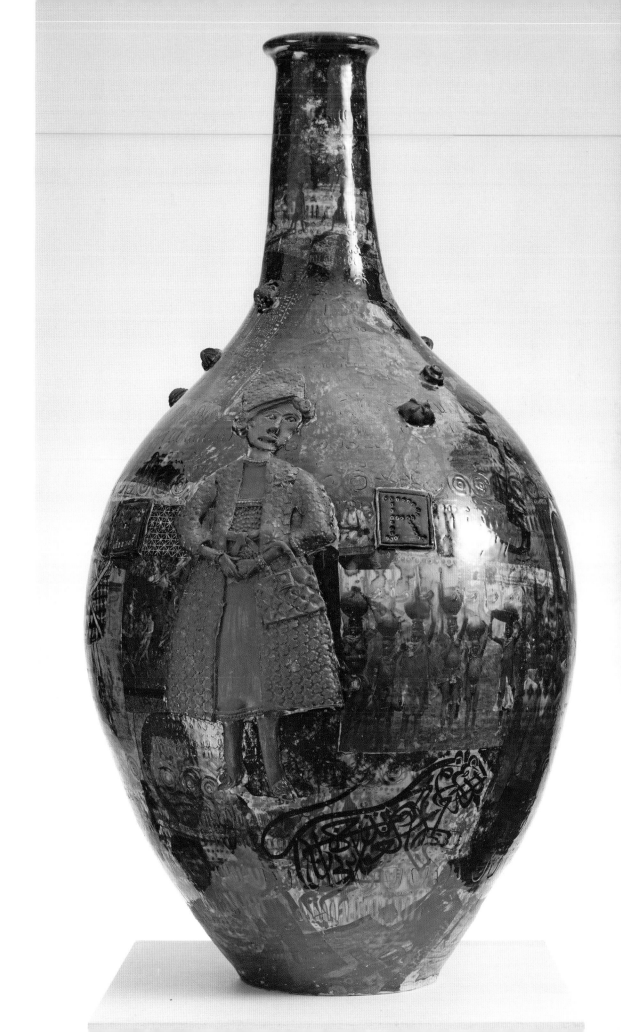

I have never been to Africa
Grayson Perry, 2011
Glazed ceramic
81 x 45 cm

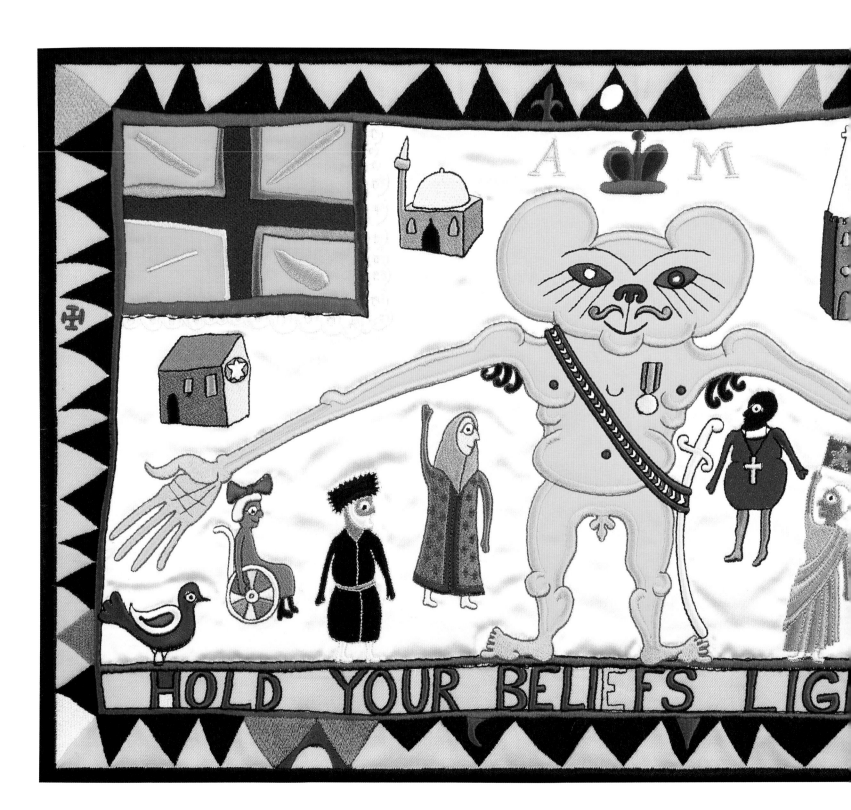

These Asafo flags are one of the most visually lively results of the 'give and take' of cultural conversation. In the 1600s the Fante people of the Gold Coast (now modern-day Ghana) set up military groups called Asafo. The Asafo adopted some European military practices including the display of a Company flag. In a curious twist, Lord Baden Powell is thought to have been influenced by the Asafo when setting up the scout movement. The flags usually depict proverbs or are visual jibes at rival companies. The freshness of these flags compared to the pageantry of Britain makes me think that ritual can become stultified if not kept relevant to its time and context. On the left is Alan Measles, the guru of doubt, doling out sensible advice to other religions.

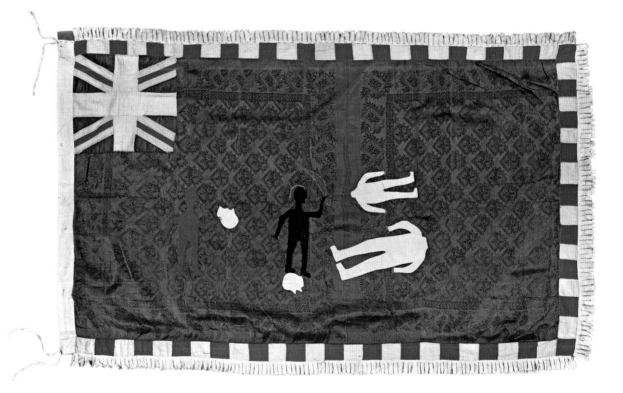

Hold Your Beliefs Lightly (left)
Grayson Perry, 2011
Computerized embroidery
on cotton and silk
32.5 x 45 cm

Asafo flag
Fante, Ghana, 1850–1927
Silk and cotton, appliqué
90 x 146 cm
British Museum

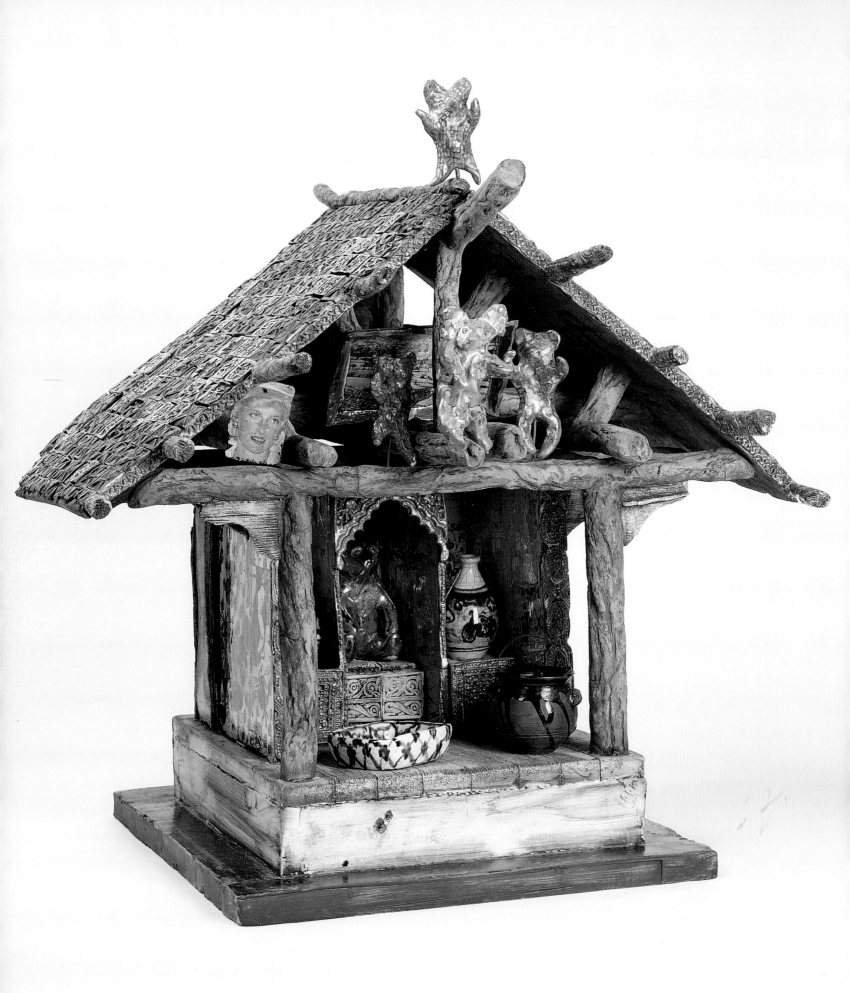

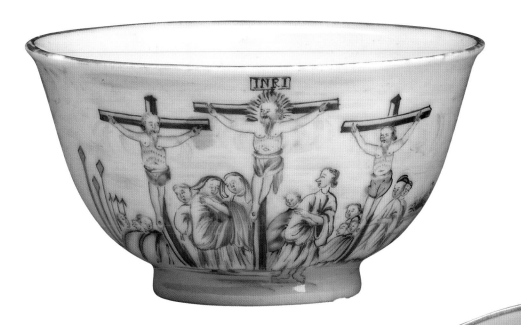

**Cup and saucer showing
Christ's crucifixion**
China, Qing Dynasty, made in
Jingdezhen, Jiangxi Province,
1740–60
Porcelain with overglaze enamels
Cup: diam. 7 cm
Saucer: diam. 12 cm
British Museum

Shrine to Alan Measles (opposite)
Grayson Perry, 2007
Glazed ceramic
72 x 66 x 52 cm

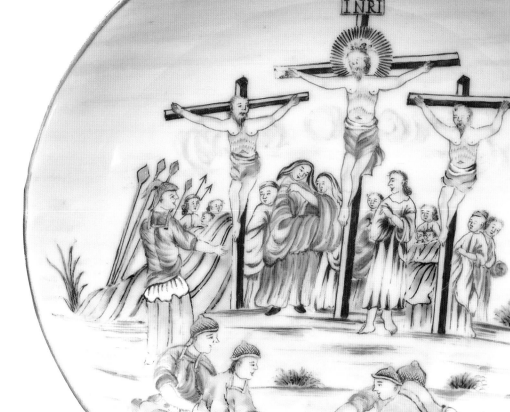

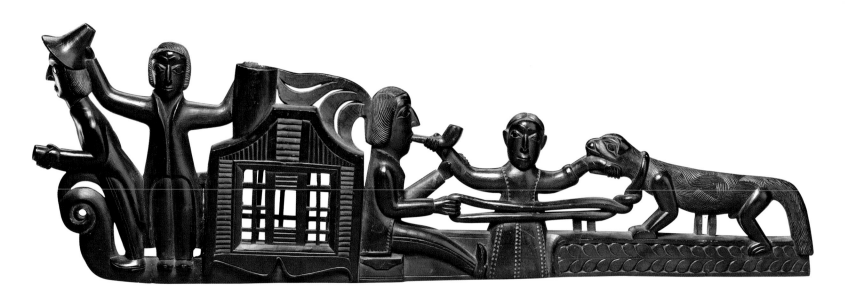

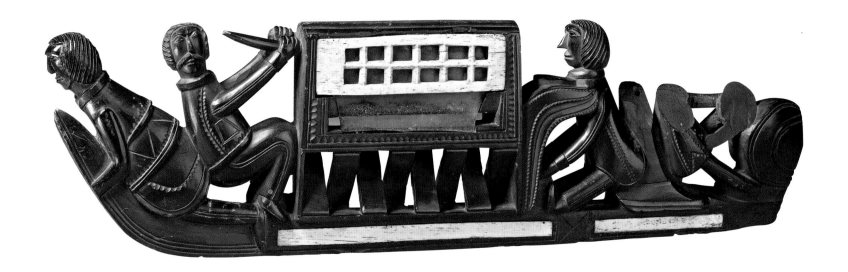

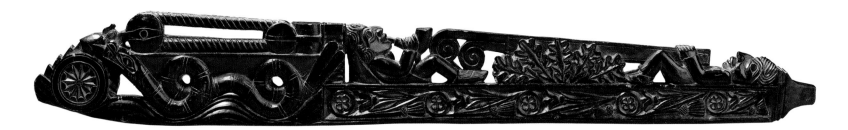

Smoking pipe (top)
Haida, Haida Gwaii, Canada,
1840–50
Argillite
11 x 36 cm
British Museum

Smoking pipe (middle)
Haida, Haida Gwaii, Canada,
1830–70
Argillite, glass, bone and ivory
10 x 32 cm
British Museum

Smoking pipe (bottom)
Haida, Haida Gwaii, Canada,
1830–5
Argillite
6.8 x 44.5 cm
British Museum

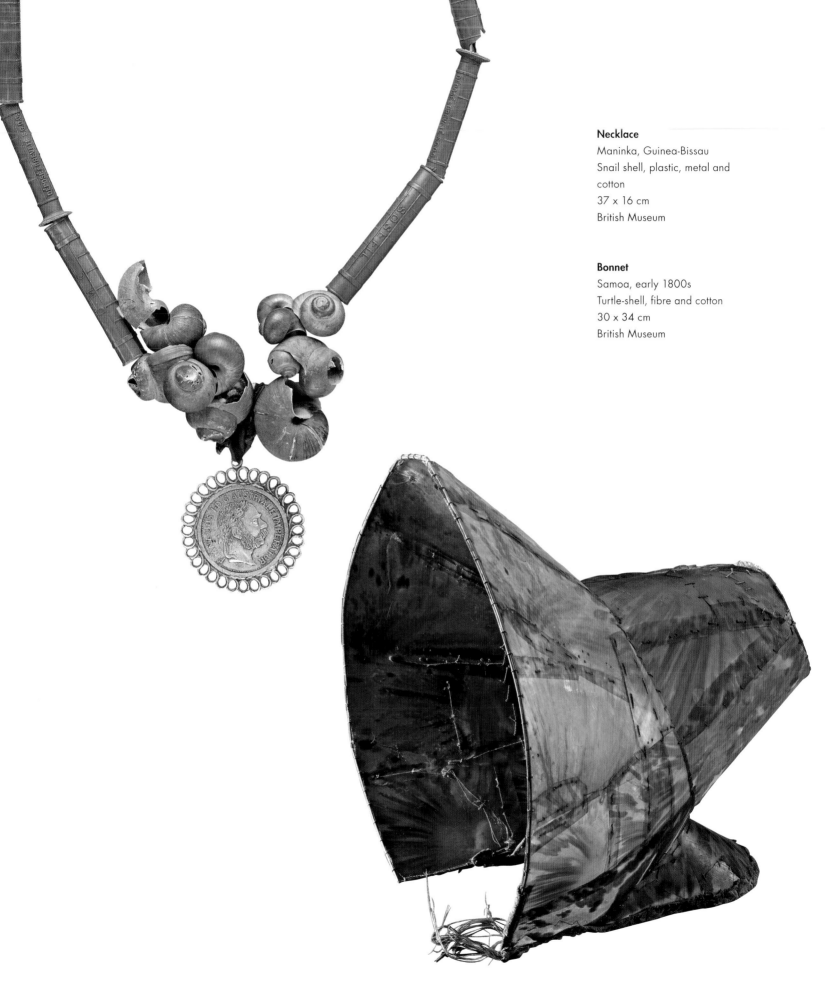

Necklace
Maninka, Guinea-Bissau
Snail shell, plastic, metal and cotton
37 x 16 cm
British Museum

Bonnet
Samoa, early 1800s
Turtle-shell, fibre and cotton
30 x 34 cm
British Museum

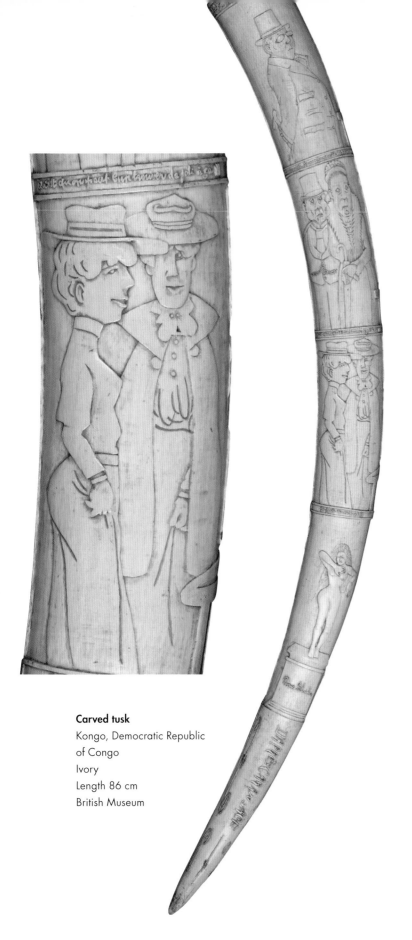

As a voracious consumer of imagery, I am constantly on the lookout for artefacts that somehow reflect but also enhance my visual language. In 2008 I was searching for a starting point for a large drawing that was to become *The Walthamstow Tapestry*. Someone showed me a book of early-twentieth-century batik sarongs. I knew instantly I had found my source. This is a beautiful example combining the dense fluid decoration with a charming palette and European motifs. I particularly like the elegant treatment of the figures. I am never more aware of the lyrical transformations wrought by the hand of a skilled craftsman than when I see a familiar figure of a colonial royal rendered in an exquisite traditional hand.

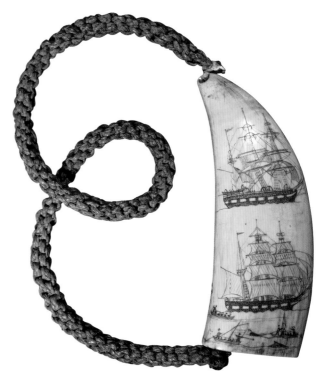

Carved tusk
Kongo, Democratic Republic of Congo
Ivory
Length 86 cm
British Museum

Pendant (above)
Fiji, late 1800s
Sperm whale tooth and cord
33 x 17 cm
British Museum

Batik (opposite)
Indonesia, 1880–1913
Plain weave cotton
111 x 108 cm
British Museum

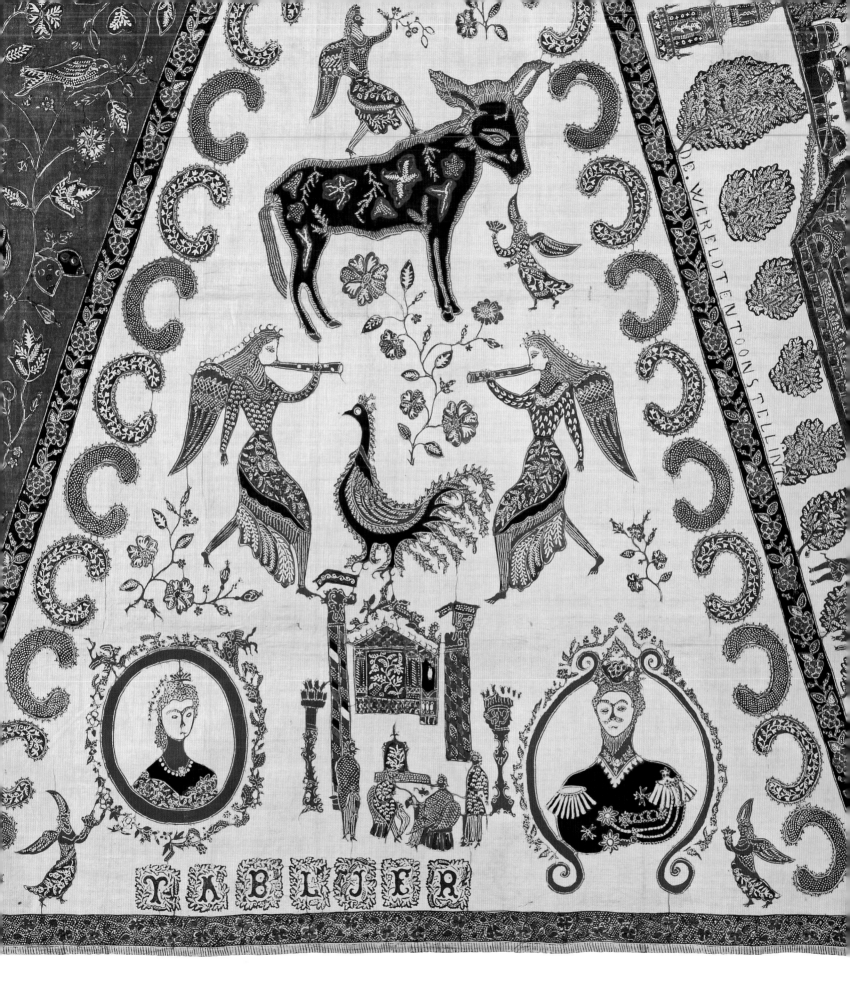

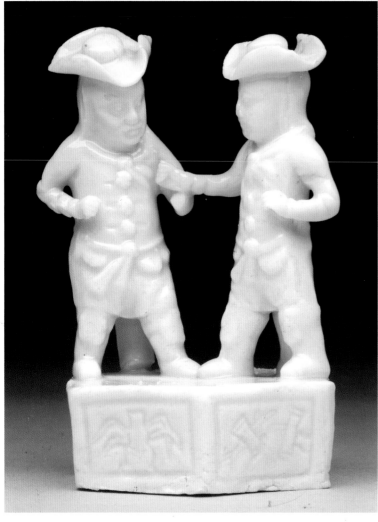

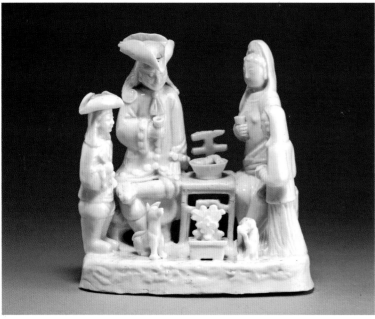

Model of two Dutchmen (above left)
China, Qing Dynasty, made in Dehua, Fujian Province, 1662–1722
Porcelain with clear glaze
8 x 5.5 cm
British Museum

Sculpture of a European Family
China, Qing Dynasty, made in Dehua, Fujian Province, 1700–1750
Porcelain with clear glaze
16.8 x 15.5 cm
British Museum

Figure (above)
Haida, Haida Gwaii, Canada, 1830–65
Argillite
24.5 x 14 cm
British Museum

Figure (opposite)
Haida, Haida Gwaii, Canada, 1850–70
Argillite
15 x 14 cm
British Museum

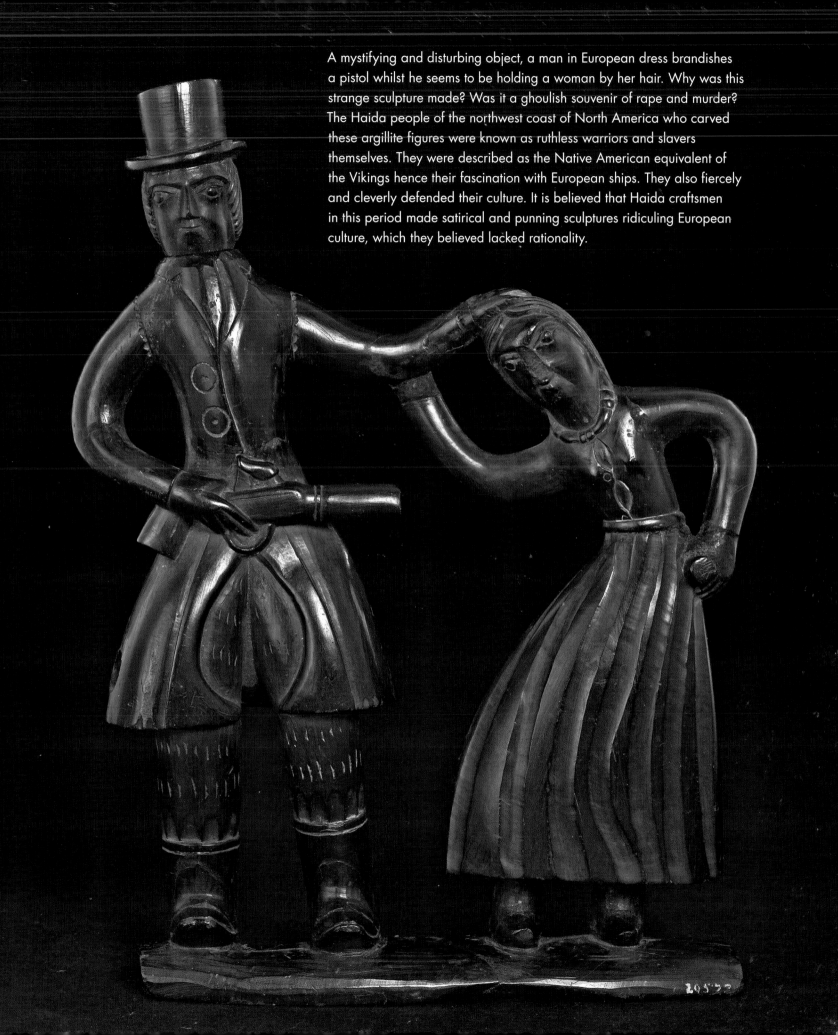

A mystifying and disturbing object, a man in European dress brandishes a pistol whilst he seems to be holding a woman by her hair. Why was this strange sculpture made? Was it a ghoulish souvenir of rape and murder? The Haida people of the northwest coast of North America who carved these argillite figures were known as ruthless warriors and slavers themselves. They were described as the Native American equivalent of the Vikings hence their fascination with European ships. They also fiercely and cleverly defended their culture. It is believed that Haida craftsmen in this period made satirical and punning sculptures ridiculing European culture, which they believed lacked rationality.

SHRINES

I love a good shrine. Shrines to me embody the essence of what I do. I put significant artefacts in a special place for us to contemplate. The special place could be in your pocket, in a corner of your house or by a roadside, it could also be a contemporary art gallery or the British Museum. As humans I think how we look at art has developed from the way we look upon gods, altars and relics in shrines and sacred spaces.

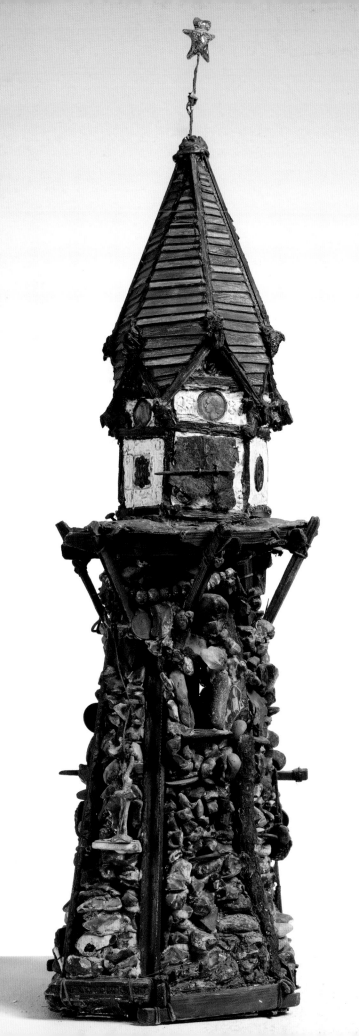

I made this model from flints from the beach and detritus I found around the squat where I was living in 1983. It reminds me that I can make art with hardly any money and on the kitchen table.

La Tour de Claire
Grayson Perry, 1983
Flint, wood, found objects
65 x 25 cm

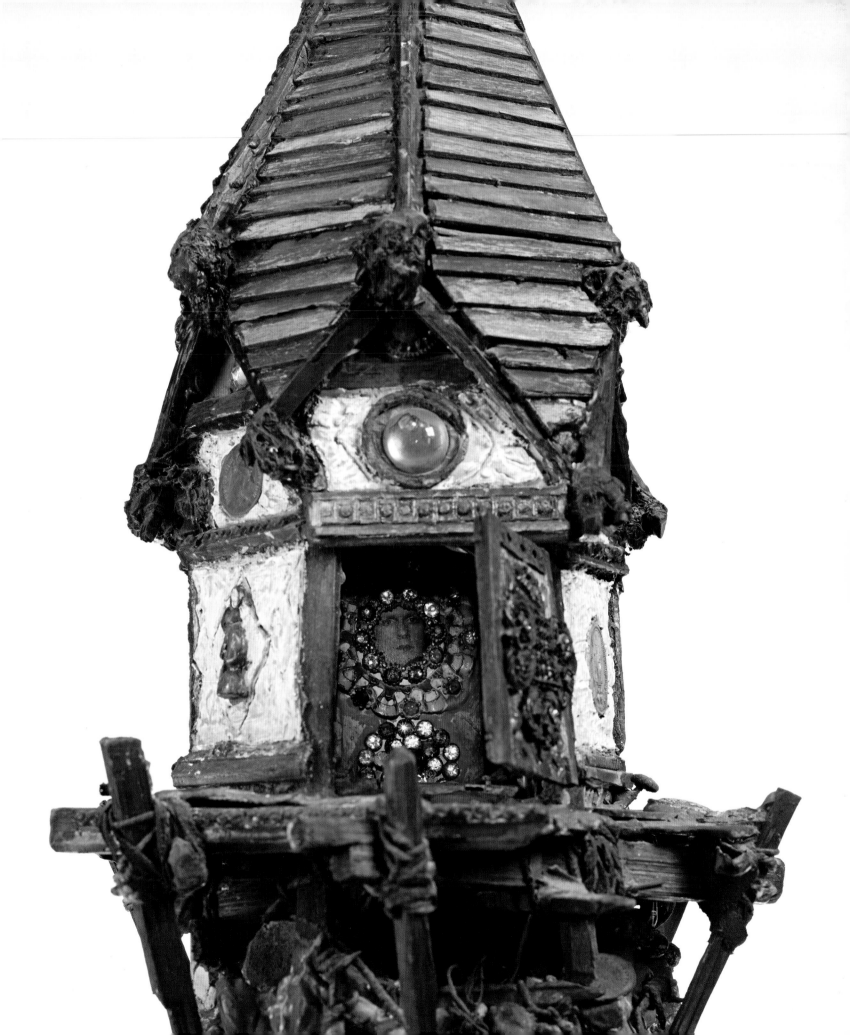

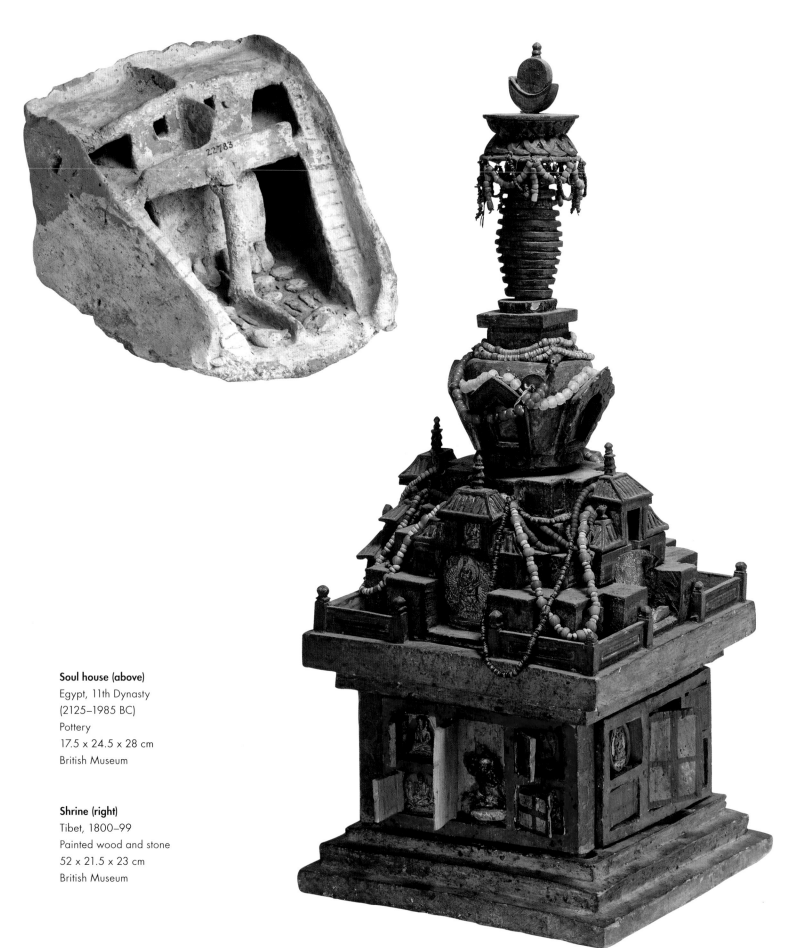

Soul house (above)
Egypt, 11th Dynasty
(2125–1985 BC)
Pottery
17.5 x 24.5 x 28 cm
British Museum

Shrine (right)
Tibet, 1800–99
Painted wood and stone
52 x 21.5 x 23 cm
British Museum

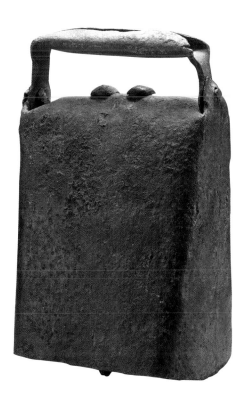

Iron bell (above)
Celtic, AD 600–1099
Iron, copper alloy
27.5 x 18 x 12.5 cm
British Museum

Plaque (right)
Ascoli Picena, The Marshes,
Italy, 1747
Tin glazed earthenware
26.5 x 20.5 x 15 cm
British Museum

SUOR TECLA DELL IMACOLATA
CONC.E FONDATRICE E PRIMA PREFETA
MAGGIORE DELLE PIE OPERARIE DELL'IMMACOLATA
CONCEZIONE DI ASCOLI D'ANNI XLII.
1747

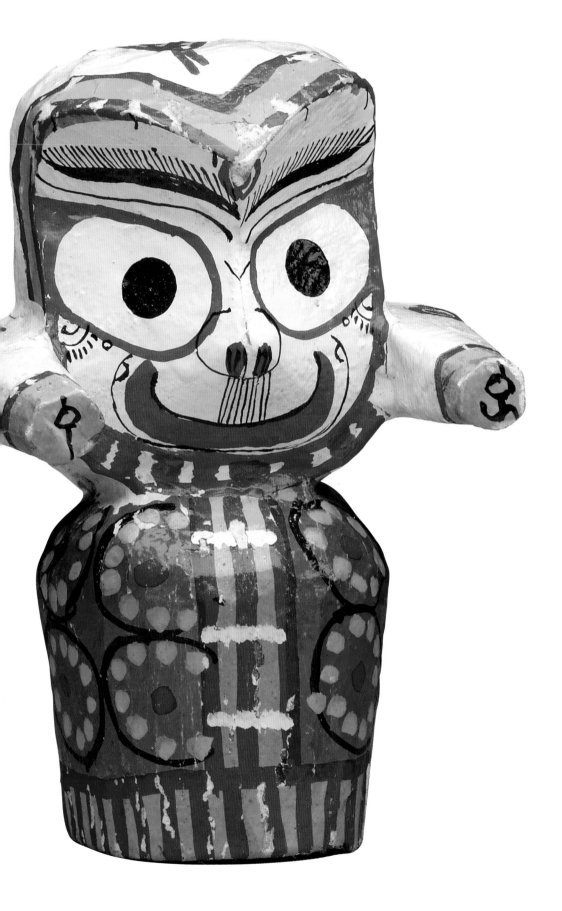
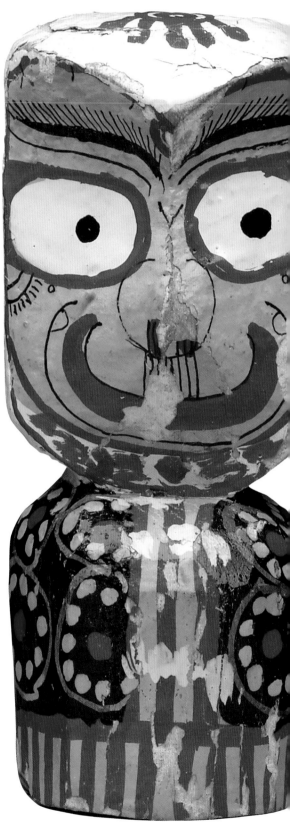

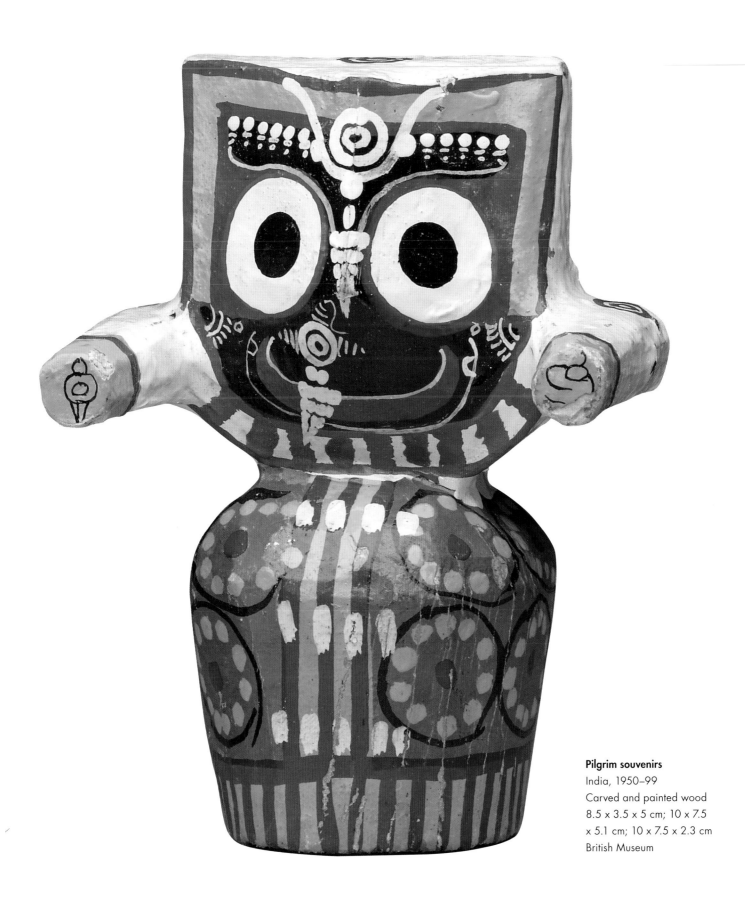

Pilgrim souvenirs
India, 1950–99
Carved and painted wood
8.5 x 3.5 x 5 cm; 10 x 7.5
x 5.1 cm; 10 x 7.5 x 2.3 cm
British Museum

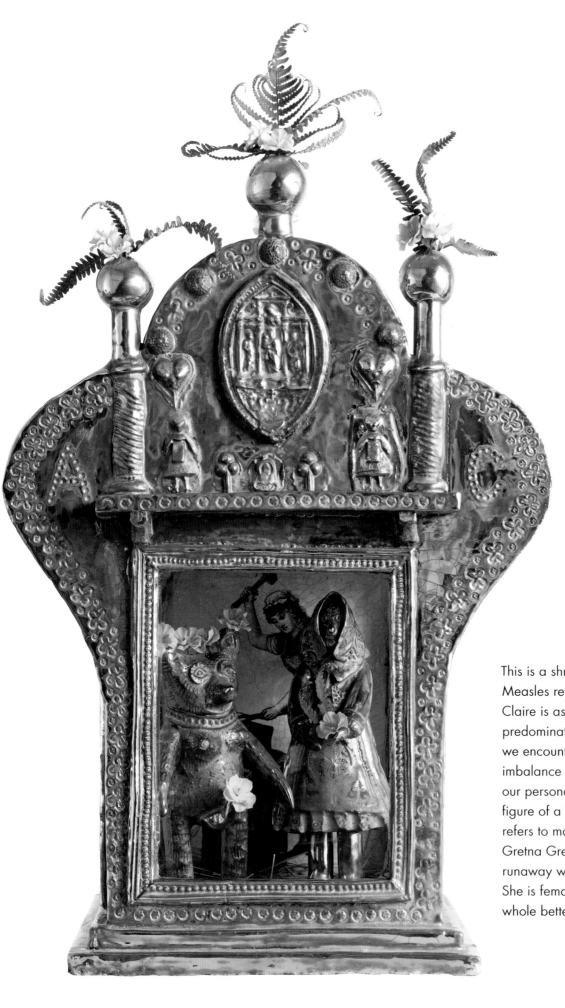

Shrine to Alan and Claire
Grayson Perry, 2011
Glazed ceramic
Shrine: 46 x 32 x 24 cm
Figures: 19 x 8 cm and
17 x 10 cm

This is a shrine to integration. Alan Measles represents my maleness whilst Claire is associated with feelings seen as predominately female. Many problems we encounter in society come from an imbalance in the way these two sides of our personalities are dealt with. The figure of a blacksmith on the rear wall refers to marriage and more specifically Gretna Green in Scotland, famous for runaway weddings and its 'Anvil priests'. She is female as women are on the whole better at working with feelings.

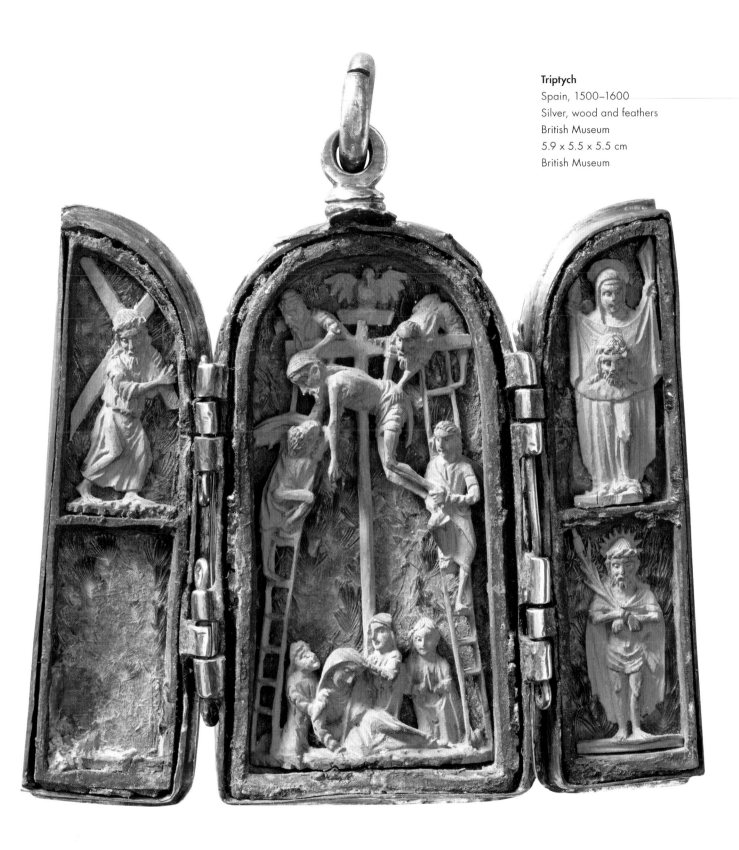

Triptych
Spain, 1500–1600
Silver, wood and feathers
British Museum
5.9 x 5.5 x 5.5 cm
British Museum

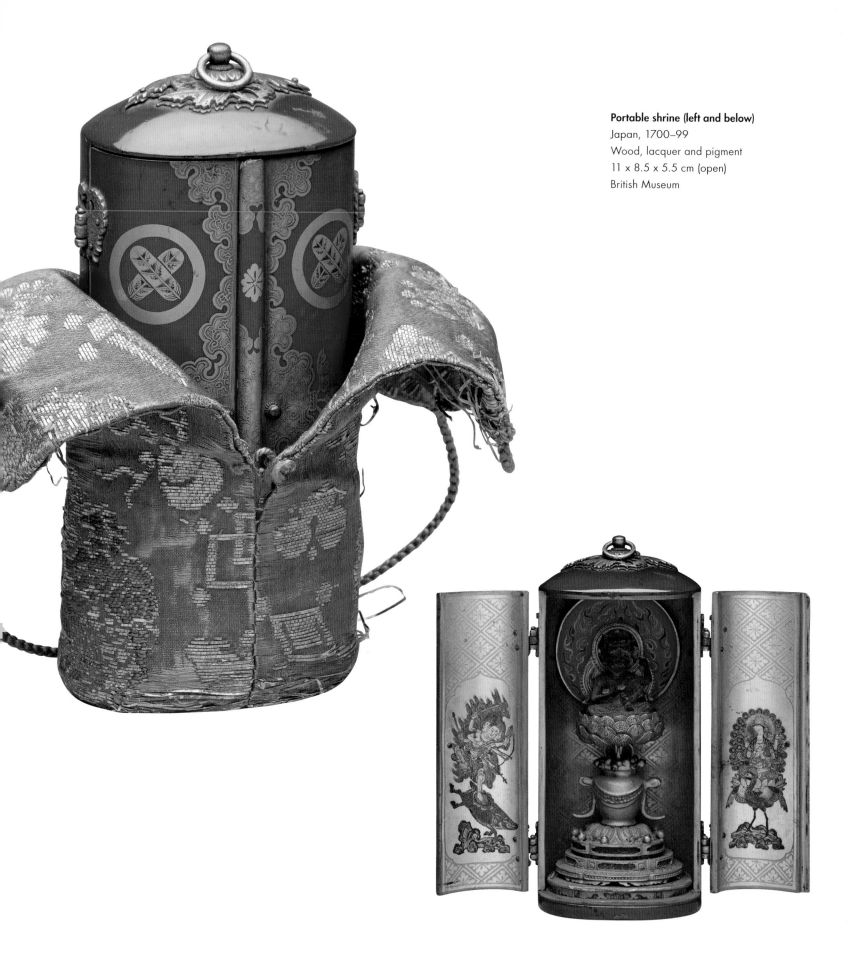

Portable shrine (left and below)
Japan, 1700–99
Wood, lacquer and pigment
11 x 8.5 x 5.5 cm (open)
British Museum

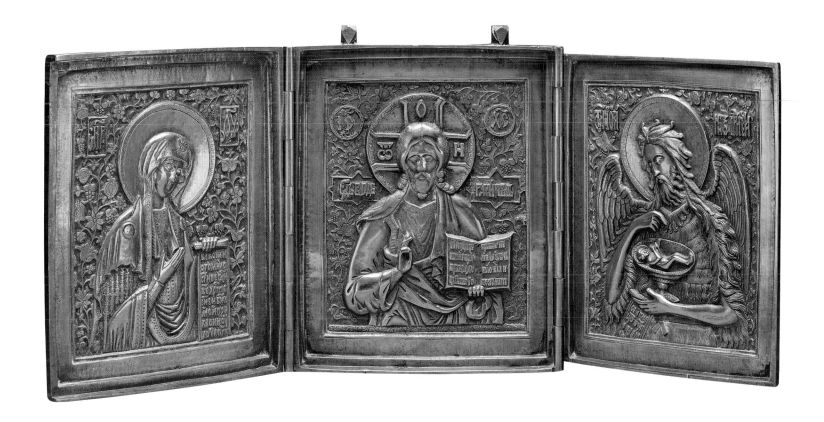

This seems like a miniature wardrobe belonging in a doll's house owned by a 1920s film starlet, yet this exquisite portable shrine is a copy of a tenth-century example in Kyoto National Museum. As a lover of things I am drawn to the wondrous craftsmanship. Japan recognizes the importance of traditional skill and in 1950 set up a law that certified 'Preservers of important intangible cultural properties'. The holders of this glorious title, popularly known as 'living national treasures', are paid by the government to keep and pass on ancient skills and also to make them relevant to the present. If you think the idea of a portable shrine archaic then look no further than the photo album on your smartphone.

Triptych (above)
Russia, 1700–1899
Enamelled brass
17 x 39 x 1.5 cm
British Museum

Portable shrine (right)
Japan, c.1920
Wood and lacquer
11.6 x 8 x 6 cm (closed)
British Museum

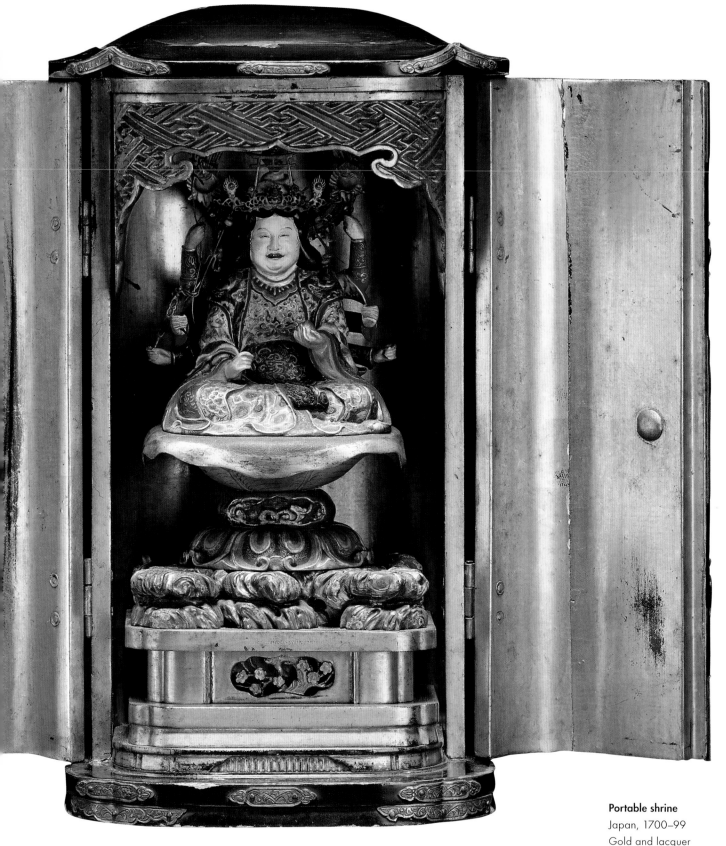

Portable shrine
Japan, 1700–99
Gold and lacquer
22 x 23 x 10 cm (open)
British Museum

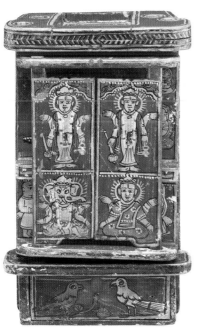

Portable shrine
India, 1800–1999
Painted wood
31 x 19.5 x 12.5 cm (closed)
British Museum

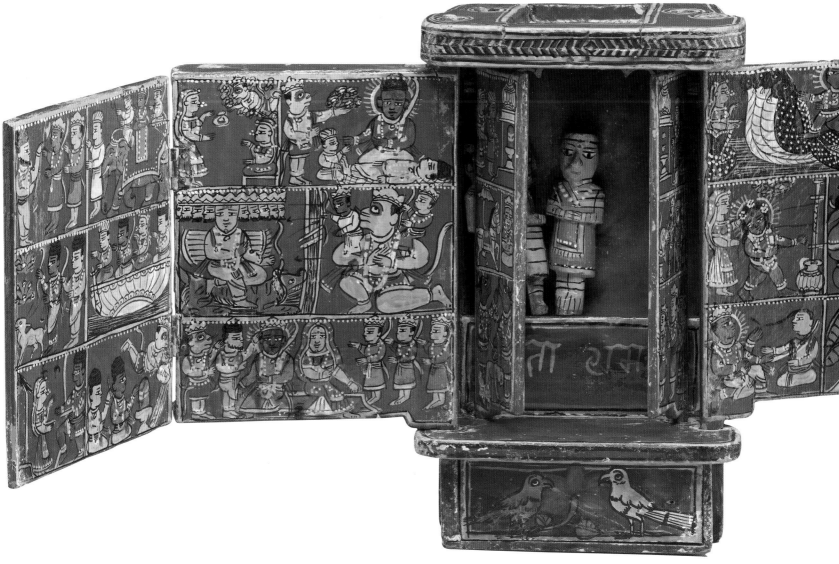

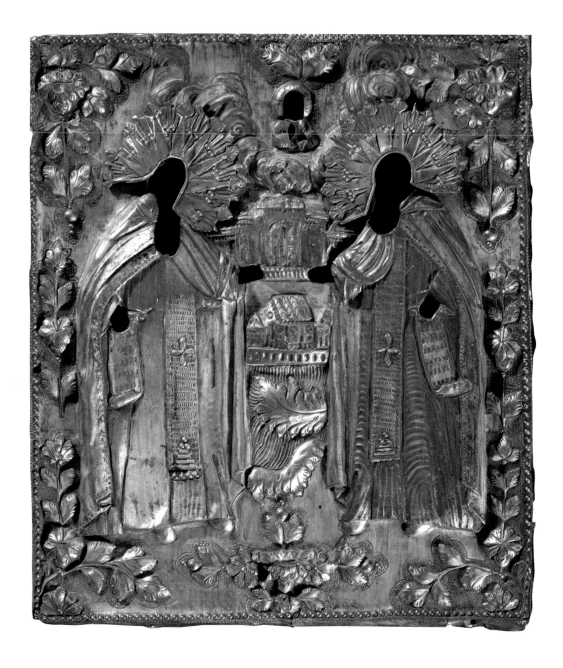

I love the way the figures just peep out through the
metal cover. This is called a riza or oklad and protects
and venerates the icon. These paintings are more than
just images, they are treated as precious ritual objects
or even people, which can be touched, held and kissed.
I like a painting to be more than just a window or
flimsy stage set.

Icon and cover (above and right)
Russia, 1750–1800
Painted, embossed, gessoed
wood and metal
31 x 27 x 3.5 cm
British Museum

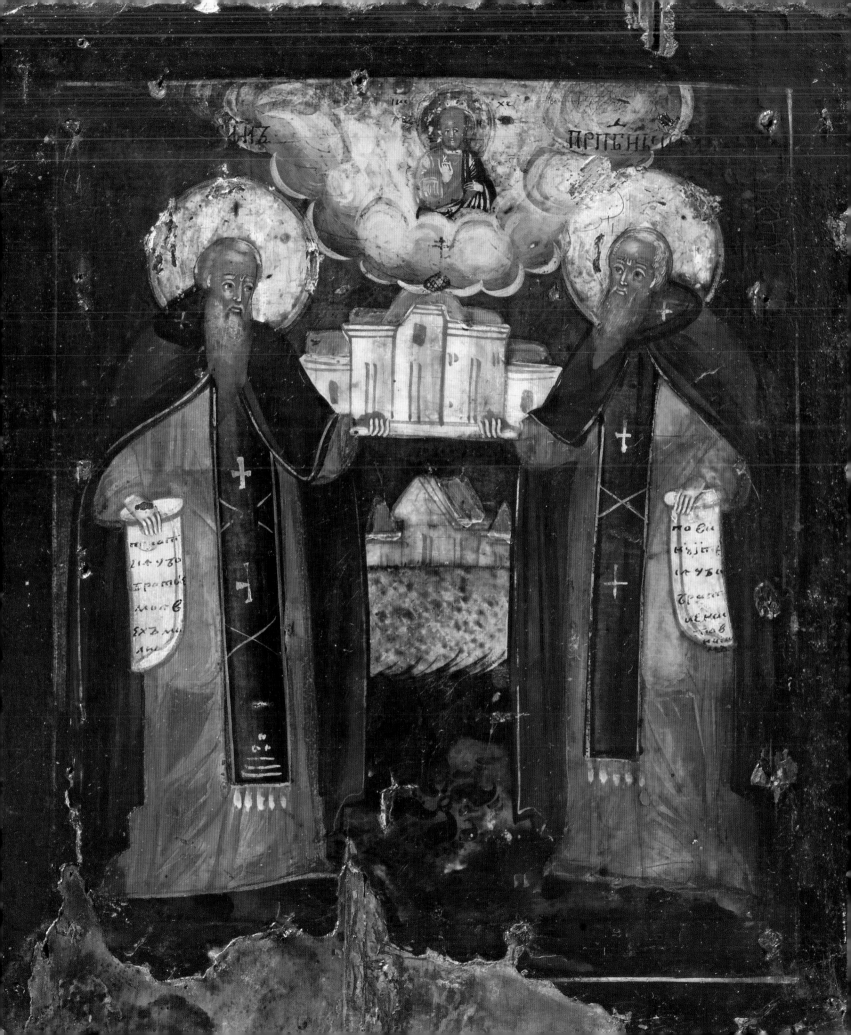

The Chinese clay workers used exactly the same
techniques I use today, over 2200 years later,
such as this stamped decoration.

Tomb brick
North China, 206 BC–AD 220
Earthenware with moulded and
stamped decoration
83 x 64 x 24 cm
British Museum

s an artist is similar to
or witch doctor. I dress
give things meaning and
make them a bit more significant. Like
religion this is not a rational process,
I use my intuition. Sometimes our very
human desire for meaning can get in
the way of having a good experience
of the world. Some people call this
irrational unconscious experience
spirituality. I don't.

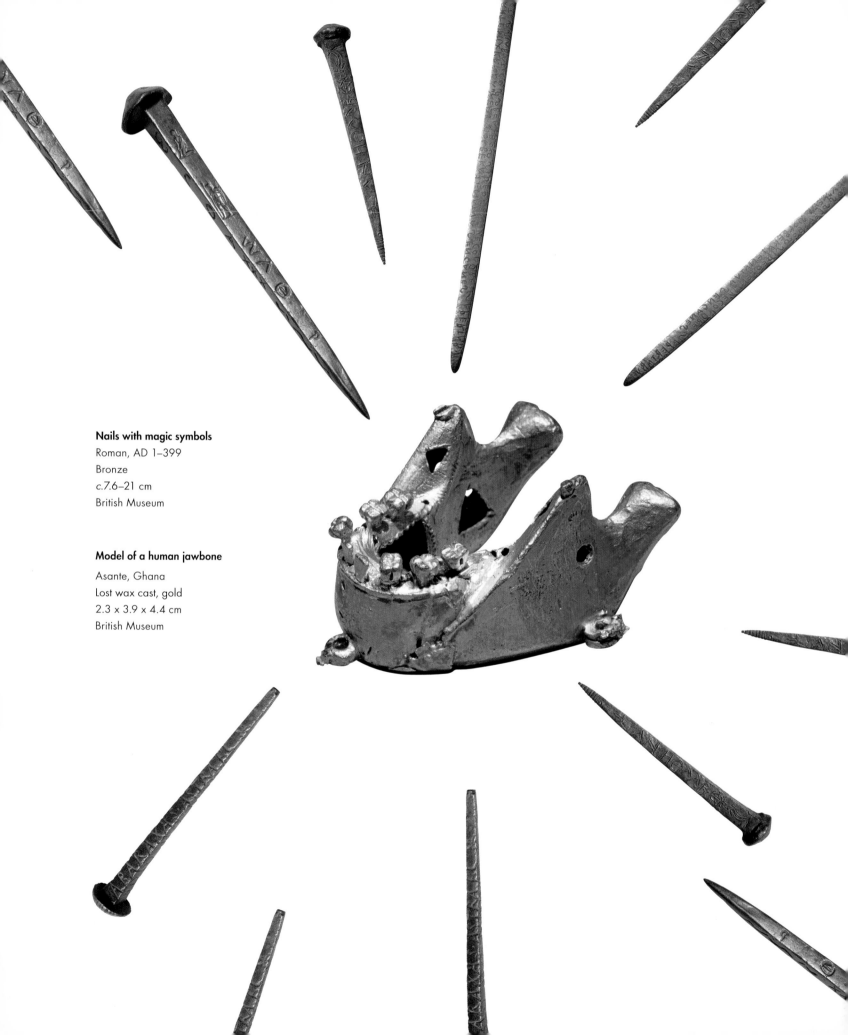

Nails with magic symbols
Roman, AD 1–399
Bronze
c.7.6–21 cm
British Museum

Model of a human jawbone
Asante, Ghana
Lost wax cast, gold
2.3 x 3.9 x 4.4 cm
British Museum

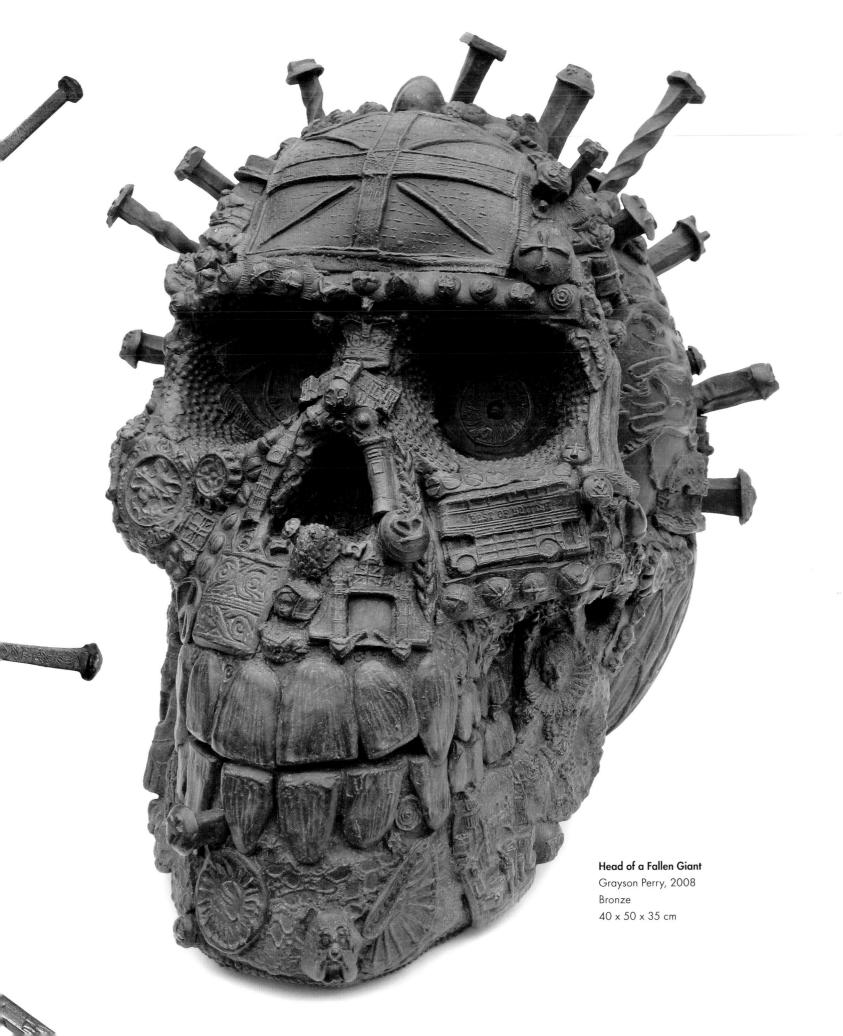

Head of a Fallen Giant
Grayson Perry, 2008
Bronze
40 x 50 x 35 cm

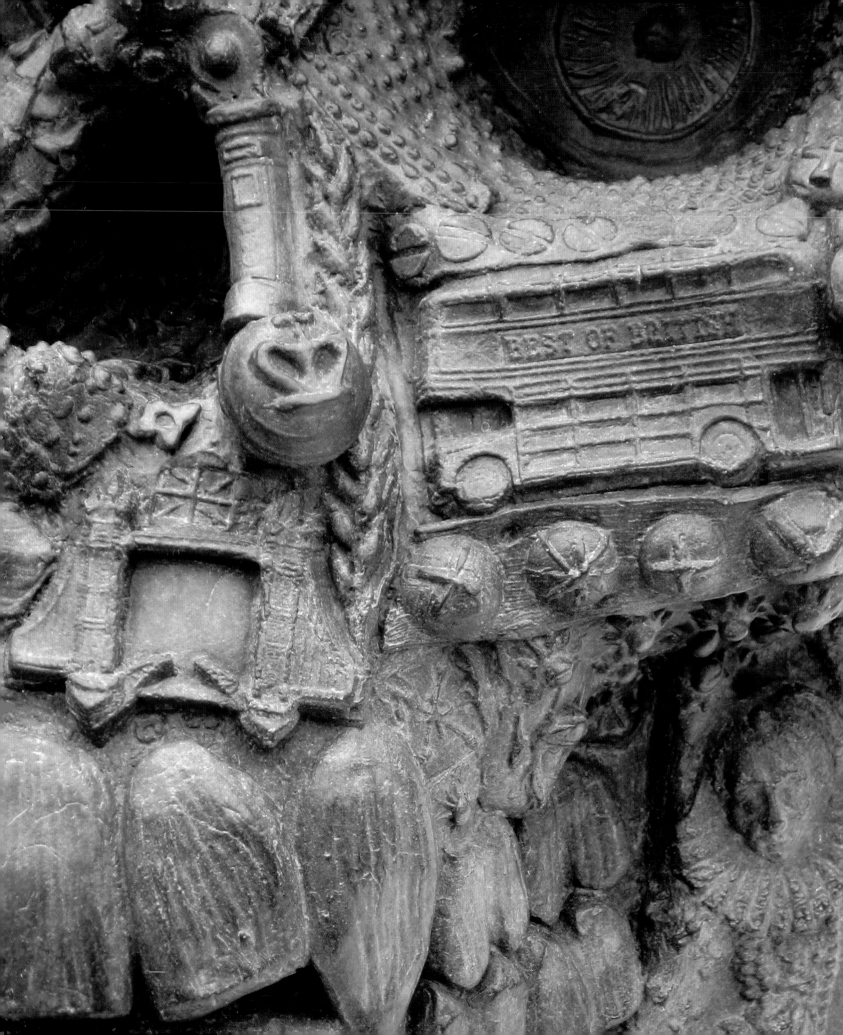

There has been much debate about what exactly is Englishness. We struggle to define it. I wanted to make something that looked like an ethnographic artefact that was about England. At once mystical and banal, this is the skull of a decaying maritime superpower. Like a World War Two mine washed up on the beach encrusted with the boiled down essence of empire in the form of tourist tat.

Head of a Fallen Giant
(left, detail)

The Rosetta Vase (right)
Grayson Perry, 2011
Glazed ceramic
78.5 x 40.7 cm

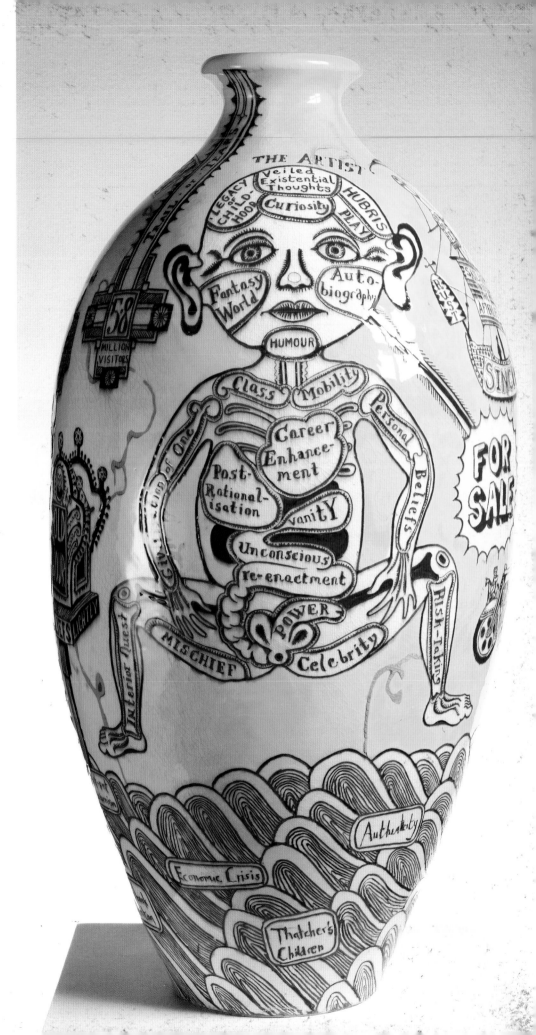

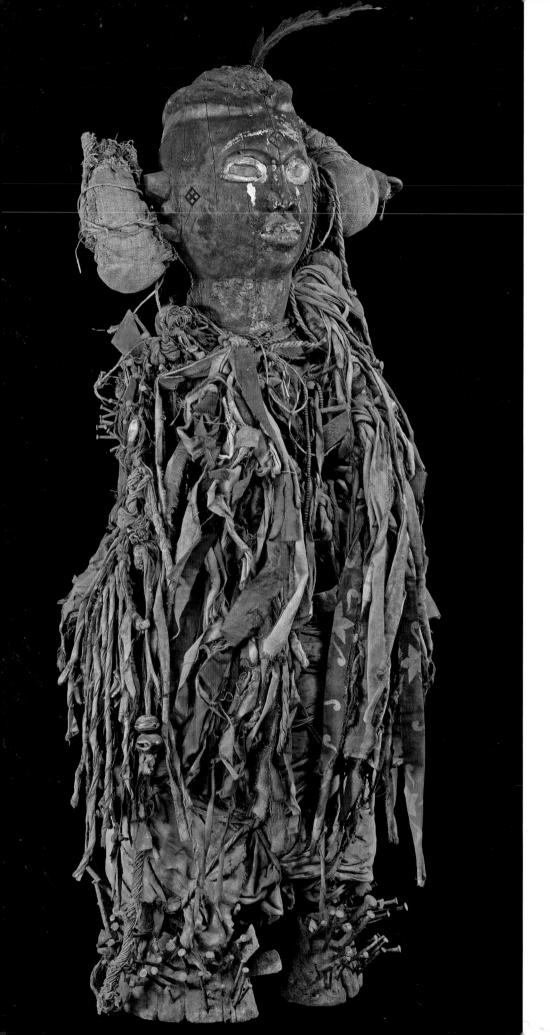

Power figure (left)
Kongo, Democratic Republic
of Congo
Wood, iron, cotton, raffia palm
leaf, feather, glass, gourd
and seed pods
90 x 40 x 30 cm
British Museum

The Rosetta Vase (right, detail)

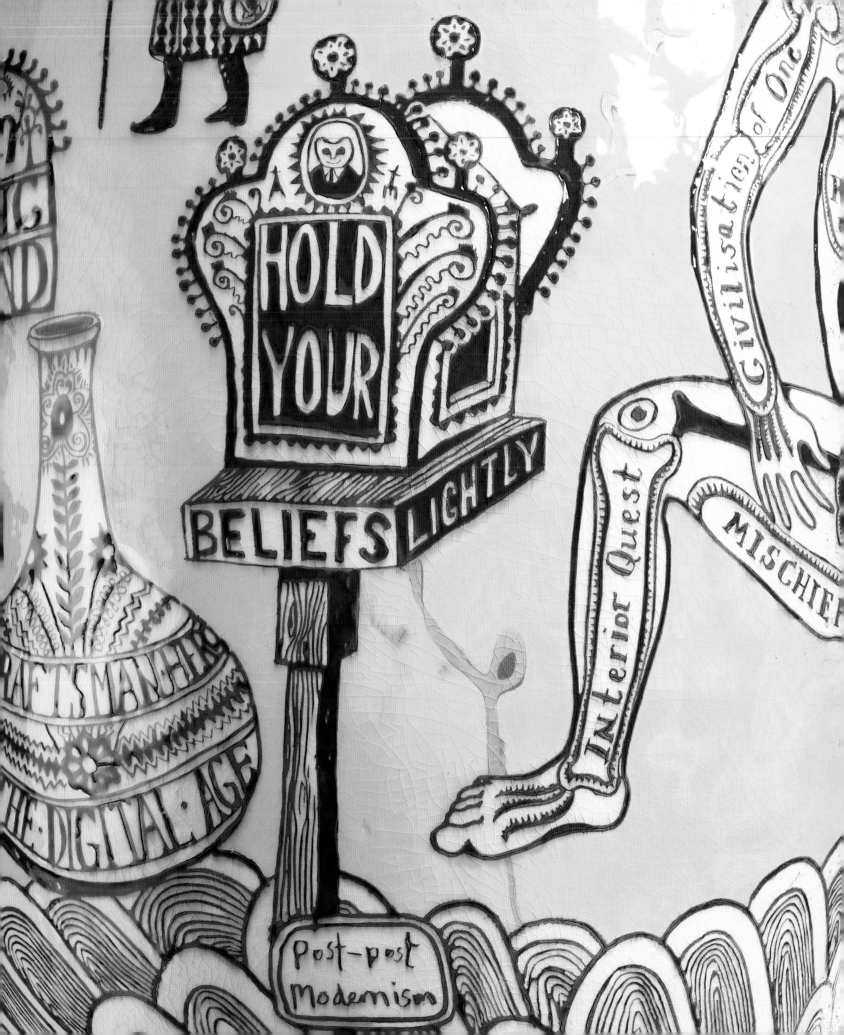

The Rosetta Vase (left)

Artists are the hermits, saints and holy fools of the church of contemporary art. On the right is a relic from half a lifetime ago.

Coffin Containing Artist's Ponytail (right)
Grayson Perry, 1985
Glazed ceramic and haiir
6.5 x 26 x 6.7 cm

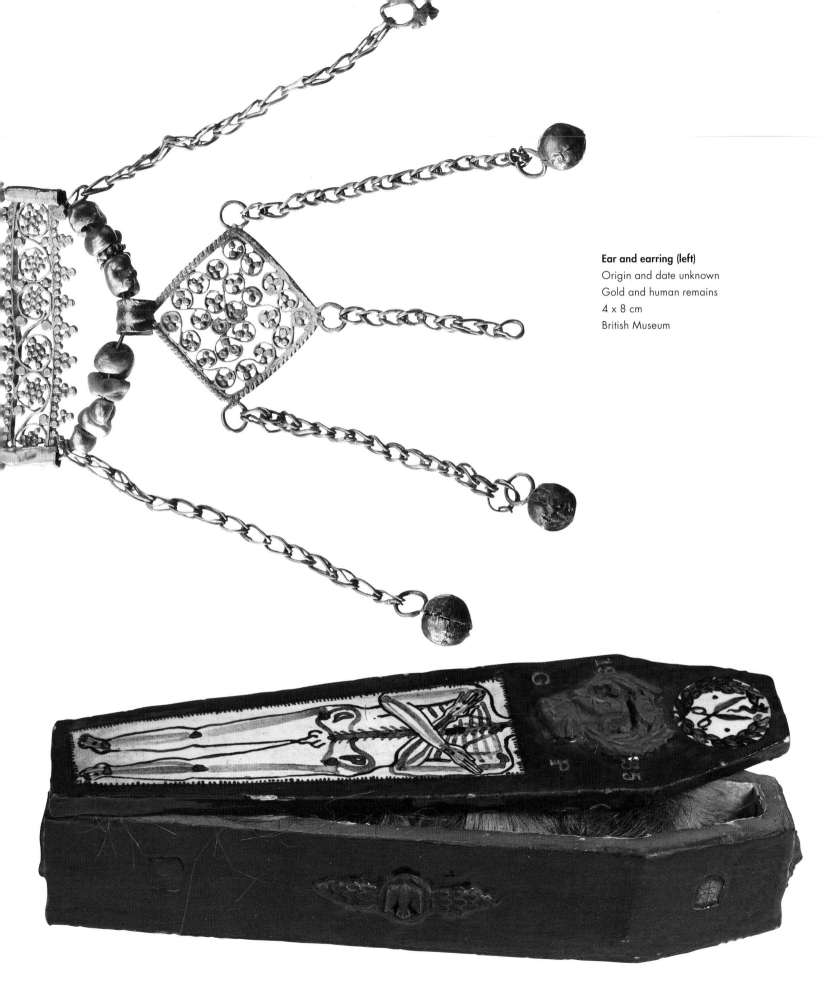

Ear and earring (left)
Origin and date unknown
Gold and human remains
4 x 8 cm
British Museum

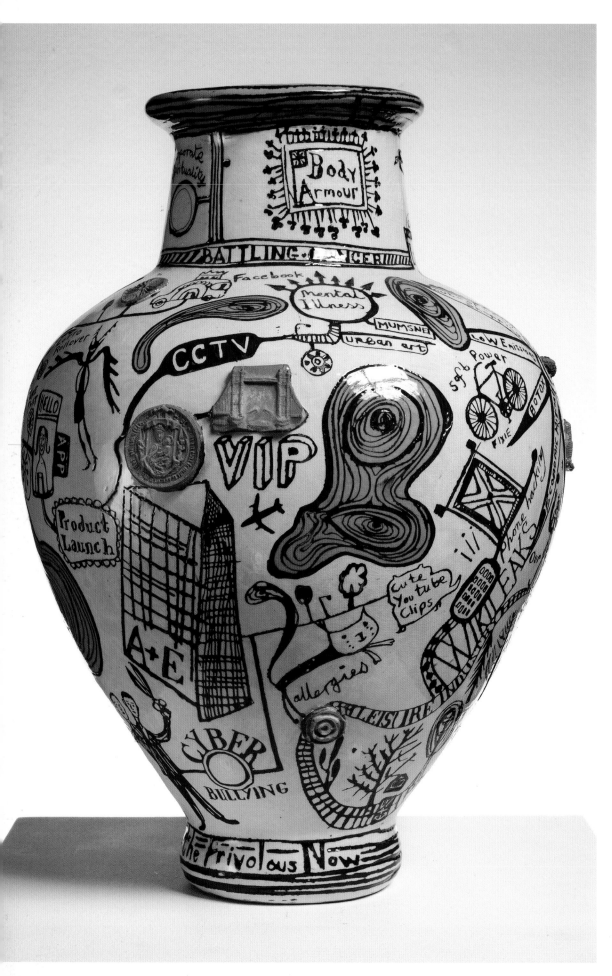

The Frivolous Now
Grayson Perry, 2011
Glazed ceramic
47 x 32.8 cm

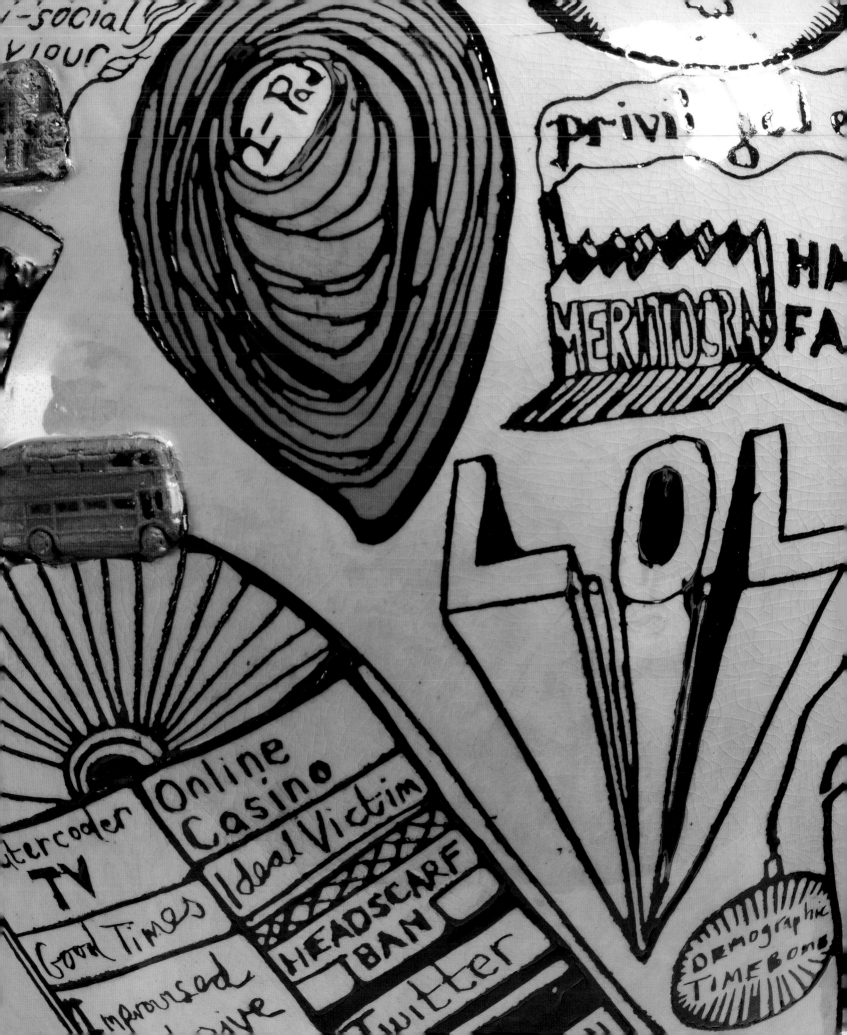

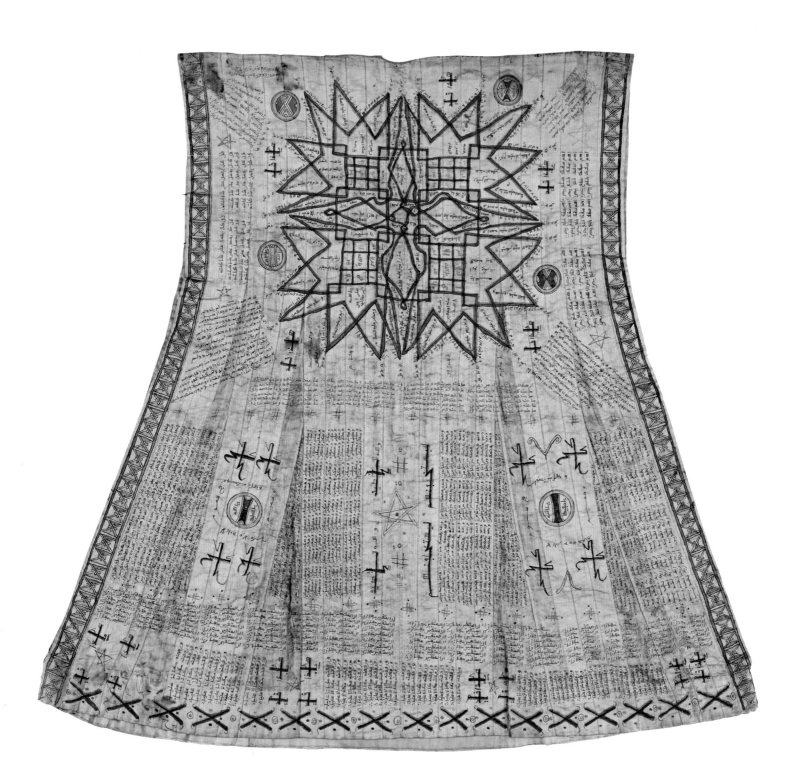

Painted tunic
Probably Northern Nigeria
Cotton and leather
87 x 92 cm
British Museum

قل اللهم مالك الملك تؤتي الملك من تشاء وتنزع الملك ممن تشاء وتعز من تشاء وتذل من تشاء بيدك الخير إنك على كل شيء قدير تولج الليل في النهار وتولج النهار في الليل وتخرج الحي من الميت وتخرج الميت من الحي وترزق من تشاء بغير حساب

إسم الله الرحمن الرحيم لقد جاءكم رسول من أنفسكم عزيز عليه ما عنتم حريص عليكم بالمؤمنين رؤوف رحيم فإن تولوا فقل حسبي الله لا إله إلا هو عليه توكلت وهو رب العرش العظيم

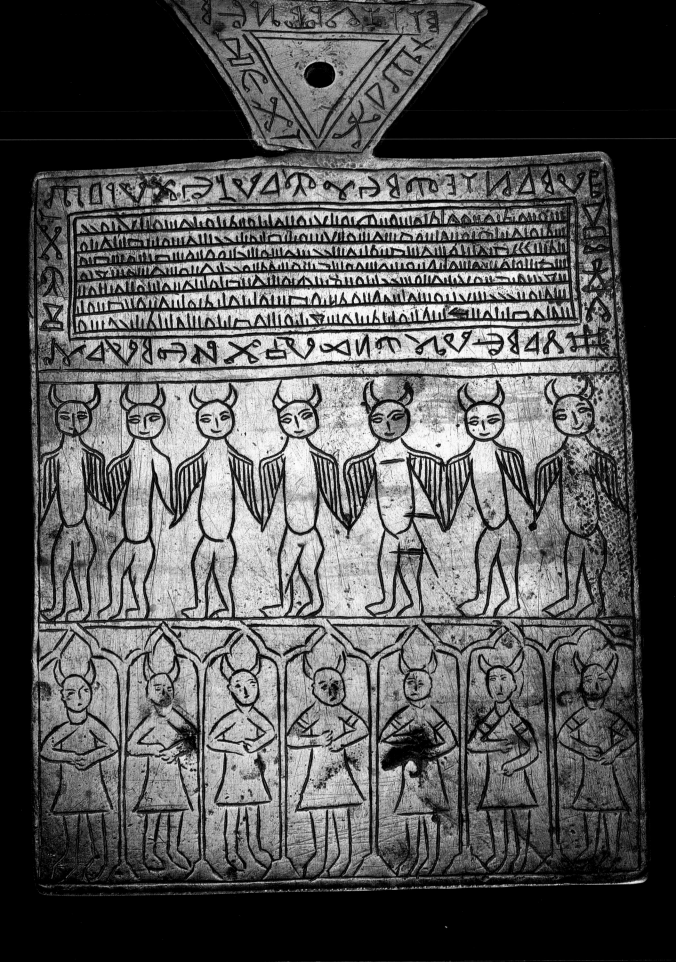

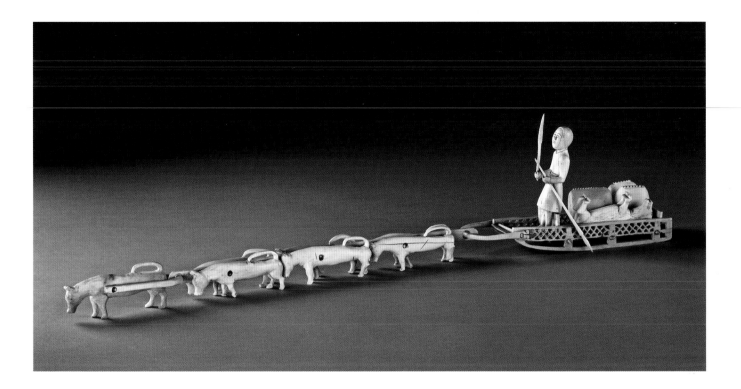

Models
Russia, c.1850
Pine and ivory
11 x 46 x 5 cm
British Museum

Magic bowl (right)
Egypt, 1700s–1800s
Bronze, engraved
Diam. 18 cm
British Museum

Talismanic plaque (opposite)
Egypt, 1800s
Brass
18 x 13 cm
British Museum

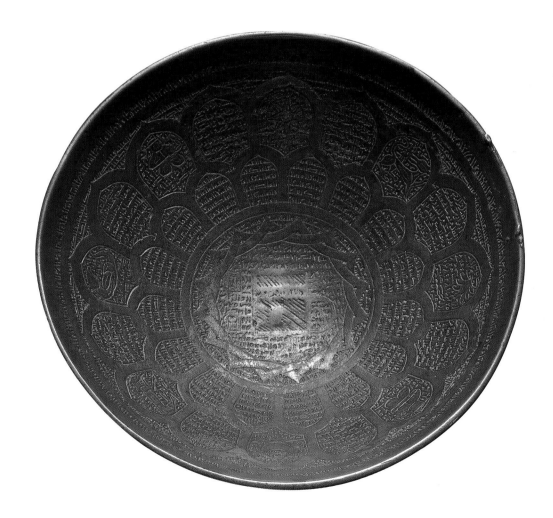

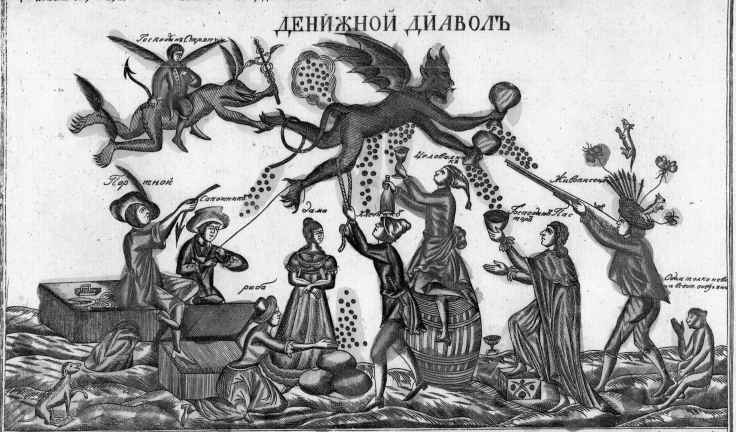

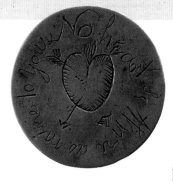
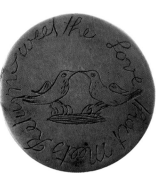
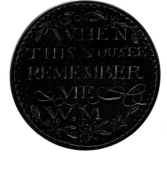

Love tokens (right)
British, c.1770–90
Copper
Diam. c.2.5 cm
British Museum

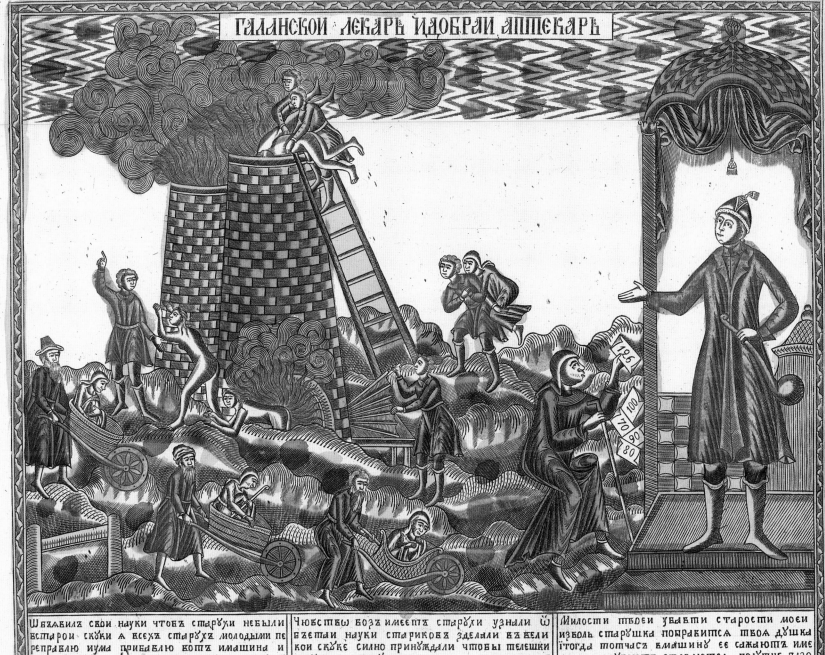

The money devil showering coins on the greedy (opposite, above) and A forge for turning old people into young (above)
Russia, c.1800–50
Hand-coloured engraving
35.6 x 45.2 cm; 32.5 x 35.8 cm
British Museum

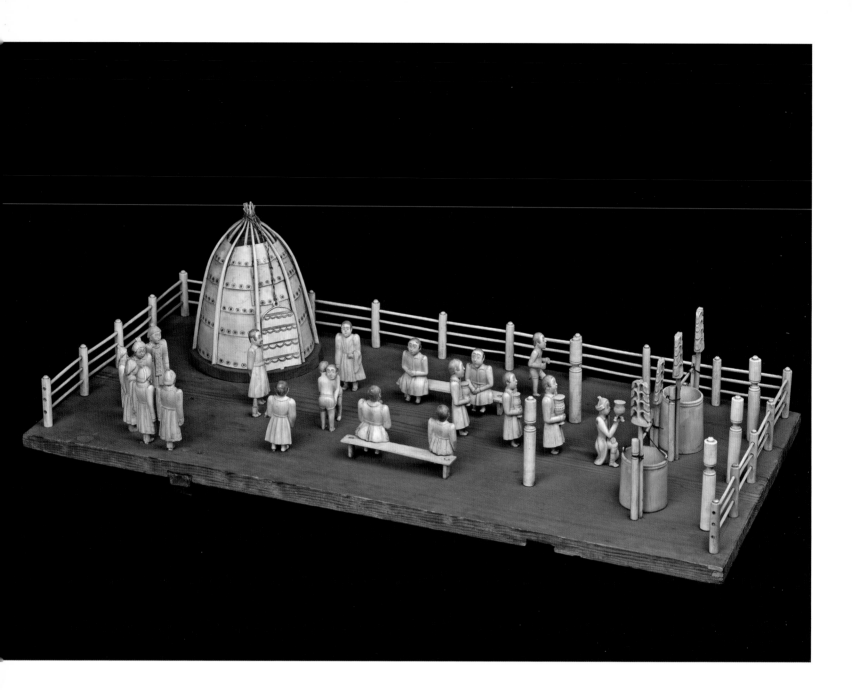

Models
Russia, *c.*1850
Pine and ivory
22 x 74 x 36 cm
British Museum

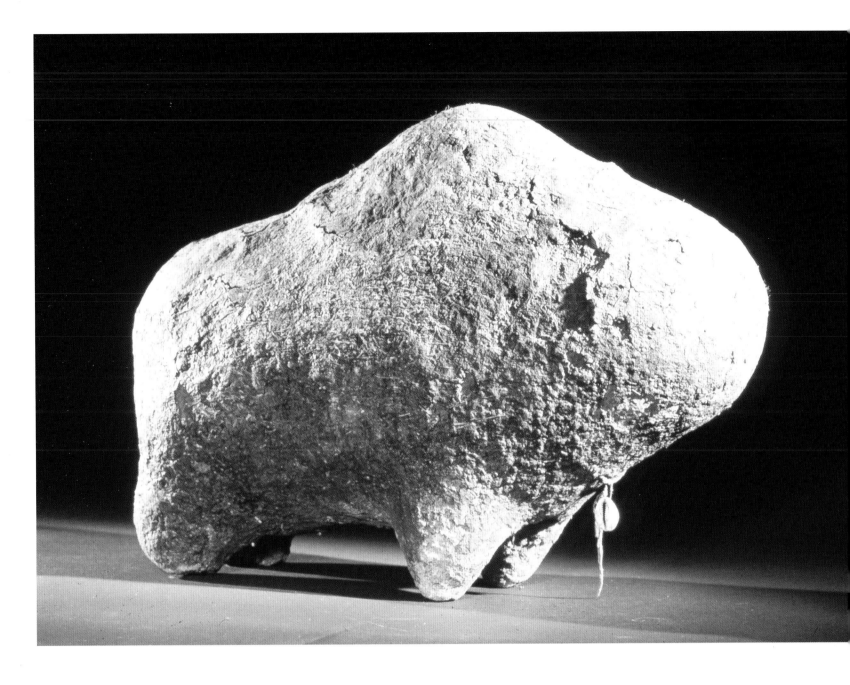

Boli figure or power figure
Bamana, Mali
Clay, mud, cowrie shell,
fibre and wood
41 x 57 x 23 cm
British Museum

As soon as I saw this object I knew I must include it in this show. For me it possesses a raw potency that seems to hark back to the very beginnings of art. It also seems quite modern in its pared down form. It seems to vibrate with a disturbing magical force put there by the people who made it. A modern artist can also be a bit of a witch doctor, having the ability to transform ordinary materials into something significant. One of my twentieth-century artistic heroes Joseph Beuys saw himself as having this mythical skill: 'So when I appear as a kind of shamanistic figure, or allude to it, I do it to stress my belief in other priorities and the need to come up with a completely different plan for working with substances. For instance, in places like universities, where everyone speaks so rationally, it is necessary for a kind of enchanter to appear.'

MAPS

We trust maps. Maps are meant to
be a trustworthy diagram of reality.
All maps, though, contain some very
human bias. They can emphasize
desirable features and leave out the
undesirable. I like maps of feelings,
beliefs and the irrational; they use our
trust of maps to persuade us that there
might be some truth in their beauty.

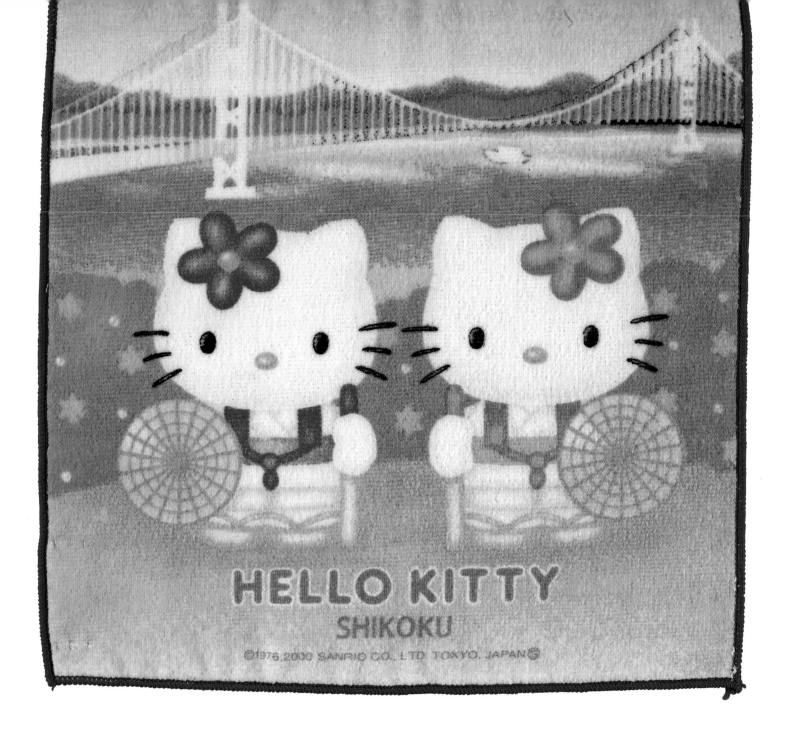

HELLO KITTY
SHIKOKU
©1976,2000 SANRIO CO., LTD. TOKYO, JAPAN ®

Hand towel

Japan, 2000
Cotton, synthetic
20 x 20 cm
British Museum

Perhaps more than any other object this hand towel embodies the spirit of this exhibition. It is fitting that it comes from Japan, a country that seems to have a remarkable ability to blend ancient traditions with modern technology and popular culture. Two Hello Kitty characters, created for merchandising in 1974, are dressed as traditional Japanese pilgrims (*o-henro-san*) in white robes, sticks and straw hats. This towel was sold as a souvenir on the island of Shikoku, famous for its 1200 km pilgrimage route taking in eighty-eight Buddhist temples. So here we have an object featuring modern cartoon characters and a ritual dating back to the eighth century AD coming together on an object carried in most Japanese women's handbags.

Sarakatsani costume
Greek, from Alexandroupolis,
Thrace, early 1900s
Wool, linen, cotton, metal
152 x 25 cm
British Museum

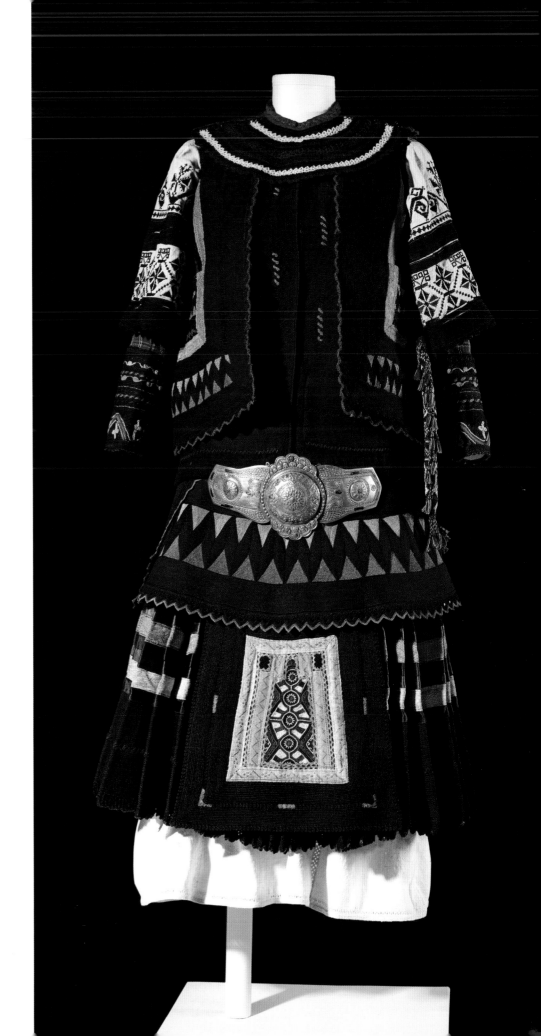

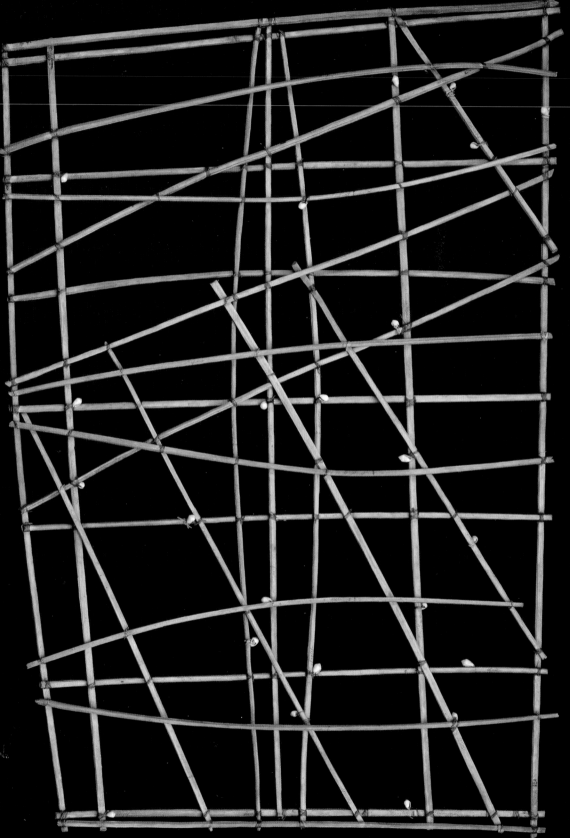

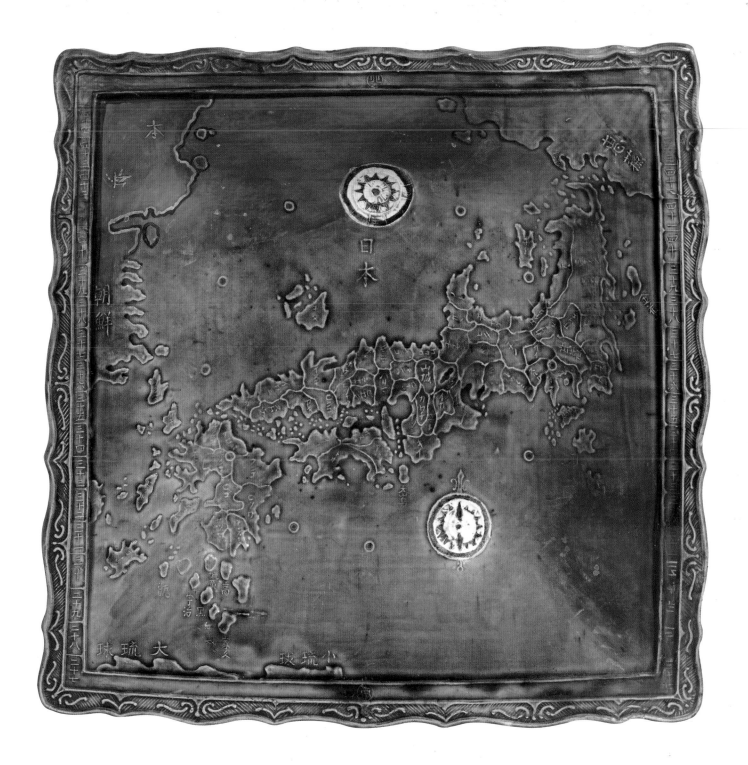

Sailing chart (opposite)
Marshall Islands, late 1800s
Cane, fibre shell
100 x 69 x 3 cm
British Museum

Dish (above)
Japan, 1751–1850
Glazed pottery
31 x 30 cm
British Museum

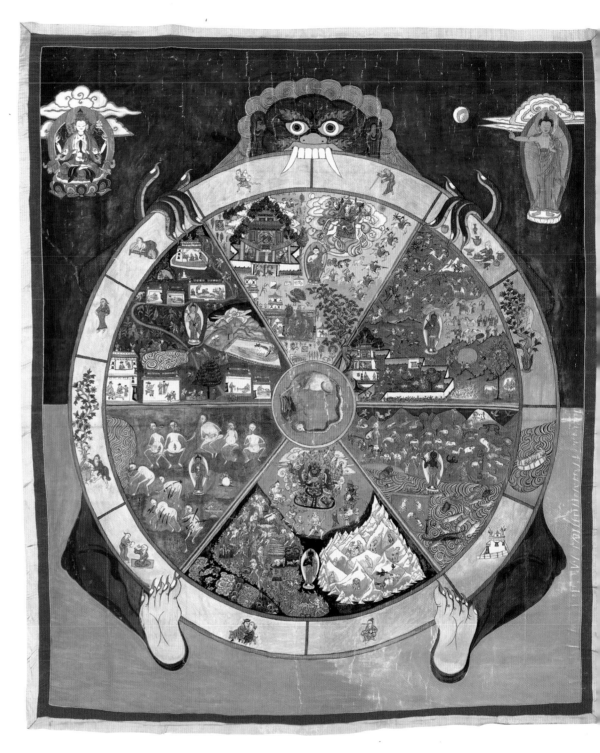

**Map of the Eastern hemisphere
(detail, opposite)**
From an album of Persian
costume, animal and
topographical drawings
Iran, Isfahan, 1684–5
Ink on paper
21.4 x 29.9 cm
British Museum

Painted textile, 'thang-ka'
Tibet, 1900–90
Paint on textile
176 x 135 cm
British Museum

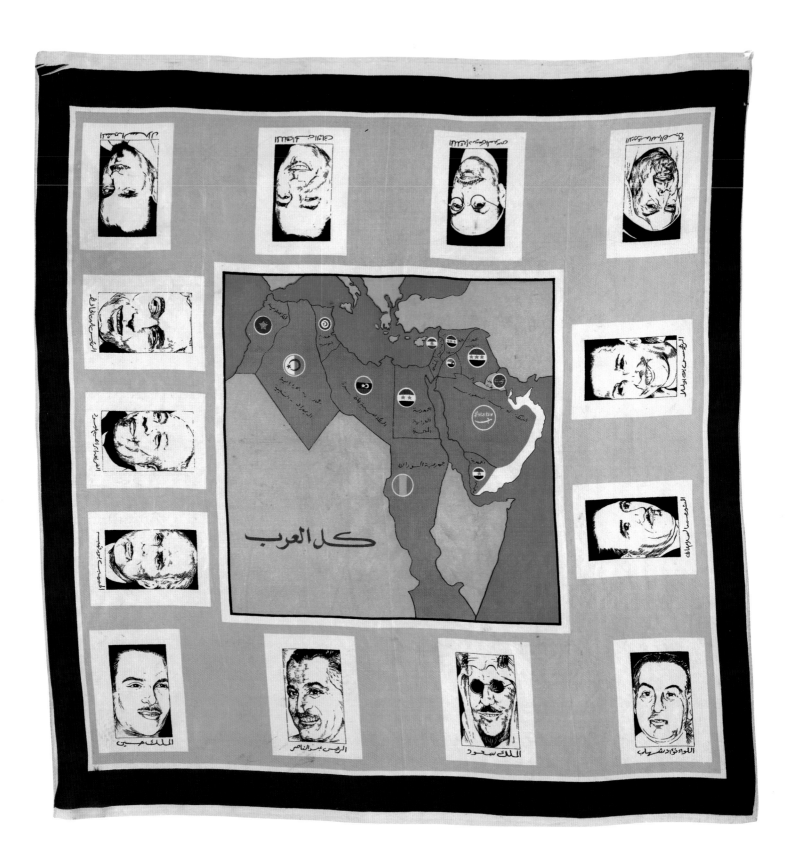

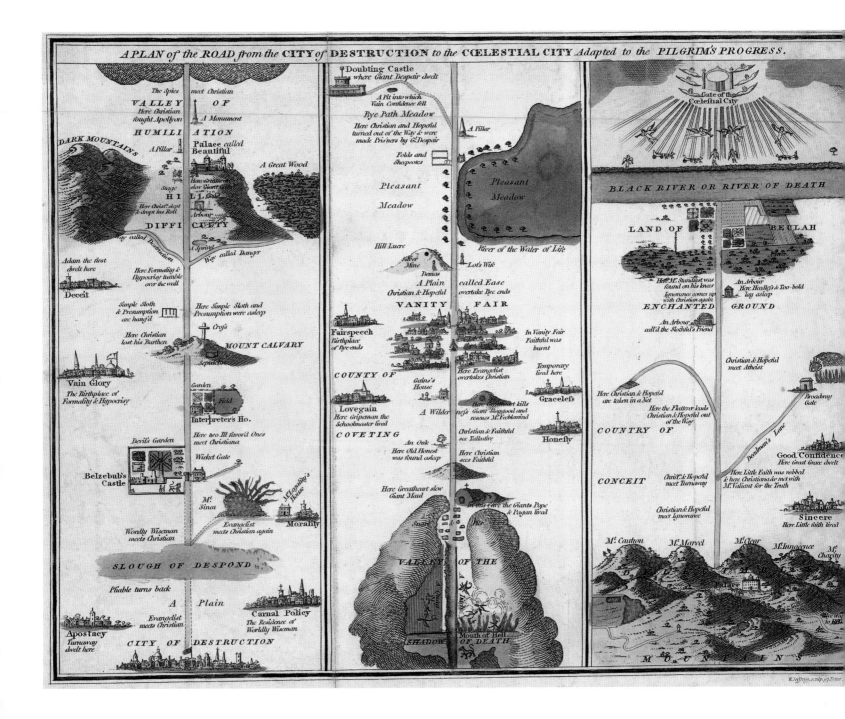

A PLAN of the ROAD from the CITY of DESTRUCTION to the CŒLESTIAL CITY Adapted to the PILGRIM'S PROGRESS.

Map based on Bunyan's
Pilgrim's Progress
W. Jefferys, Britain, c.1800
Hand-coloured etching
22 x 28.5 cm
British Museum

Woman's scarf (opposite)
Egypt, 1963–4
Printed silk
80 x 16 cm
British Museum

Maps that purport to show the geography not of real places but of imaginary lands, feelings or social phenomena have always fascinated me. I think they are symptomatic of our desire to make sense of the unpredictable and irrational in our lives. As I child I would make maps of my imaginary world and I still enjoy creating them today. Applying such an empirical device to emotive issues in society seems inherently humorous. In form this map from around 1800 reminds me of the pilgrimage maps of Benedictine monk Mathew Paris (c.1200–1259) in that only landmarks that one might encounter on the route are shown. Perhaps someone today should devise a satnav App for moral guidance.

Painting (above)
India
Paint on paper
59 x 94 cm
British Museum

Codex (left)
Mexico, Aztec, 1500s
Painting and drawing on paper
50 x 77 cm
British Museum

The tapestry shows many possible pilgrimage destinations, religious and secular. In the central disc are many different names for the afterlife laid out in the shape of a plan of the British Museum. The figures are from my personal iconography. The woman in black represents the contemporary world, the bear is raw emotion, the boy, innocent reason and the woman in folk costume stands for tradition.

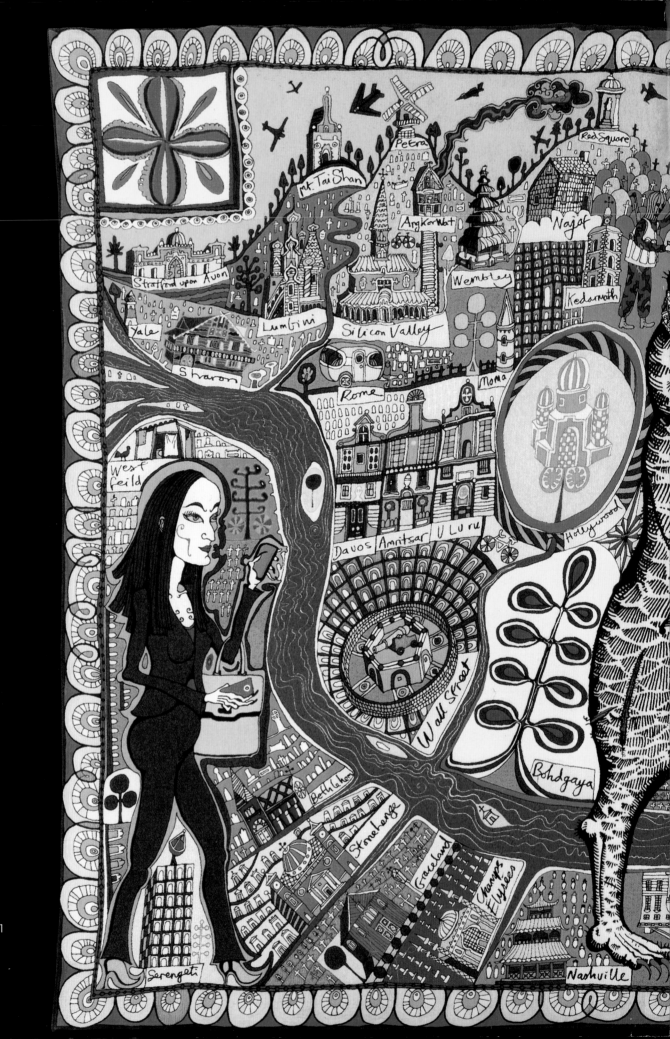

Grayson Perry
Map of Truths and Beliefs, 2011
Wool and cotton
290 x 690 cm

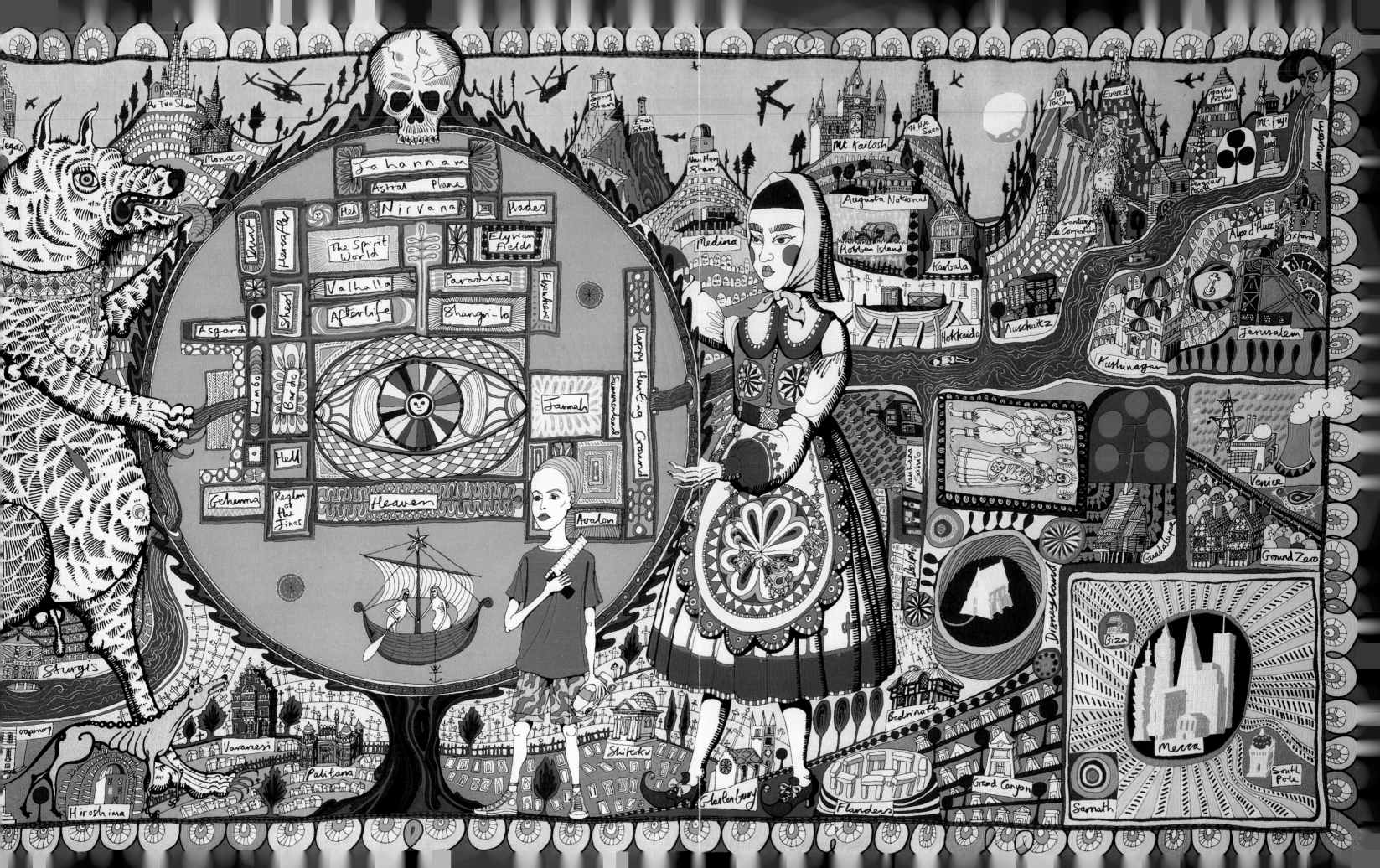

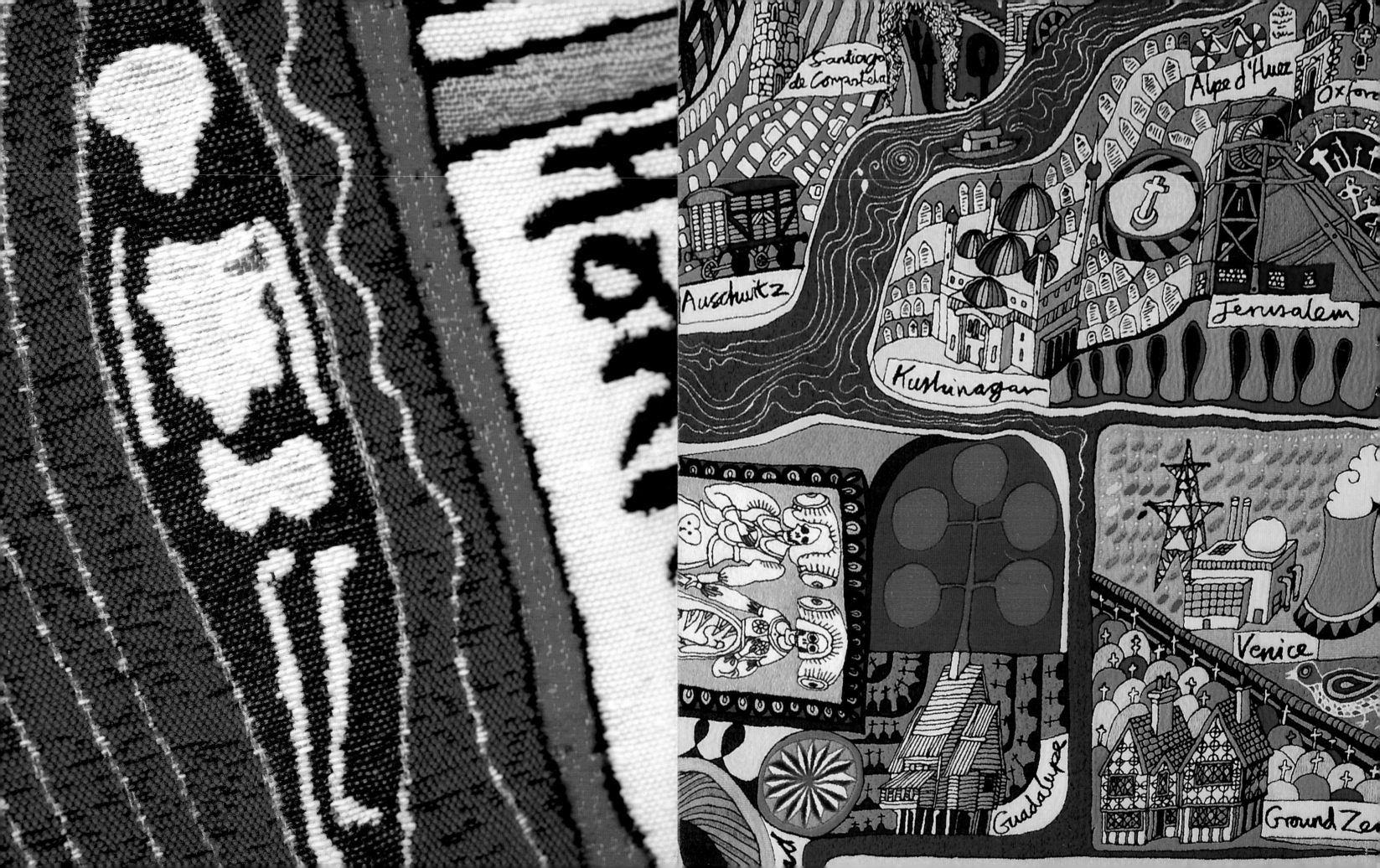

Painting
India, 1850–1950
Gouache
40.5 x 56 cm
British Museum

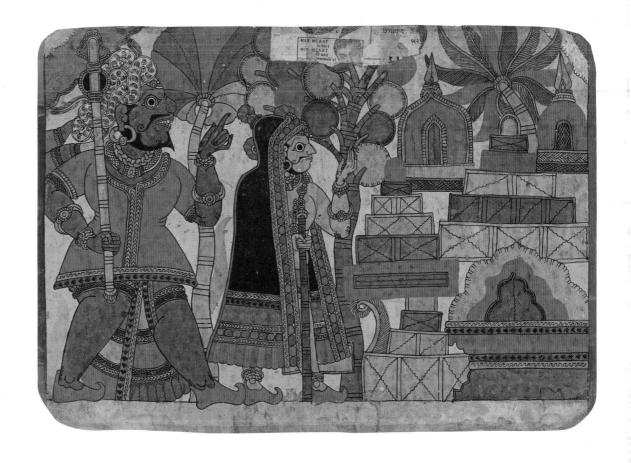

Painting
India, 1850–1950
Gouache
40.5 x 56 cm
British Museum

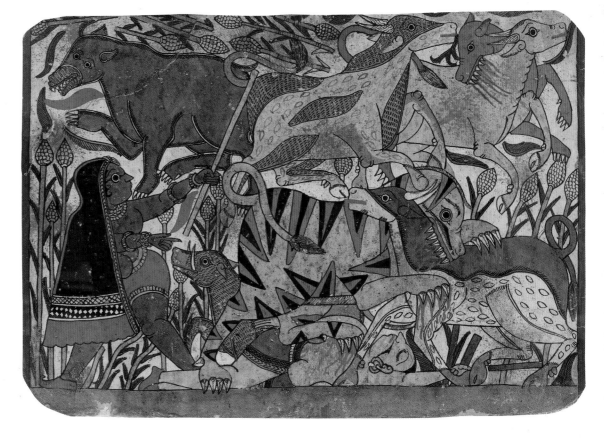

SOUVENIRS OF PILGRIMAGE

We all make journeys to see places
or people that are significant to us.
It is natural to want a keepsake of the
trip to remind ourselves and show
others. Pilgrims usually travel light so
the souvenir may be only a badge,
a photo or a signature.

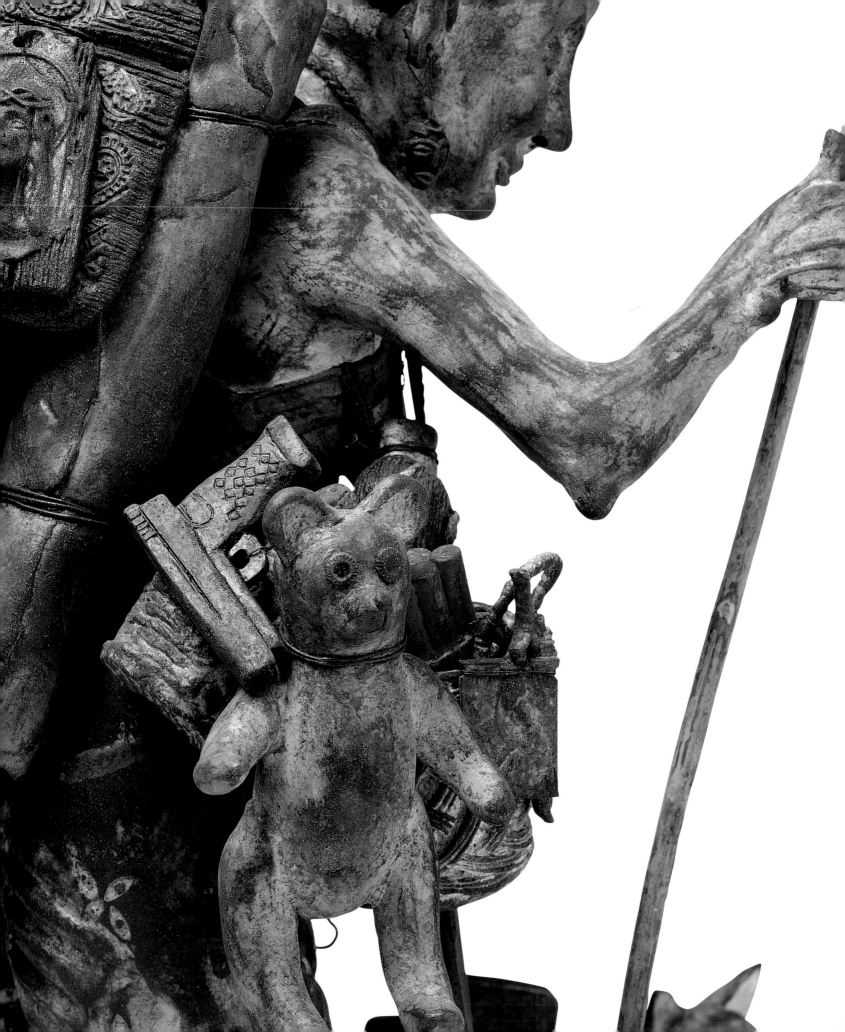

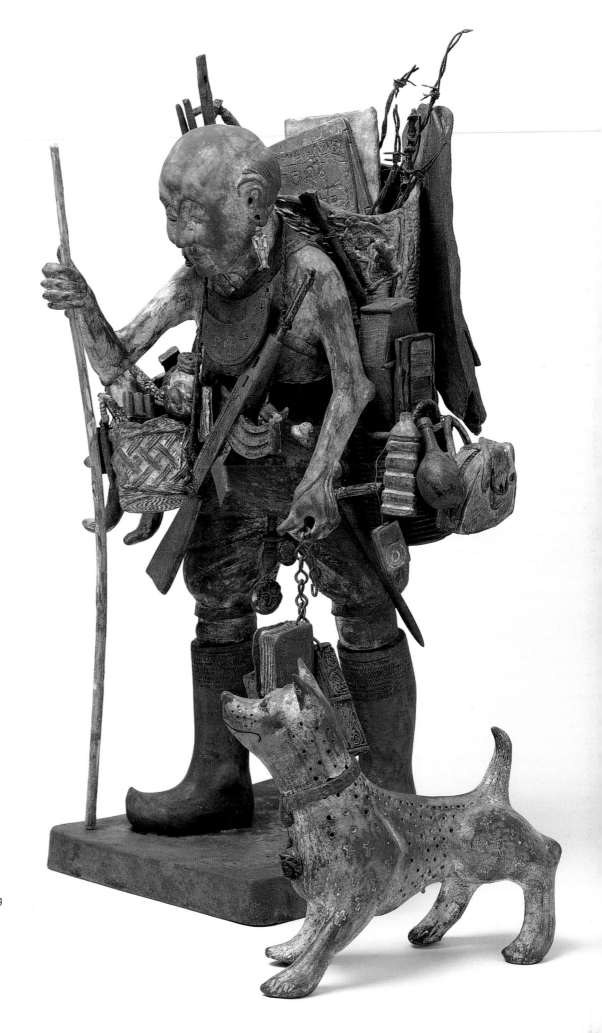

Our Father
Grayson Perry, 2007
Cast iron, oil paint and string
80 x 60 x 52 cm

Pilgrim badges
England, medieval
Lead alloy
Height 2.5–6 cm
British Museum

I first became aware of medieval pilgrim badges when I visited an exhibition in Holland of one of my favourite artists Heironymous Bosch. An accompanying display of badges excavated in Bosch's home town showed that much of the surreal iconography in his paintings derived from the popular imagery of the day. These badges, sold at holy sites and festivals, were the equivalent of today's t-shirts: 'My dad went all the way to Canterbury and all I got was this lousy lead alloy badge!' As well as conventional religious subjects badges depicted satirical proverbs, erotic jokes and fantastic hybrid creatures. I enjoy the badges for they bring home to us that for many a pilgrimage was a holiday and involved a lot of fun as well as religious devotion.

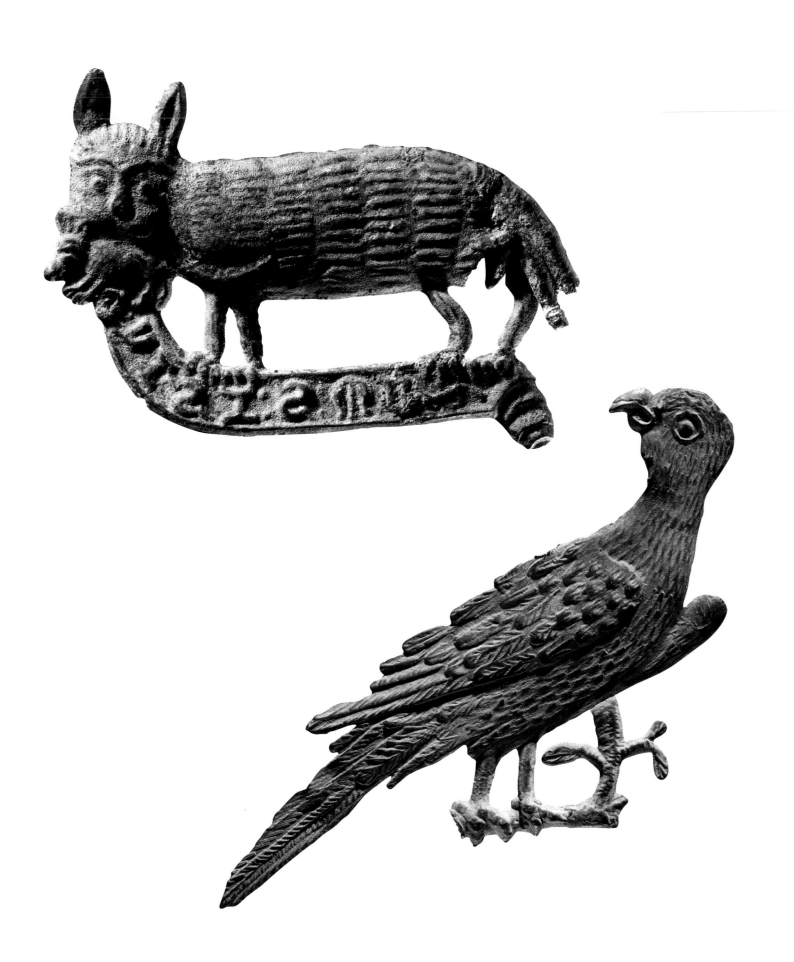

Pope Alan Stamp
Grayson Perry, 2010
Ink on scrap paper
Stamp size: 12.5 x 10.1 cm

I like the fact that a lot of the artefacts around pilgrimage are ephemeral, often given away. I wanted to make something associated with Alan Measles's pilgrimage to Germany that I could give away.

Pilgrim's passport

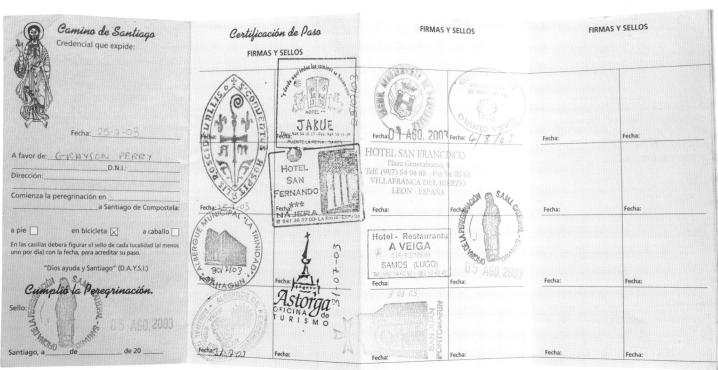

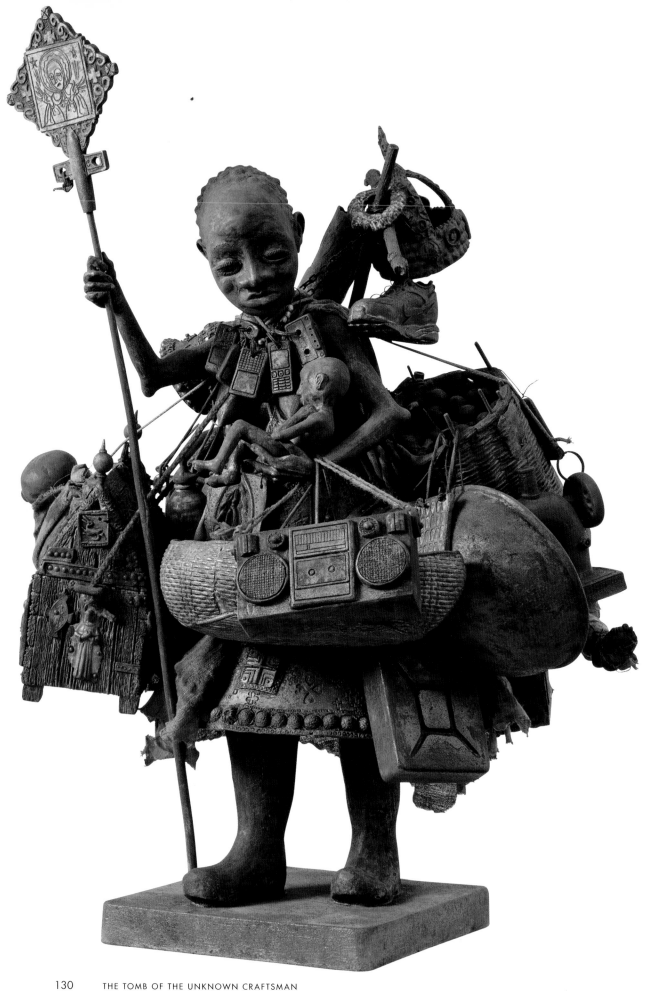

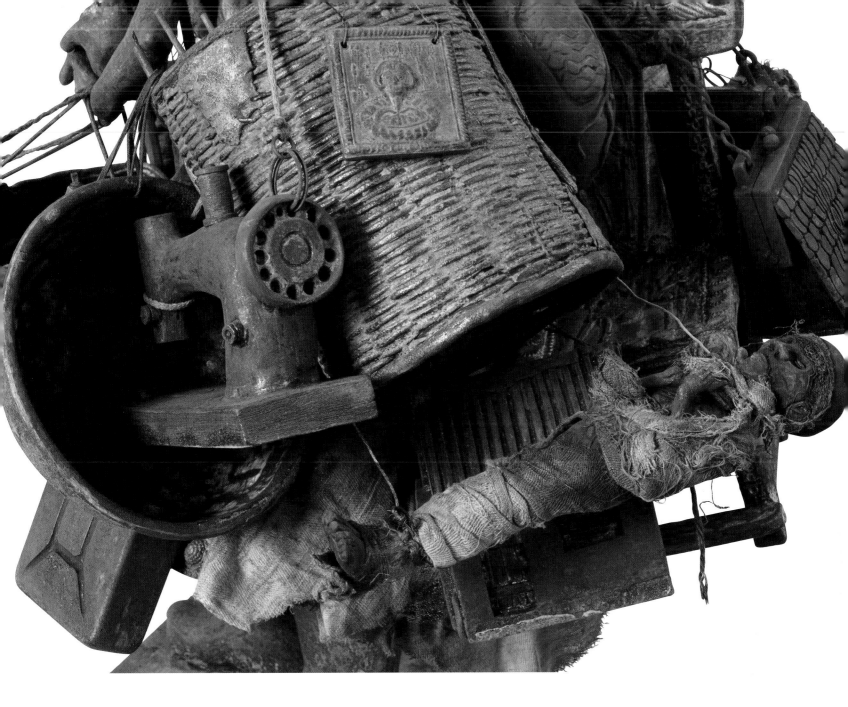

Our Mother

Grayson Perry, 2009
Cast iron, oil paint, string
and cloth
84.5 x 65 x 65 cm

Our Mother and *Our Father*: who are this couple –
pilgrims on the road of history, refugees from a past
industrial age, maybe something from Star Wars?
They are not made of bronze, the traditional metal
for sculpture. I chose to make them from iron, the stuff
of industrial archaeology. They carry the weight of
many different cultures and conflicts as well as the
domestic and familiar. They are all of us and also
from somewhere else.

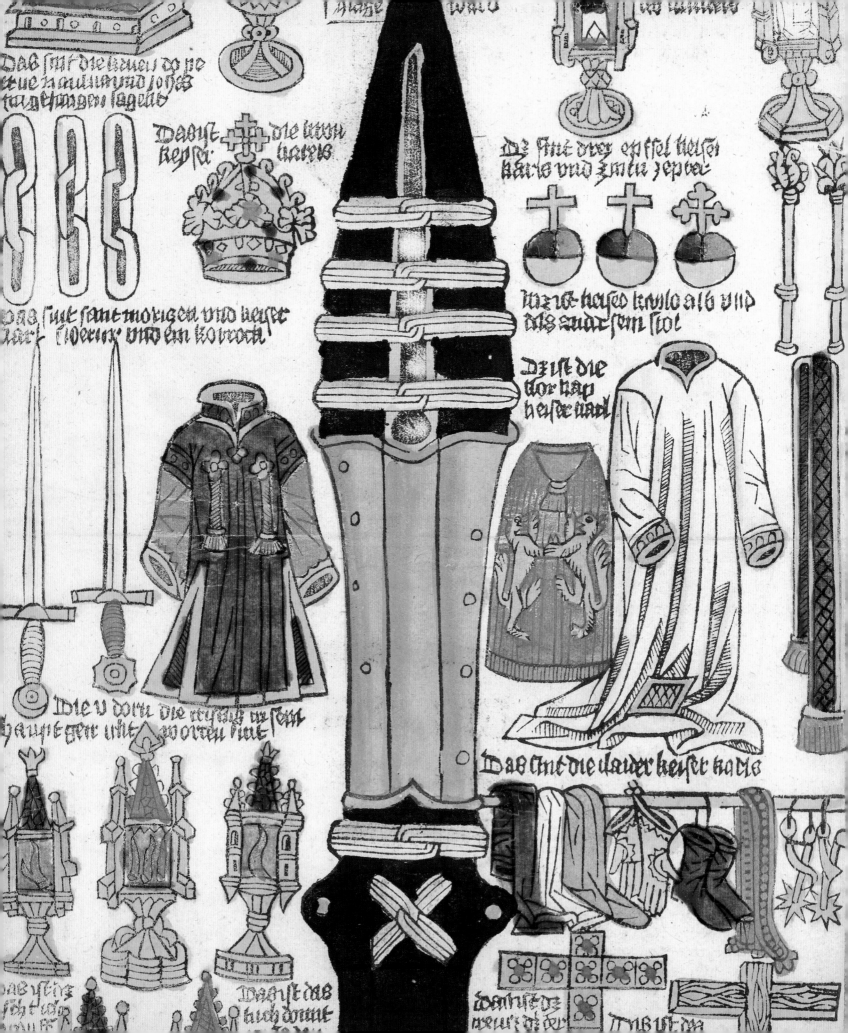

Relics of the Holy Roman Empire kept in the Church of the Holy Ghost, Nuremberg (detail, opposite)
Germany, 1470–80
Woodcut
43.4 x 29.8 cm
British Museum

Figure
Deruta, Italy, 1520–80
Tin glazed earthenware
76 x 23.5 x 22.5 cm
British Museum

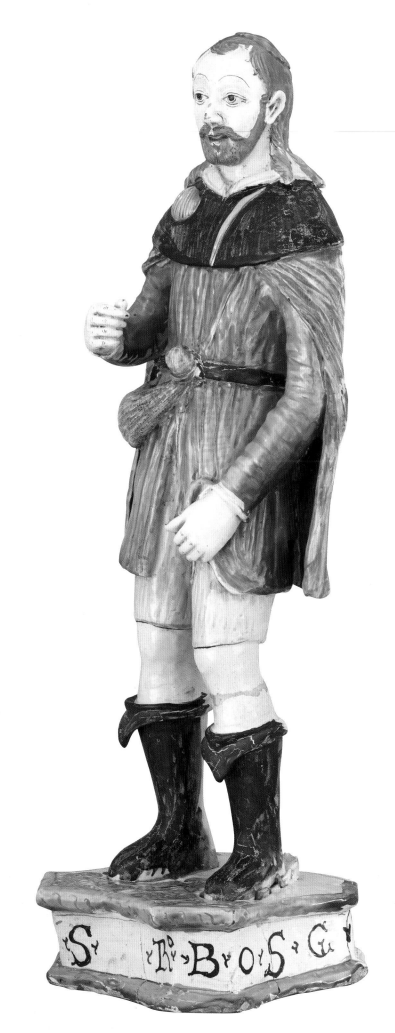

OPEN CHAMPIONSHIP
ST. ANDREWS
1978

ELGAR'S BIRTHPLACE

THE FIRST AND LAST HOUSE
LAND'S END

UEFA
euro 96
England

Badges
Various, 1913–2001
Plastic, metal and paper
British Museum

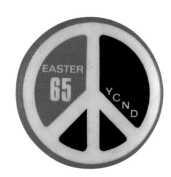

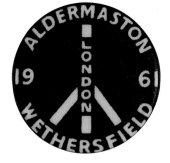

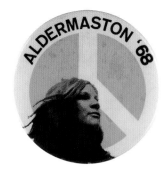

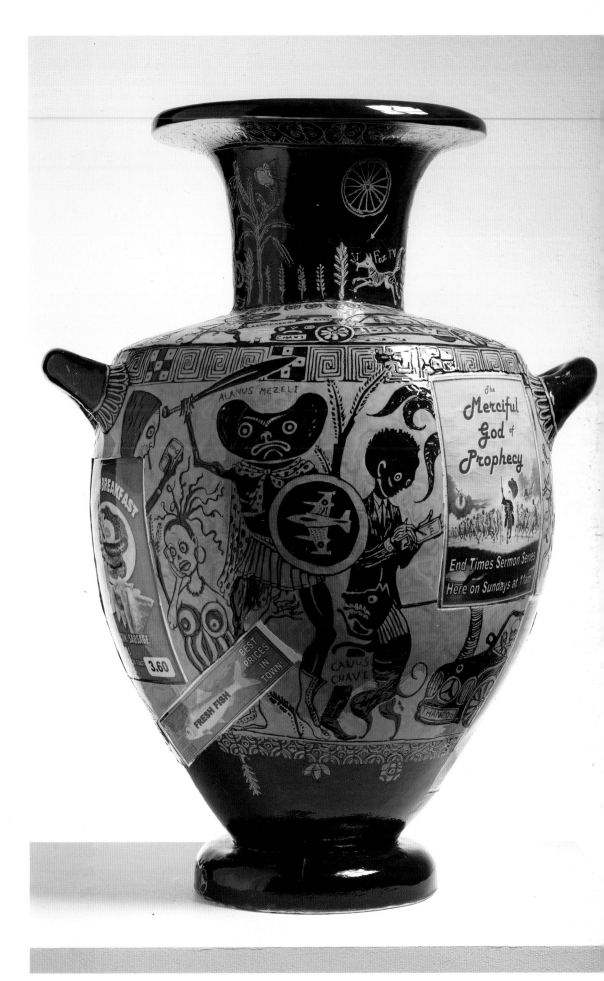

Rubbing

China, Qing Dynasty, 1734

Paper rubbing

148.5 x 112.5 cm

British Museum *

Grumpy Old God (right)

Grayson Perry, 2010

Glazed ceramic

71 x 44.6 x 53.6 cm

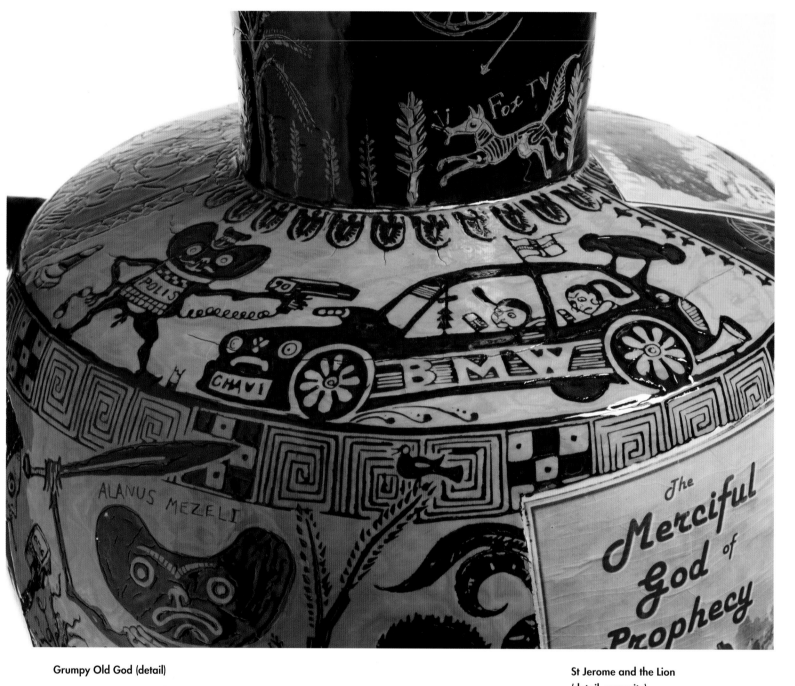

Grumpy Old God (detail)

**St Jerome and the Lion
(detail, opposite)**
Germany, 1470–80
Metalcut
27.2 x 18.8 cm
British Museum

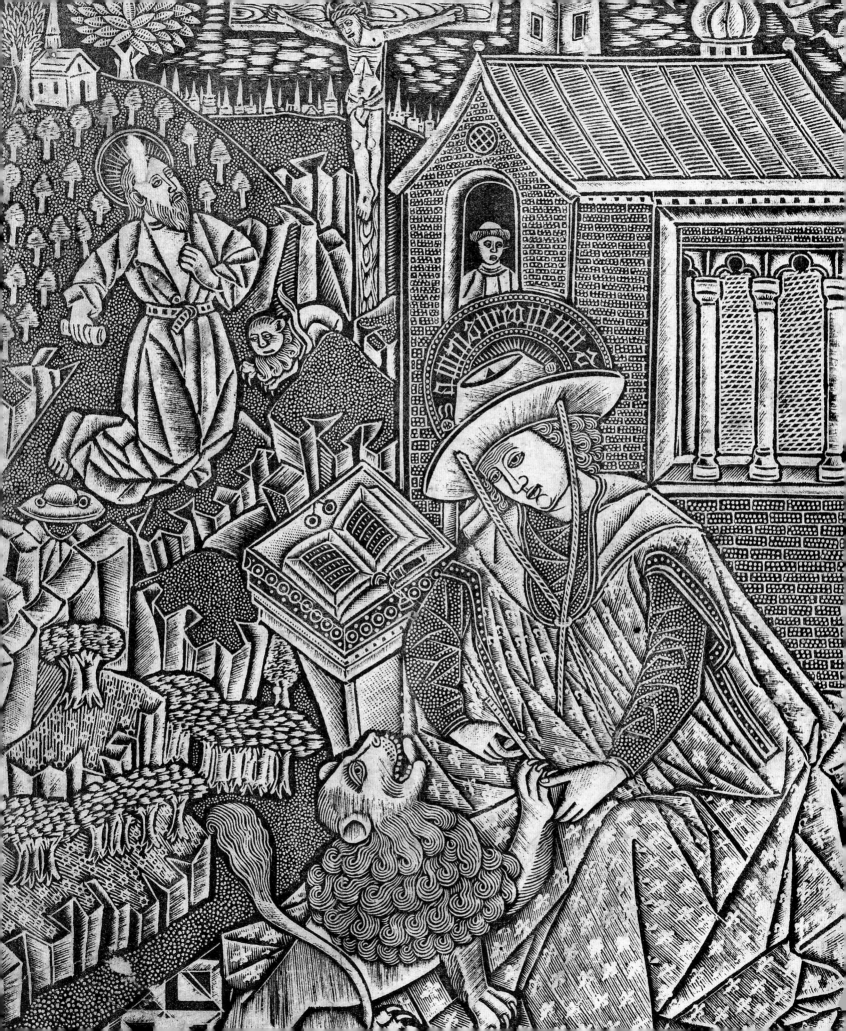

Amulet with plaque, 'Tsa Tsa'
Tibet, 1800–99
Bronze and paper
11 x 9 x 3.6 cm
British Museum

I think the way we look at art comes from religion. We go to special buildings to stare at significant and precious things. We feel it is good for us. The Tate Modern is the cathedral of the cult of Modern Art. I designed this reliquary for the Tate gift shop. Each one contains a fragment of one of my pots.

Tate Modern Reliquary (above)
Grayson Perry, 2009
Display box containing fragment of original work by Grayson Perry
Relic: 8 x 5.2 x 2.1 cm
Display box: 2.8 x 10.2 x 7.6 cm

Moulds, 'topes' (left)
Tibet, 1500–1899
Copper and wood
Length c.17–23.5 cm
British Museum

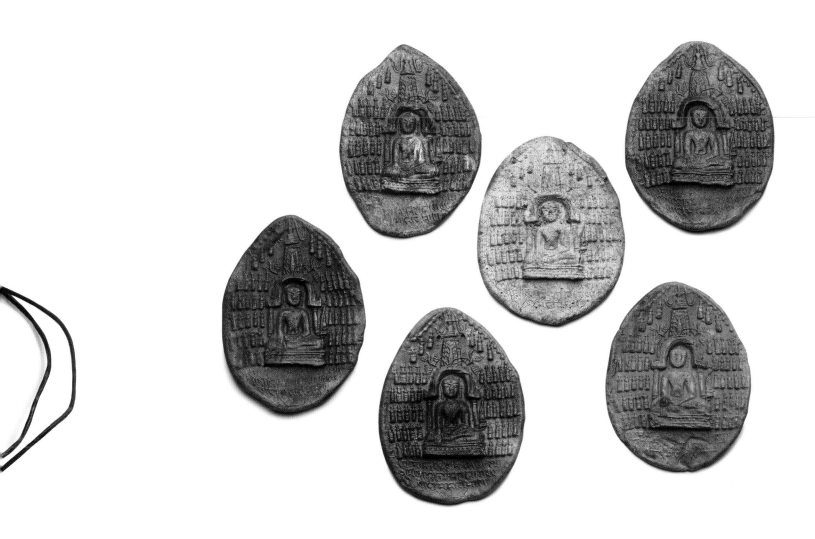

Lac plaques (above)
India
Lac
Height of central plaque: 6 cm
British Museum

Votive stupas, 'ts'a-ts'a' (below)
India, 2002–3
Moulded and painted clay
Height of largest stupa: 4.7 cm
British Museum

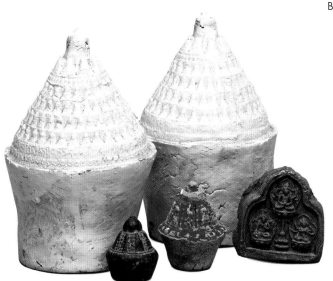

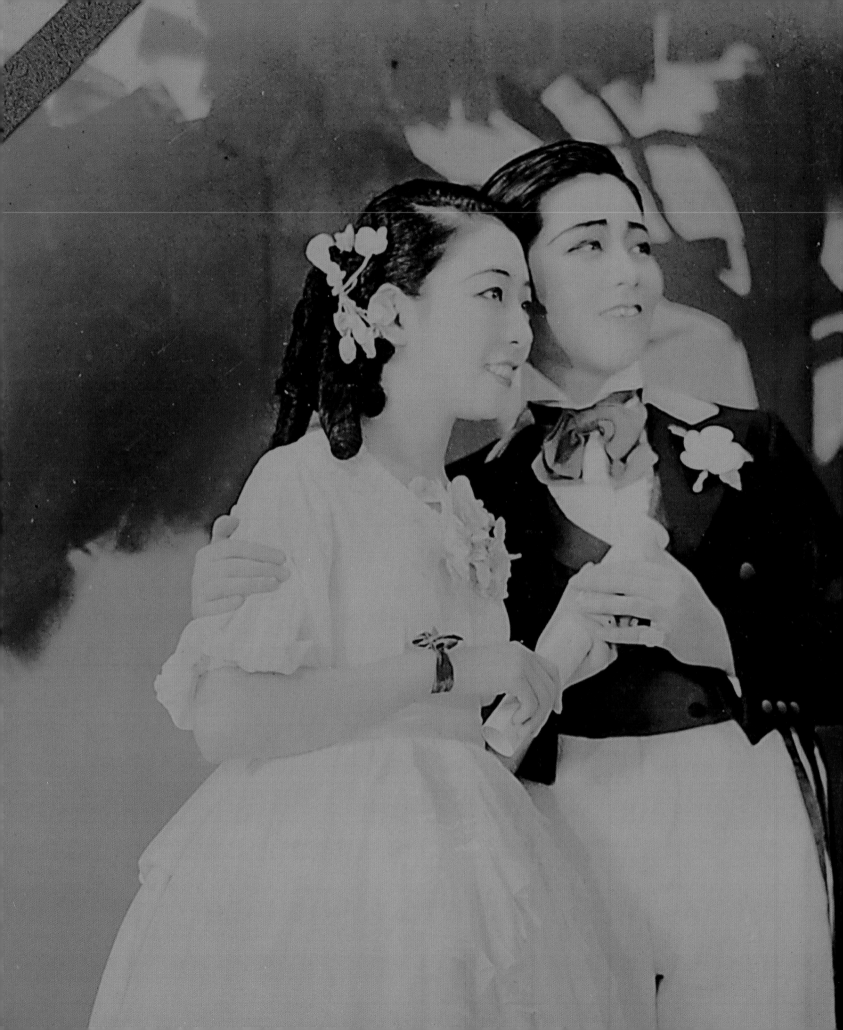

SEXUALITY & GENDER

I am a transvestite so I have always questioned gender roles and our attitudes to sex. In contemporary society there is much anxiety about the 'sexualization' of our culture but sexual imagery has always been around. I think what many commentators are really complaining about is the violence, exploitation, sexism and commercialism that are often a part of sexual imagery.

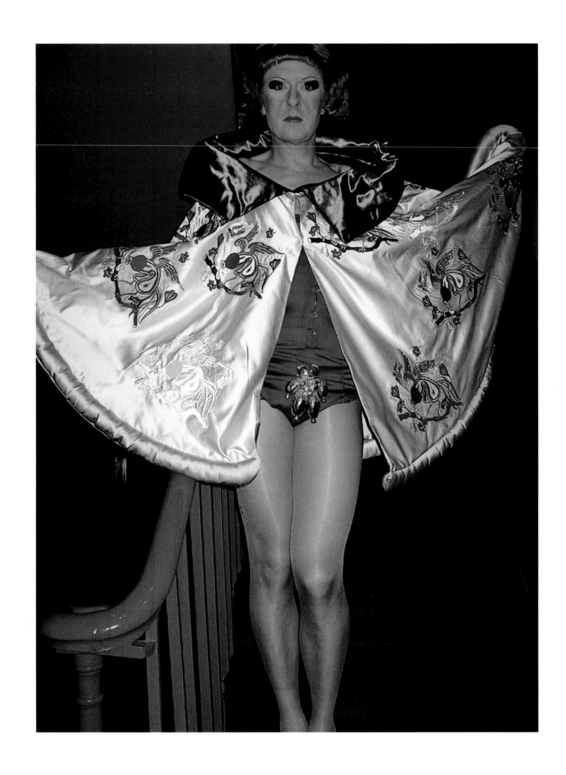

High Priestess Cape
Grayson Perry, 2007
Embroidered cape,
rayon on satin
96 x 166 cm

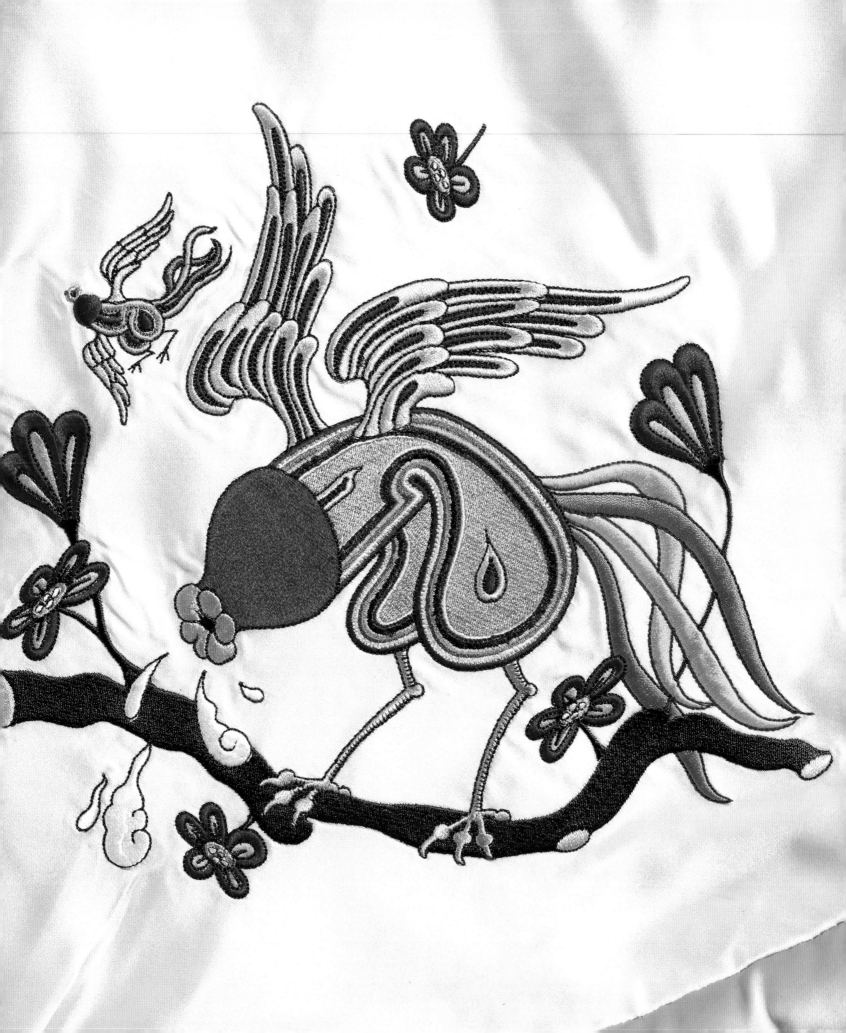

1771

La Decouverte ou la Femme Franc Maçon. *The Discovery or Female Free-Mason*

Lady Charles, Louis, Cezar, Auguste, Alexandre, Timothée,
D'Eon de Beaumont, Avocat au Parlement, Secretaire de
l'ambassade francoise à la Cour de Russie, Aide de Camp du Duc
de Broglie, Capitaine de Dragons, Censeur Royal Secretaire
d'Ambassade Sous le Duc de Nivernois, Chevalier de l'ordre
militaire de St. Louis, Ministre Plenipotentiaire au près de
S. M. Britanique, & recû Franc-Maçon à la loge de l'immortalité
de l'ordre, at the Crown & Anchor in the Strand.

Lady Charles, Louis, Cezar, Augustus Alexander, Timotheus,
D'Eon of Beaumont ———— Advocate of the Parliament of
Paris, Secretary to the Ambassy at the Court of Russia, Aid de
Camp of the Duke de Broglio, Captain of Dragons, Royal Cen-
sor Secretary of Ambassy under the Duke de Nivernois, Knt.
of y. Military order of St. Louis, Minister Plenipotentiary to his
Britanic Majesty & accep: free Mason at the Lodge of immortality
at the Crown & Anchor in the Strand.

The Chevalier D'Eon (left)
Britain, 1771
Mezzotint
37.5 x 25 cm
British Museum

Pack of playing cards (below)
Ōtsuka Takashi (Taq, born 1948)
Japan, 1997
Paper
Each 10.5 x 7.2 cm
British Museum

When I was a young transvestite I joined Britain's oldest group for crossdressers, the Beaumont society initiated in 1966. It is named after the Chevalier D'Eon de Beaumont (1728–1810). The Chevalier was born into a family of the petite noblesse. An accomplished intellect and swordsman, he rose to become a diplomat for Louis XV. He also like dressing as an attractive young woman. He was sent as a secret agent to the Russian court in St Petersburg where he spent six months as one of the Empress Elizabeth's ladies in waiting. Like most transvestites he could also be pretty macho and commanded a company of dragoons in the Seven Years War. He died in England and is buried in London in St Pancras churchyard.

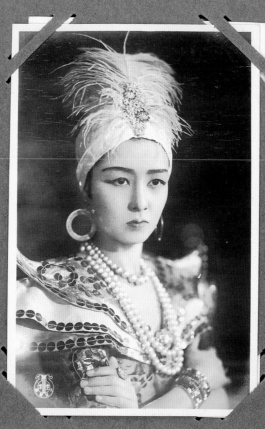
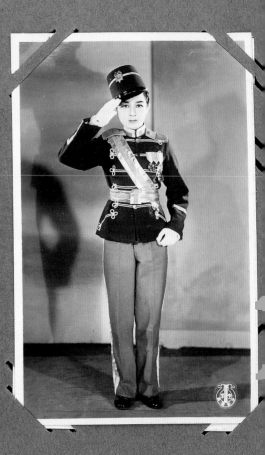
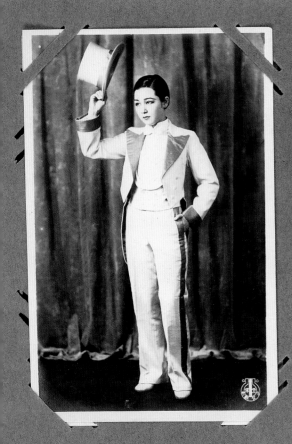
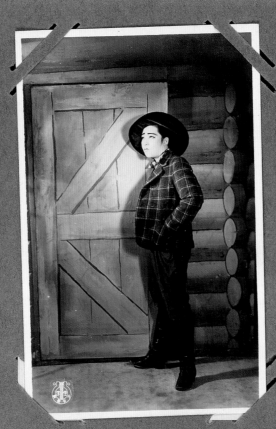
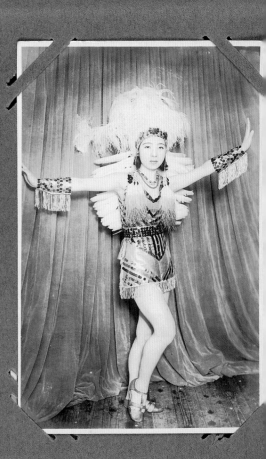

Album of 200 photos
Japan, 1935–9
Paper with fabric-covered covers
34 x 19.5 cm
British Museum

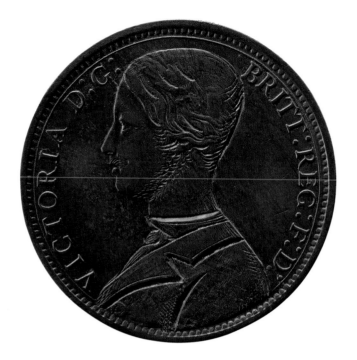

Re-engraved coin
Britain, 1882
Bronze
Diam. 3 cm
British Museum

Re-engraved coin
Britain, 1882
Bronze
Diam. 3 cm
British Museum

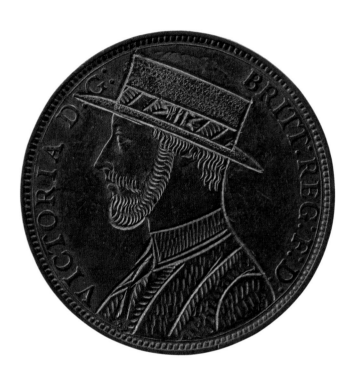

One fact that every transvestite has to come to terms with is that a person dressed up in the clothes of the opposite sex is somehow inherently funny. This can be a very difficult aspect of being a cross-dresser and I feel it has profoundly shaped my own outlook on life. I regard humour as an important and necessary aspect of art. I love the skill and transgressive wit of these 'drag king' coins.

Woman's fighting bracelets
Ait Atta, Morocco
Metal
Diam. each 10 cm
British Museum

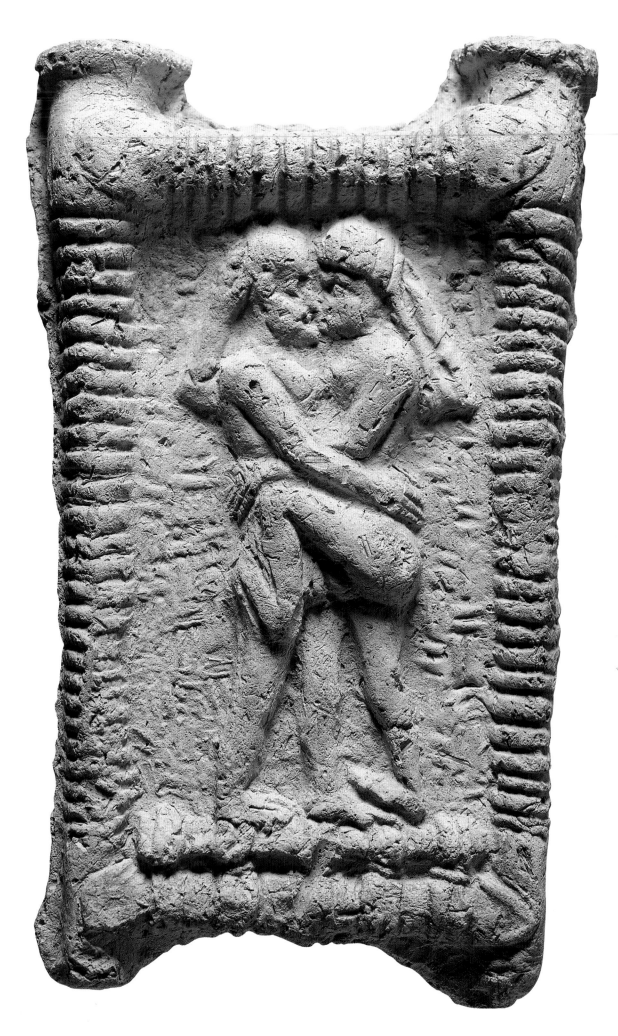

Model showing a nude couple on a bed
Mesopotamia
Moulded and fired clay
12 x 7.5 x 4.8 cm
British Museum

La femme de Barnaba
Cherchant Son Mari depuis 2000

Le Pere Barnaba distributeur de bequilles
aux femmes et filles quinen ont pas

The Wife of Barnaba (opposite)
France, 1750–90
Hand-coloured etching
39.5 x 25 cm
British Museum

Father Barnaba (left)
France, 1750–90
Hand-coloured etching
40.5 x 25 cm
British Museum

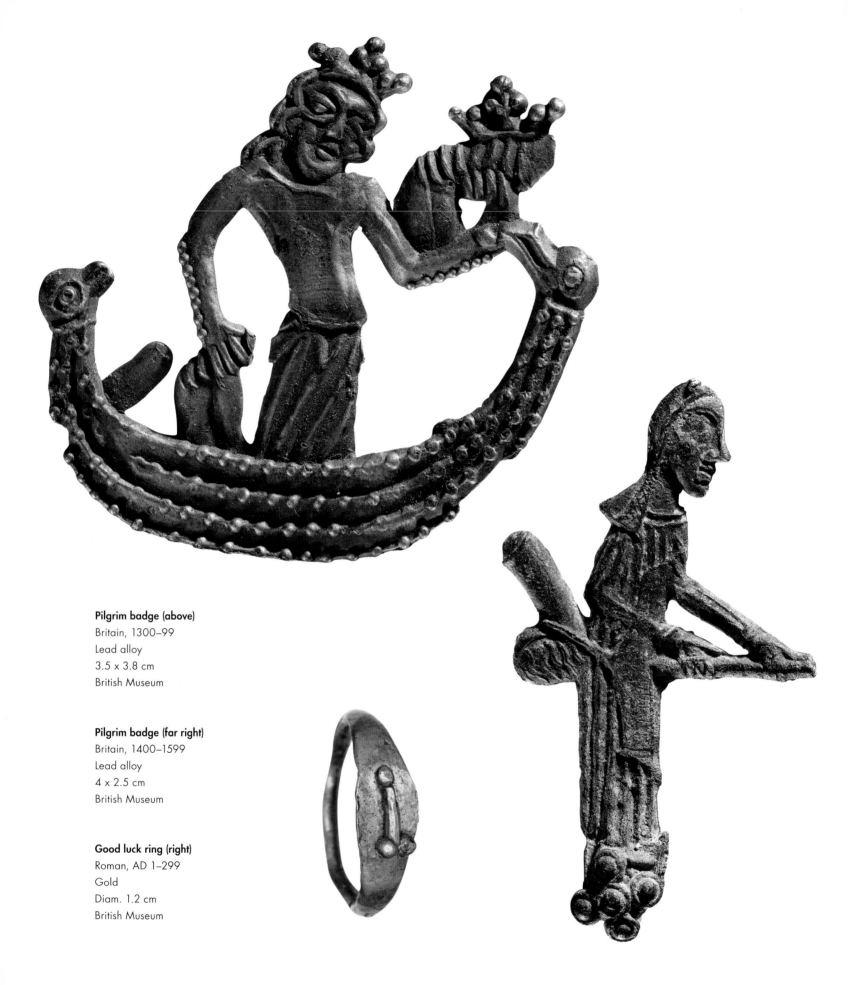

Pilgrim badge (above)
Britain, 1300–99
Lead alloy
3.5 x 3.8 cm
British Museum

Pilgrim badge (far right)
Britain, 1400–1599
Lead alloy
4 x 2.5 cm
British Museum

Good luck ring (right)
Roman, AD 1–299
Gold
Diam. 1.2 cm
British Museum

Medal (below)
Italy, 1500–99
Bronze
Diam. 4.4 cm
British Museum

Oil flask (bottom)
Greece, Corinthian,
c.560 BC
Terracotta
8.5 x 5.2 cm
British Museum

**Votive figure of the god
Amun-Ra (right)**
Egypt, 25th or 2th Dynasty
(747–525 BC)
Bronze
20.5 x 6 x 3.5 cm
British Museum

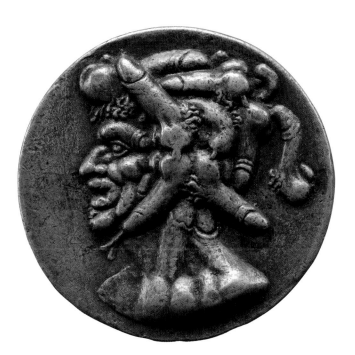

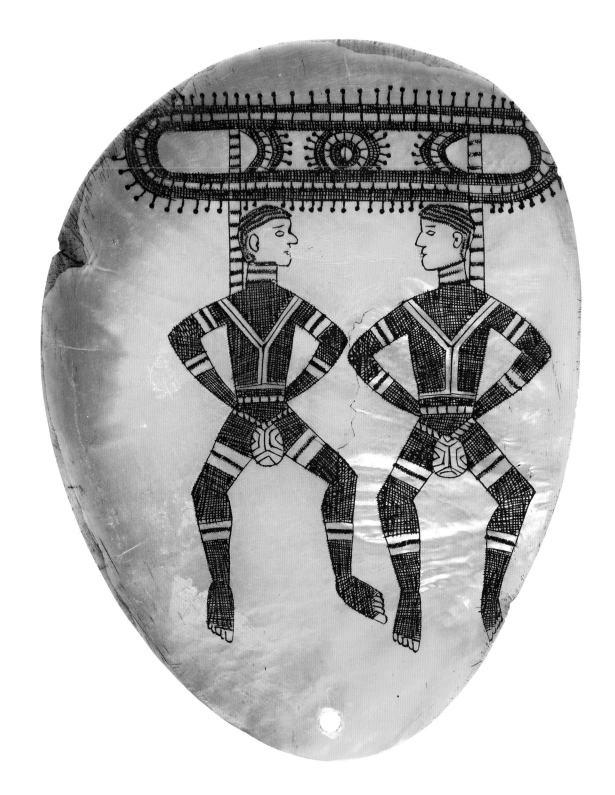

Pubic ornament

Western Australia
Pearl shell
15.7 x 12.2 cm
British Museum

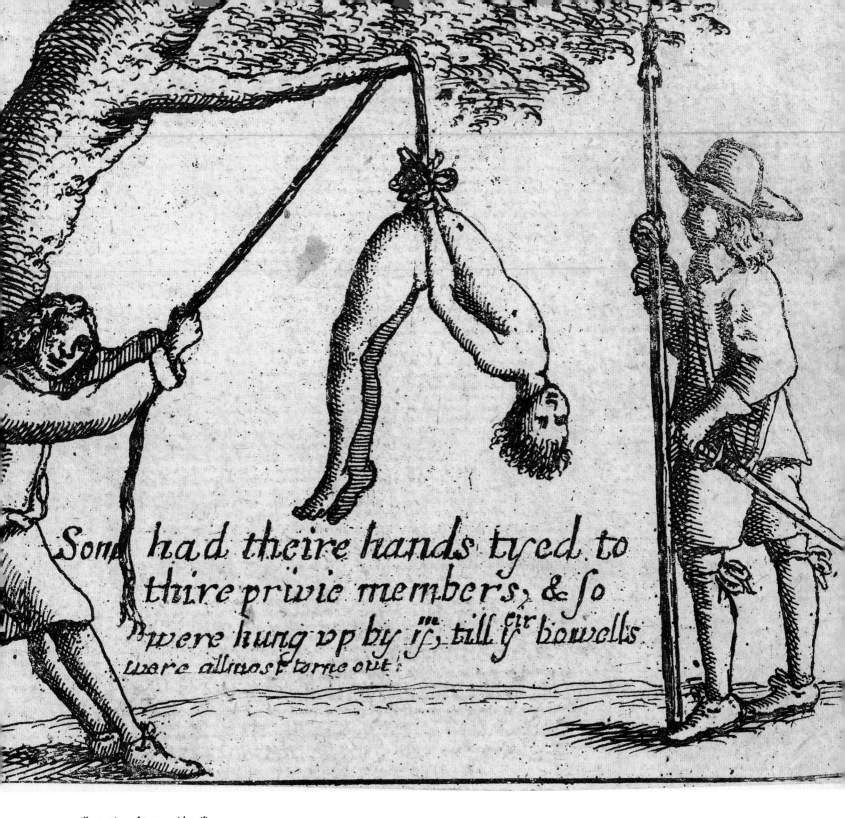

Illustration of torture (detail)
from Samuel Clarke's
General Martyrology
Britain, 1651
Etching
6.2 x 7 cm
British Museum

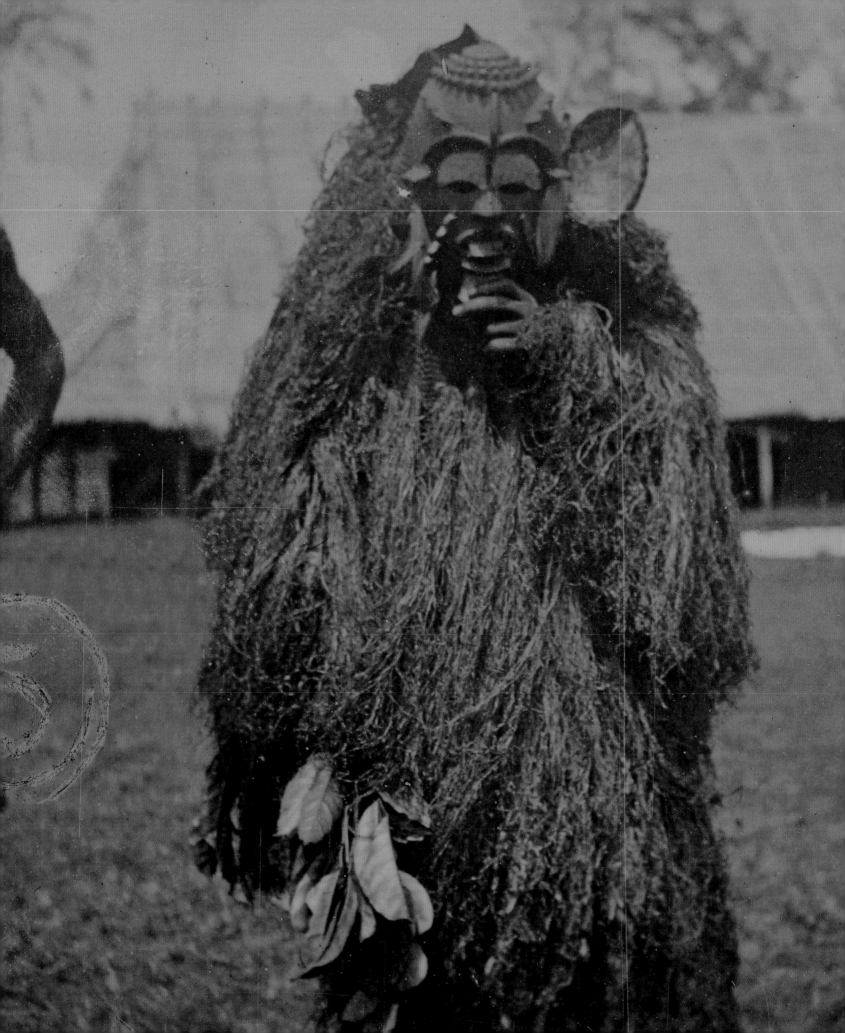

SCARY FIGURES

We have always had images at
gateways to warn and protect.
Cathedrals had carvings over the doors
showing the Last Judgement and the
damned going to hell, now we have
CCTV to dissuade us from misbehaving.
Some images are there to accompany
us into different states: drunkenness,
sleep or death.

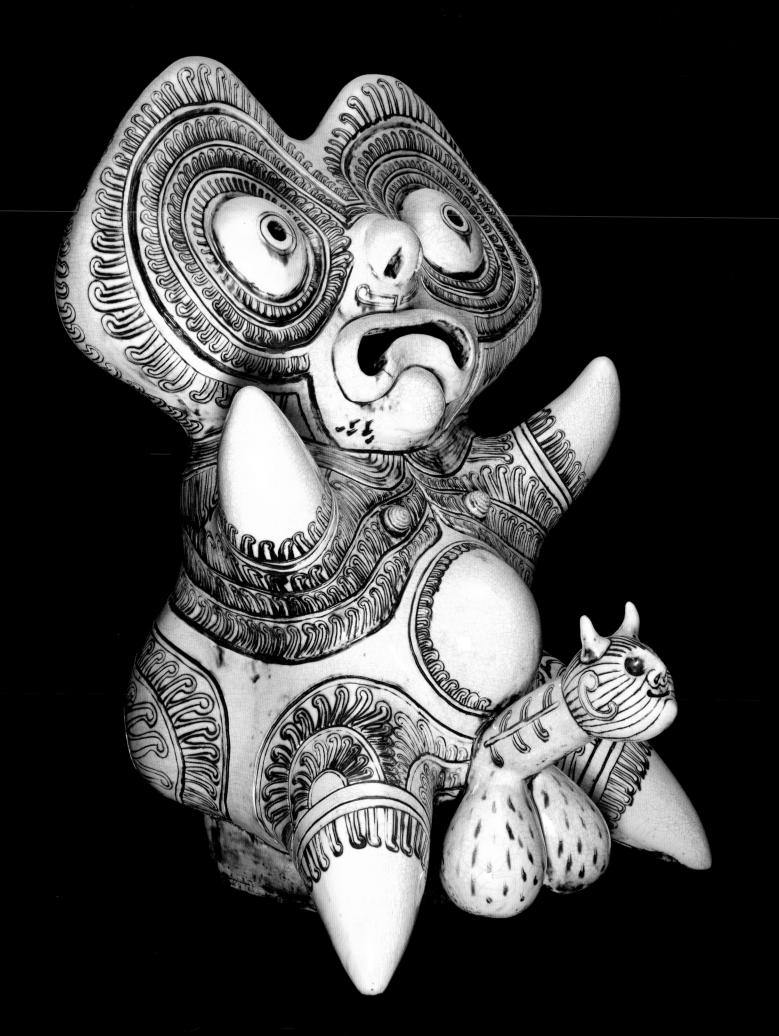

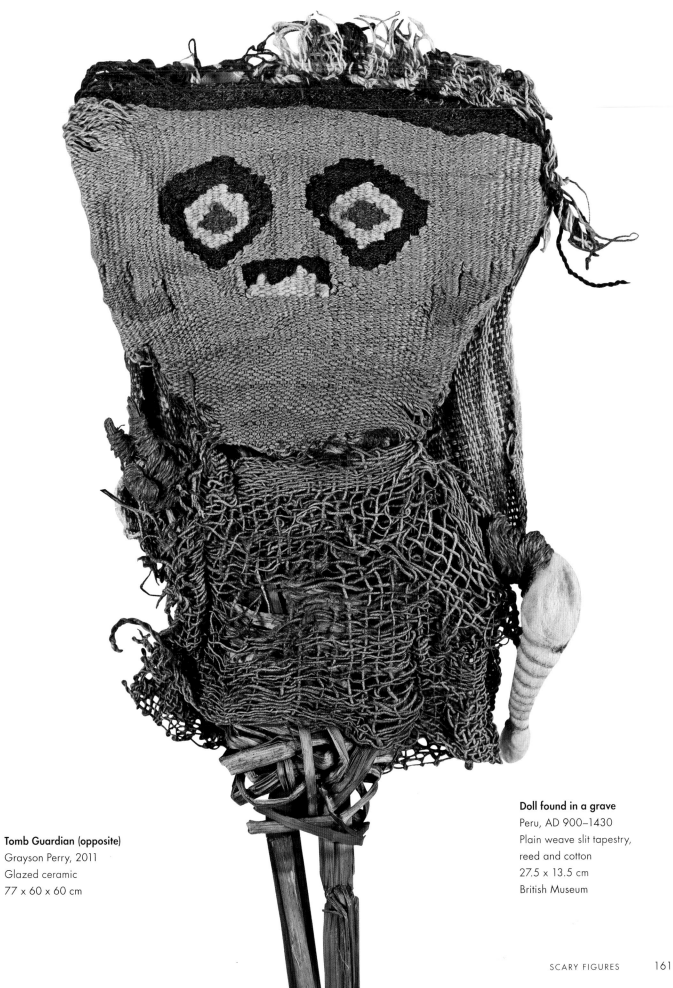

Tomb Guardian (opposite)
Grayson Perry, 2011
Glazed ceramic
77 x 60 x 60 cm

Doll found in a grave
Peru, AD 900–1430
Plain weave slit tapestry,
reed and cotton
27.5 x 13.5 cm
British Museum

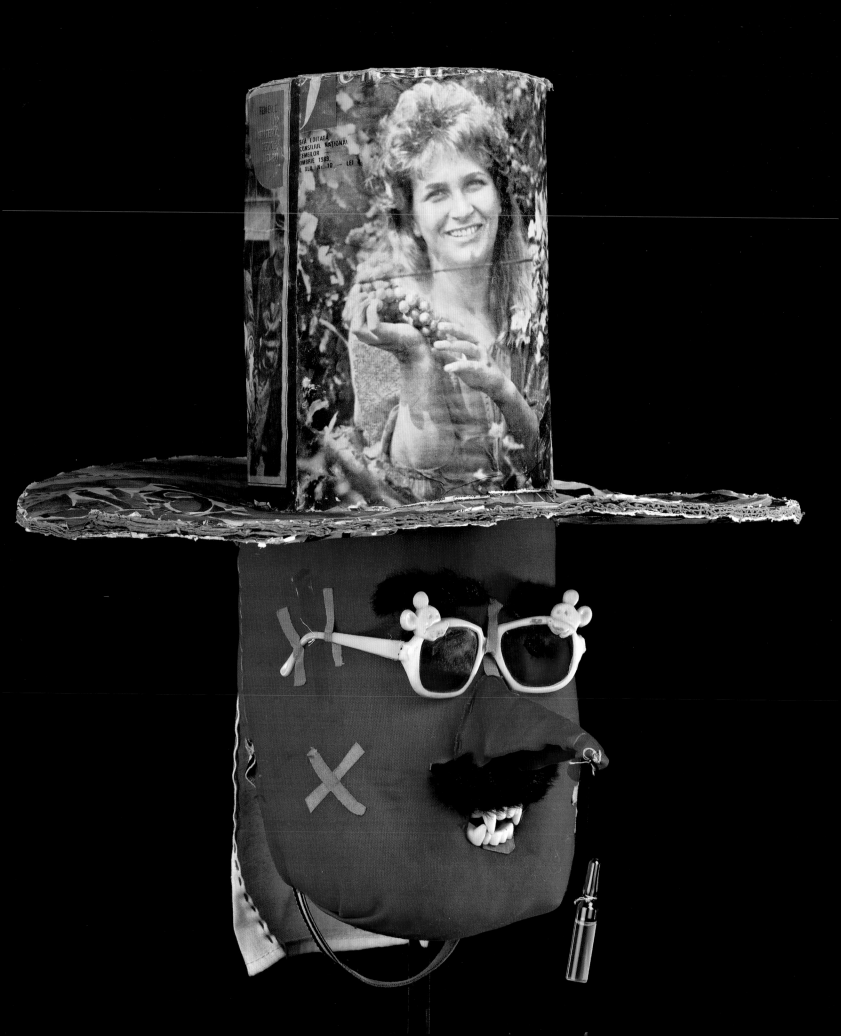

**Staff terminal depicting
the god Bes**
Egypt, Late Period
(664–332 BC)
Glazed composition
20 x 7.5 x 1 cm
British Museum

'Doctor' mask (opposite)
Romania, made by Ion Tutuianu
and his brother for New Year
performances, 1993
Paper, card, cotton, plastic,
imitation fur and synthetic fabric
Height 49 cm
British Museum

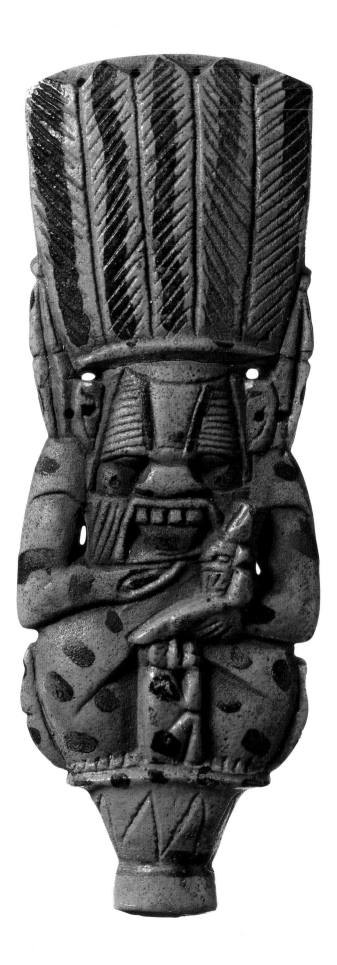

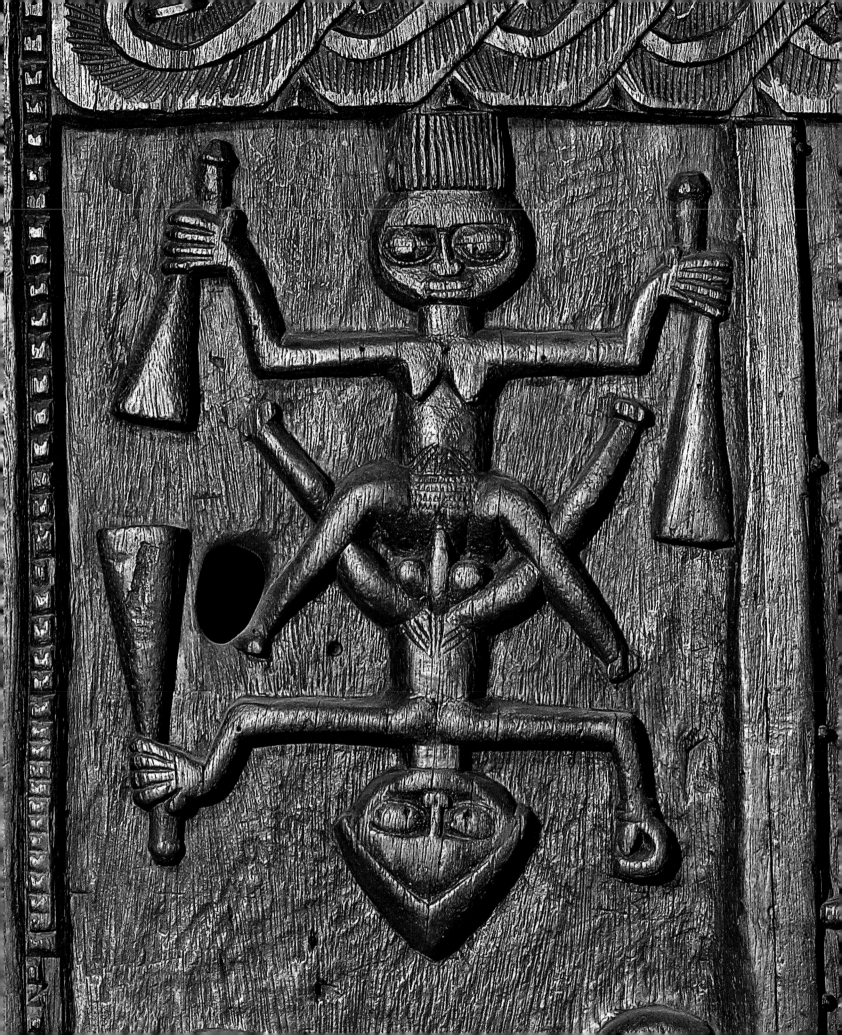

As an artist who sometimes uses sexual imagery in my work I have always been interested in the historical antecedents. Sheela-na-gigs are sculptures of females displaying their vulva found mainly on Norman or Romanesque churches and castles in Ireland and England. What they represent is not known, but theories include incorporation of an earlier pagan goddess, a figure to ward off evil spirits, a fertility goddess or a warning against female lust. Living in an age troubled by the proliferation of pornography, it is interesting to note how taboo some sexual images are today compared with other ages and cultures.

Sheela-na-gig (right)
Ireland, 1100–99
Stone
47 x 20 x 14 cm
British Museum

Door (detail, opposite)
Yoruba, Nigeria
Carved wood
181 x 99 x 6 cm
British Museum

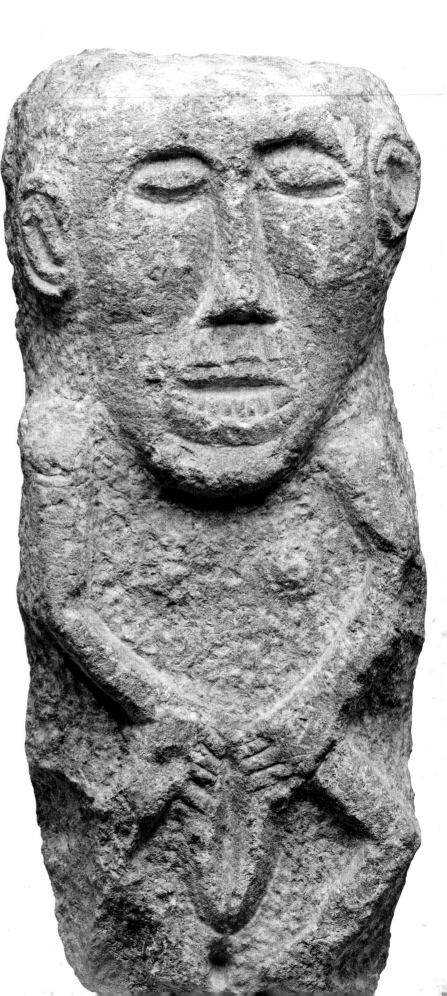

Cameo
Roman, AD 1–199
Onyx
7.5 x 6.5 cm
British Museum

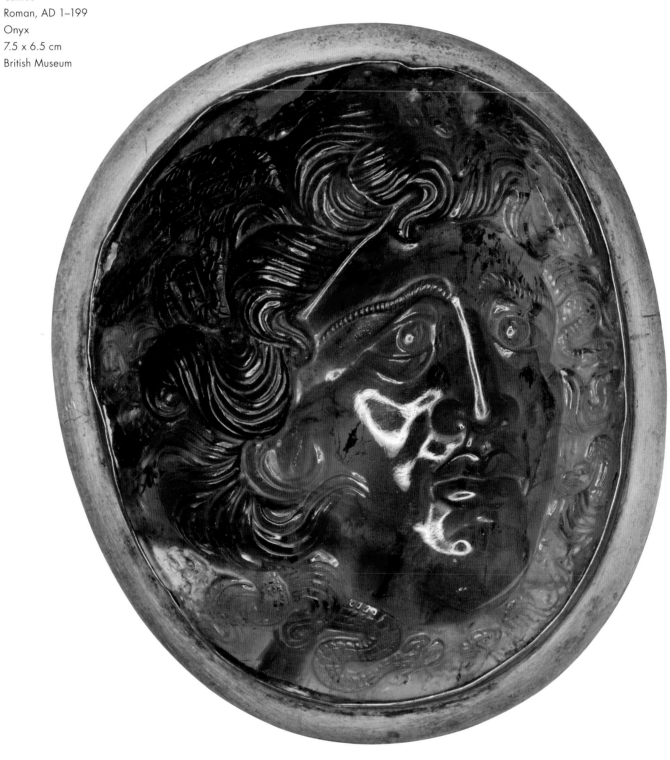

Stirrup spout bottle
Peru, 900–1430
Pottery
11 x 8.5 x 7.5 cm
British Museum

CRAFTSMANSHIP

Craftsmanship is often equated with precision but I think there is more to it. I feel it is more important to have a long and sympathetic hands-on relationship with materials. A relaxed, humble, ever-curious love of stuff is central to my idea of being an artist. An important quality of great art of the past was the pure skill in the artist's use of materials. In celebrating craftsmanship I also salute artists, well, most of them.

Pilgrim Bottle
Grayson Perry, 2011
Glazed ceramic
42 x 30 x 15 cm

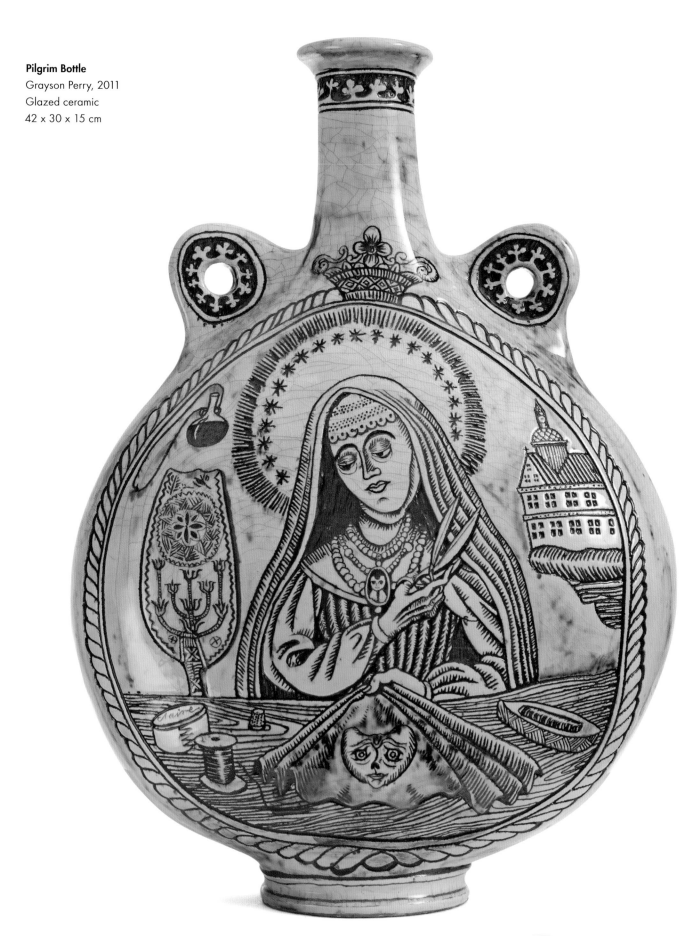

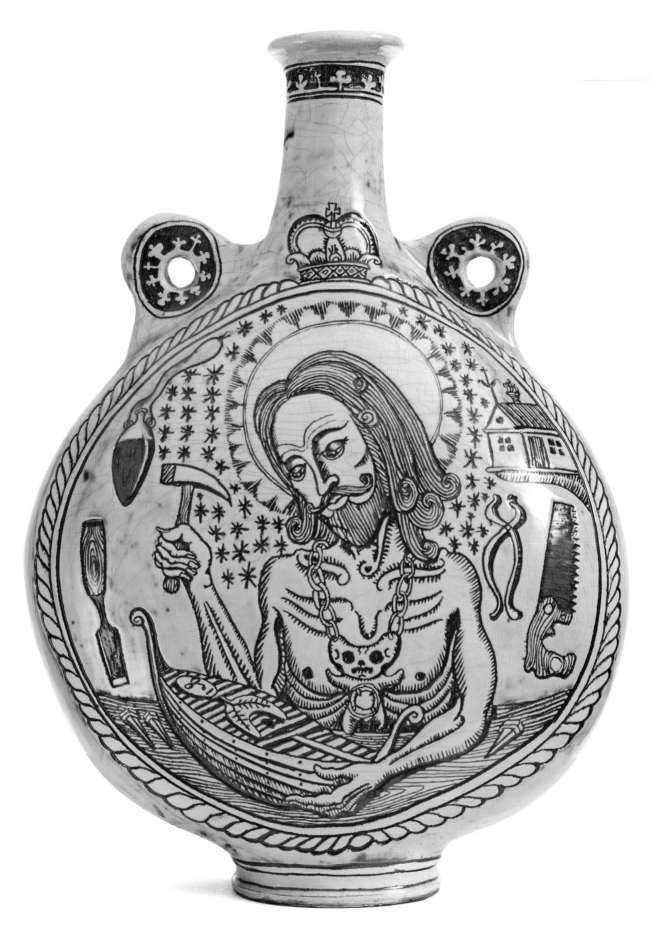

Dish
Britain, Staffordshire,
William Simpson, c.1700
Earthenware, lead-glazed,
coloured slips
Diam. 42 cm
British Museum

Dish

Britain, Staffordshire,
Ralph Toft, 1677
Earthenware, lead-glazed,
coloured slips
Diam. 45 cm
British Museum

These slipware dishes are examples of the first pottery to inspire me when I started ceramics evening classes in 1983. I was drawn to their graphic boldness and relaxed fluency. Ironically their makers are far from unknown craftsmen as they have signed the rims in large letters. Like most olden days potters, Ralph Toft and Ralph Simpson would probably have spent their entire working lives making similar wares. I'm sure they would have constantly made fresh variations on their standard output to keep themselves sane. This gives the dishes an almost cheeky Englishness. When I look at these I see the roots of my culture in the same way a Japanese artist might see the roots of his in an Edo period tea ware.

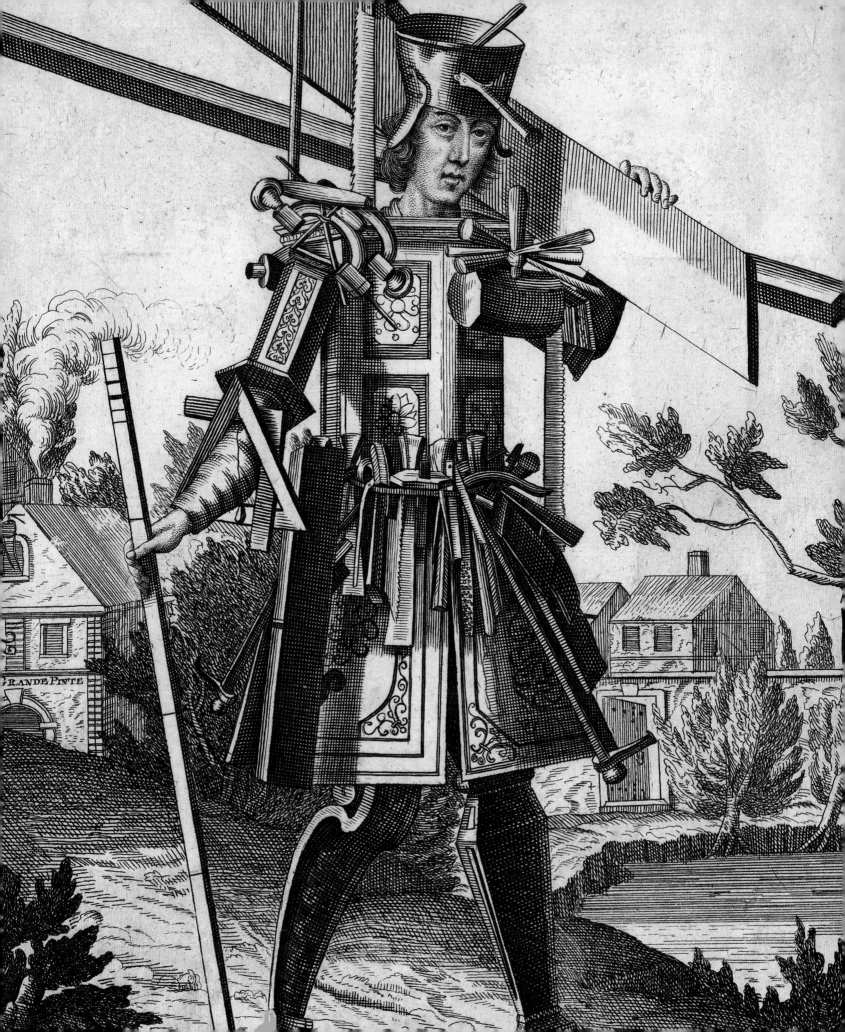

GRANDE PINTE

Cabinetmaker, with body composed of tools and wooden panels (detail, opposite)
Print by Gerard Valck after Nicolas de Larmesin II
Netherlands, 1695–1720
26.2 x 17.6 cm
British Museum

Potter's spatula (above)
Solomon Islands, 1870s
Wood
30 x 6.7 cm
British Museum

Dala ornament (below left)
Solomon Islands, 1870s
Tridacna shell, turtle shell and fibre
Diam. of disc 12.5 cm
British Museum

Drawing board (detail, below)
Egypt, 18th Dynasty `
(1479–1425 BC)
Plastered and painted wood
37 x 54.5 cm
British Museum

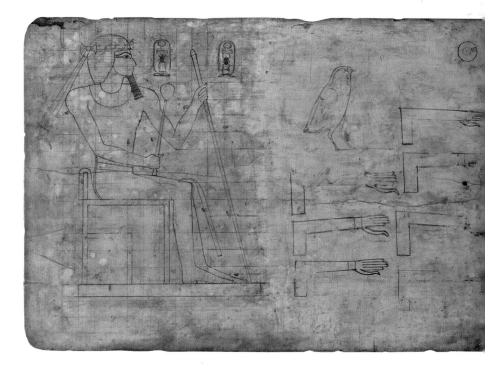

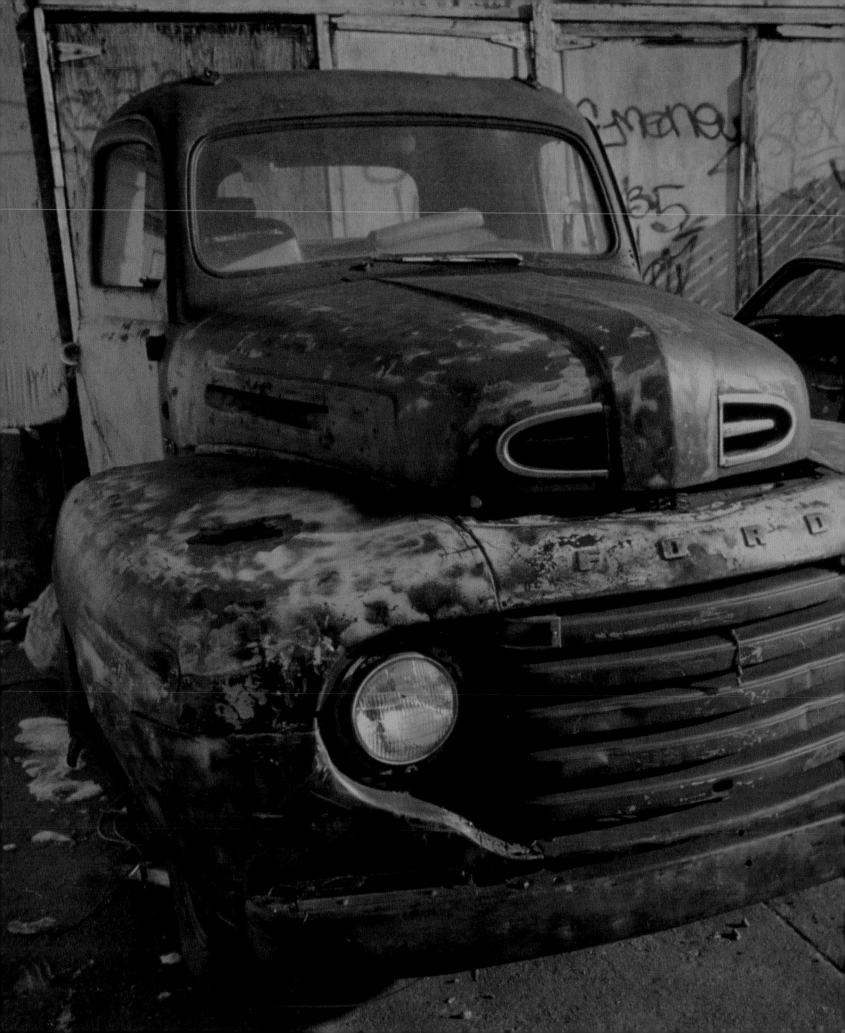

PATINA & TEXTURE

Wear, damage, dirt, repair, corrosion and decay are a large part of the language of authenticity. We give things that look old the benefit of the doubt. Age lends authority to an object. An aged artefact inveigles its way into the grand events of history. My work often borrows the shabby familiar clothes of the antique so as to lend gravitas to what it has to say. The look of age is also an important component in what we find beautiful.

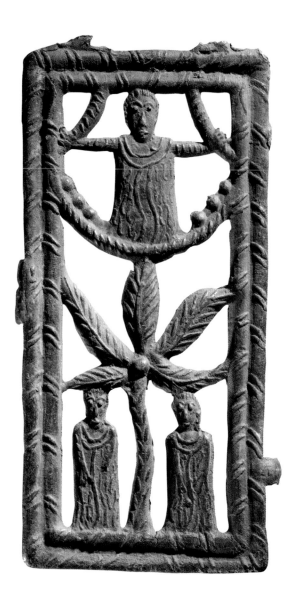
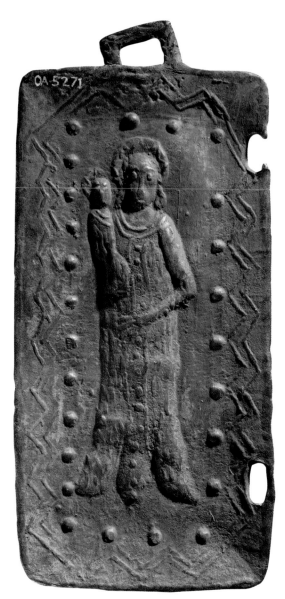

Diptych
Britain, 1800–99
Lead
24.7 x 23.7 cm
British Museum

William Smith and Charles Eaton were mudlarks searching the foreshore of the Thames for valuable objects. In 1857 they decided to manufacture their own 'finds' casting a range of 'medieval' artefacts from lead in hand-cut plaster moulds. They produced several thousand pieces and duped many collectors and even some medieval scholars. These audacious fakes tick many boxes for me. They somehow capture a camped-up version of medievalism and have a satisfying archaeological patina. I love fakes for they make us think about what it is we see in the authentic. How much of our awe in front of a great historical artefact is in its inherent beauty and how much of it is to do with its auspicious provenance?

Billy and Charlies (below)
Britain, 1857–70
Lead
Diam. 9.9 cm
British Museum

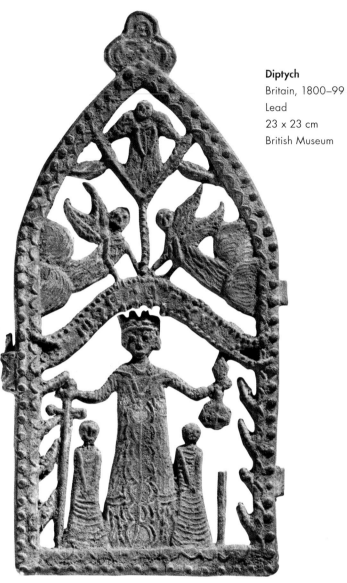

Diptych
Britain, 1800–99
Lead
23 x 23 cm
British Museum

Billy and Charlies
Britain, 1857–70
Lead
Diam. 6.7 cm
British Museum

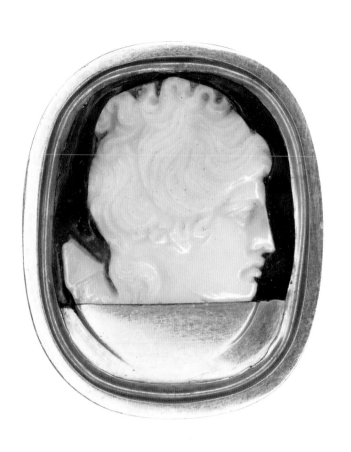

Cameo fragments
Roman, AD 1–199
Engraved onyx
Height 1.6–3.7 cm
British Museum

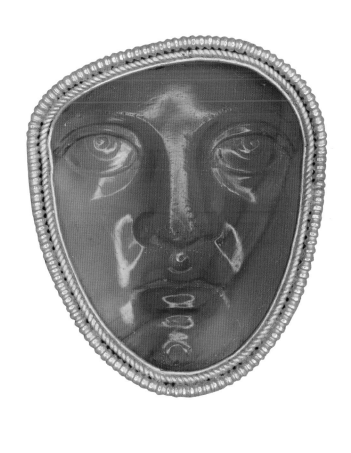

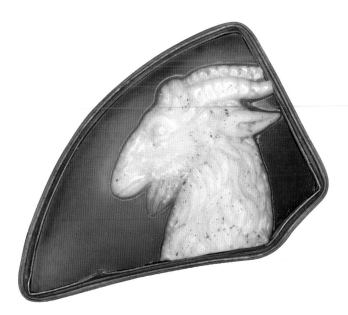

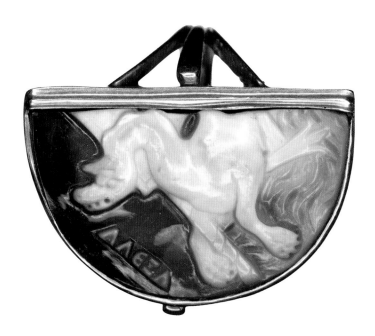

Club
Ethiopia
Wood, tree root
10 x 104 cm
British Museum

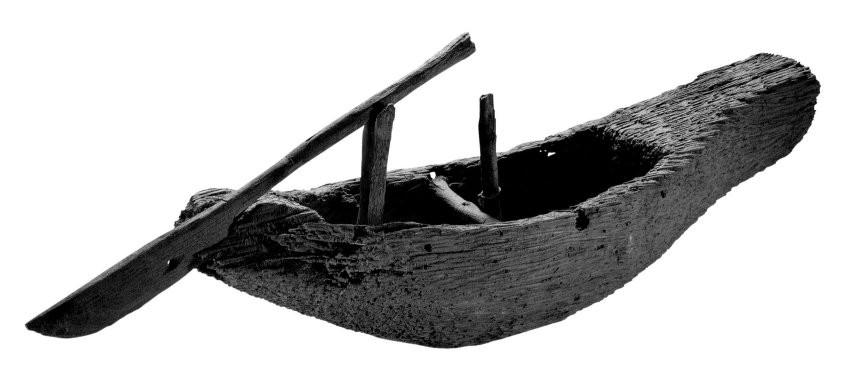

Boat model
Egypt, late 18th Dynasty
(1350–1295 BC)
Wood and fibre
10.5 x 33 x 10.5 cm
British Museum

Punch bowl
London, 1764
Used by Asante, Ghana
Silver
50 x 30 cm
British Museum

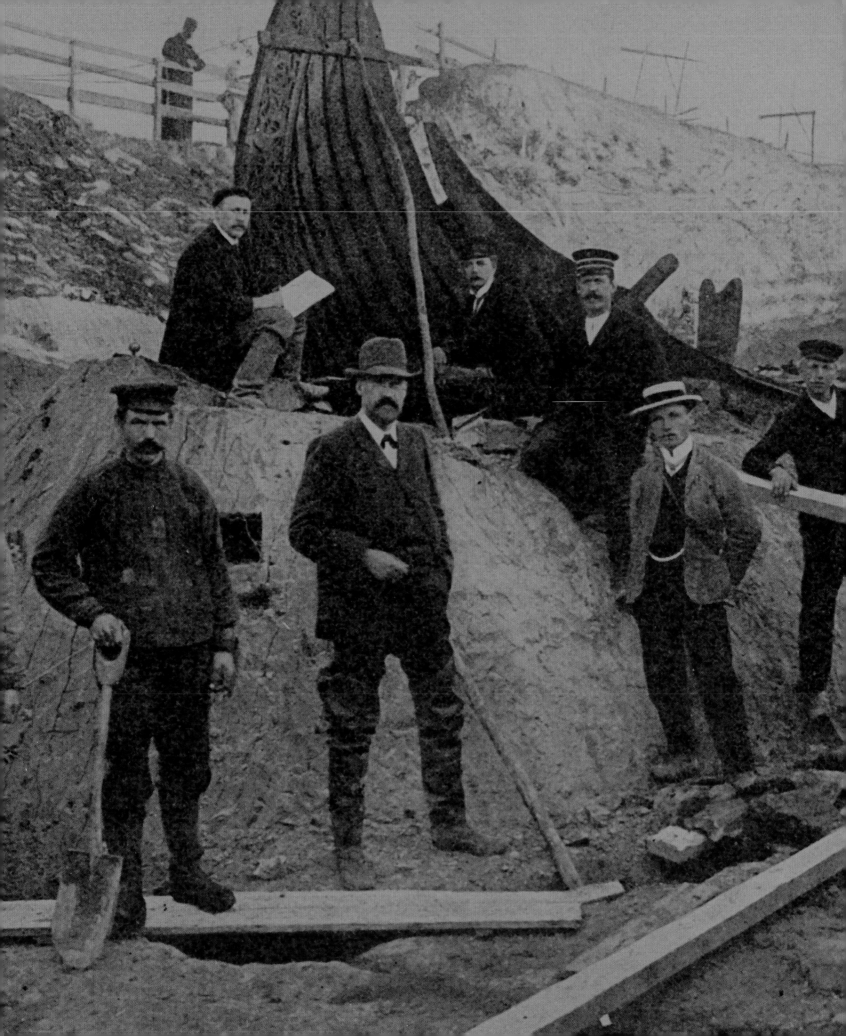

THE TOMB OF THE UNKNOWN CRAFTSMAN

And so we come to the tomb itself –
an iron ship sailing into the afterlife.
The ship is also a pun, a craft for the
craftsman. It is hung with casts of
the fruits of his labours and carries
a cargo of blood, sweat and tears.

**The Tomb of the Unknown
Craftsman**
Grayson Perry, 2011
Cast iron, oil paint, glass, rope,
wood, flint hand axe
305 x 204 x 79 cm

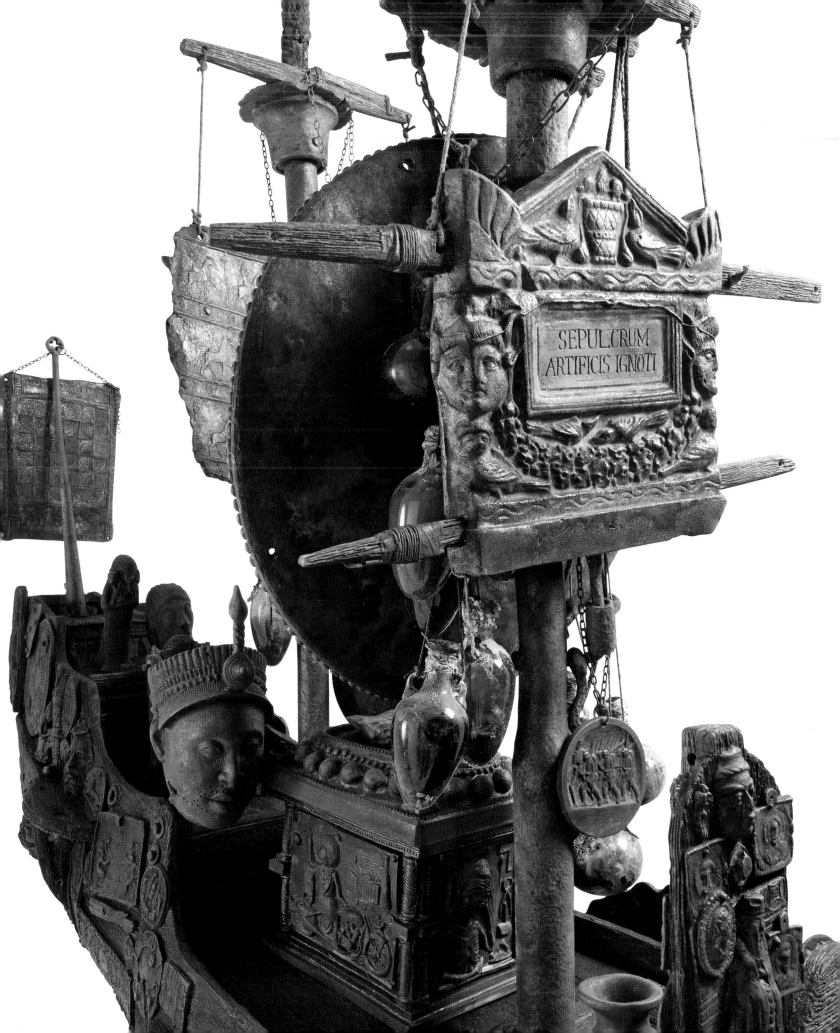

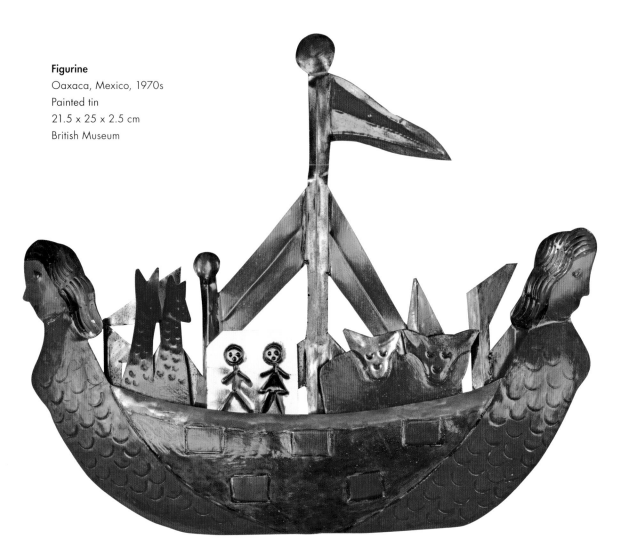

Figurine
Oaxaca, Mexico, 1970s
Painted tin
21.5 x 25 x 2.5 cm
British Museum

Treasure box, 'wakahuia'
New Zealand, Maori, 1830s
Carved wood and fibre
11.5 x 46 x 15 cm
British Museum

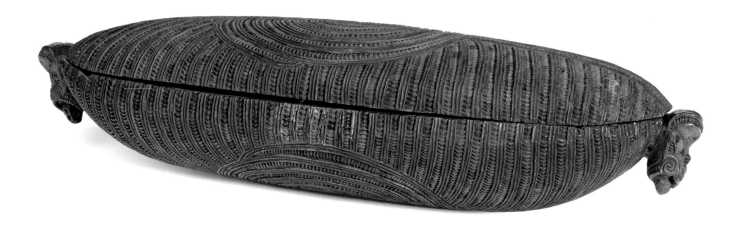

Figurine
Mexico, Metepec, 1980s
Pottery
32 x 73 x 31.5 cm
British Museum

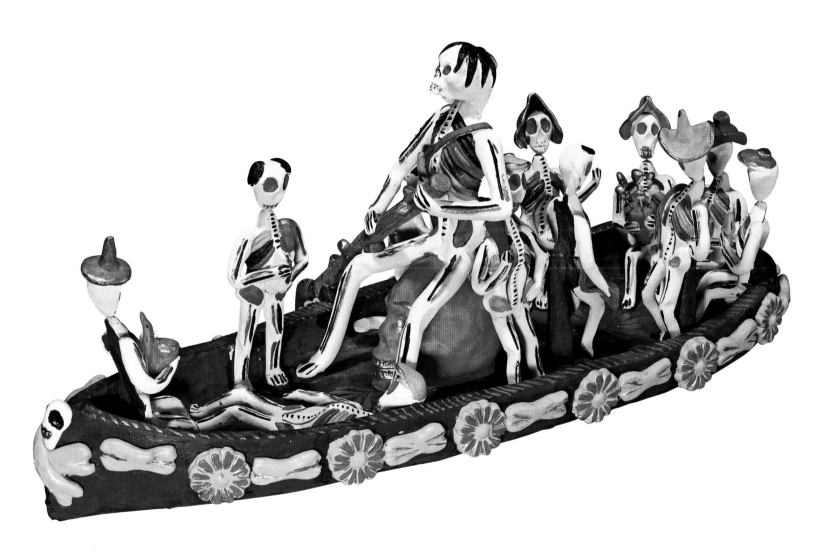

Tomb figurines (overleaf)
Attendant holding a dog
China, Tang Dynasty
(AD 700–50)
Painted and gilded earthenware
26.4 x 9 cm
British Museum

Woman holding a fan
China, Sui Dynasty
(AD 581–618)
Straw-coloured glazed
earthenware
25.5 x 5.5 cm
British Museum

Woman with a black headdress
China, Tang Dynasty
(AD 700–50)
Painted earthenware
30.5 x 8.5 cm
British Museum

Female musician and dancer
China, Tang Dynasty
(AD 700–50)
Painted and gilded earthenware
36.5 x 14.5 cm
British Museum

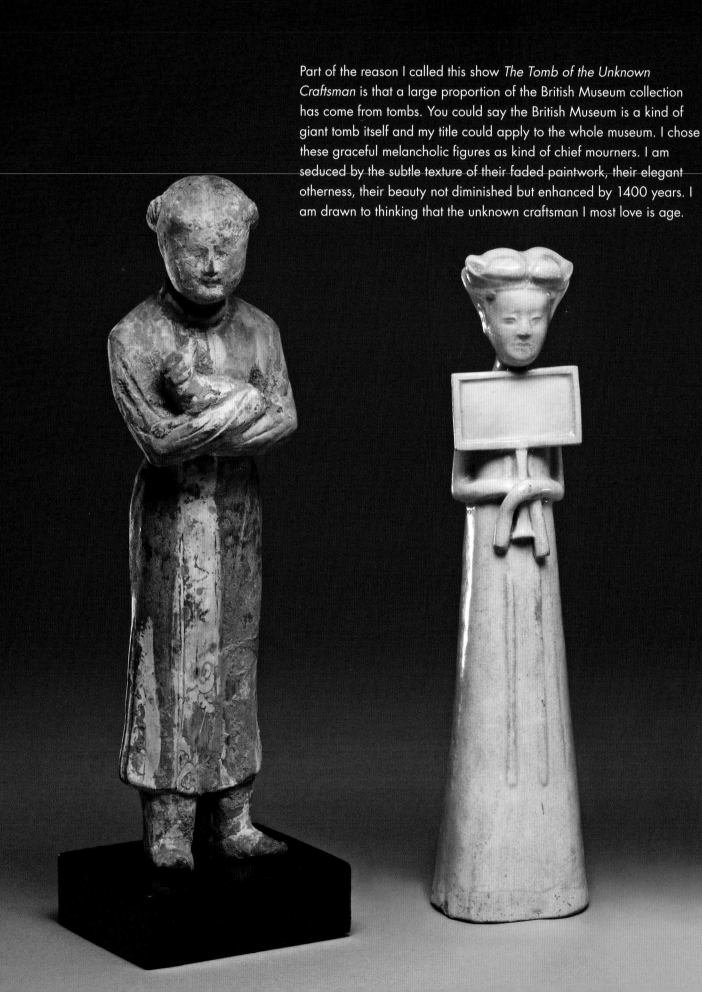

Part of the reason I called this show *The Tomb of the Unknown Craftsman* is that a large proportion of the British Museum collection has come from tombs. You could say the British Museum is a kind of giant tomb itself and my title could apply to the whole museum. I chose these graceful melancholic figures as kind of chief mourners. I am seduced by the subtle texture of their faded paintwork, their elegant otherness, their beauty not diminished but enhanced by 1400 years. I am drawn to thinking that the unknown craftsman I most love is age.

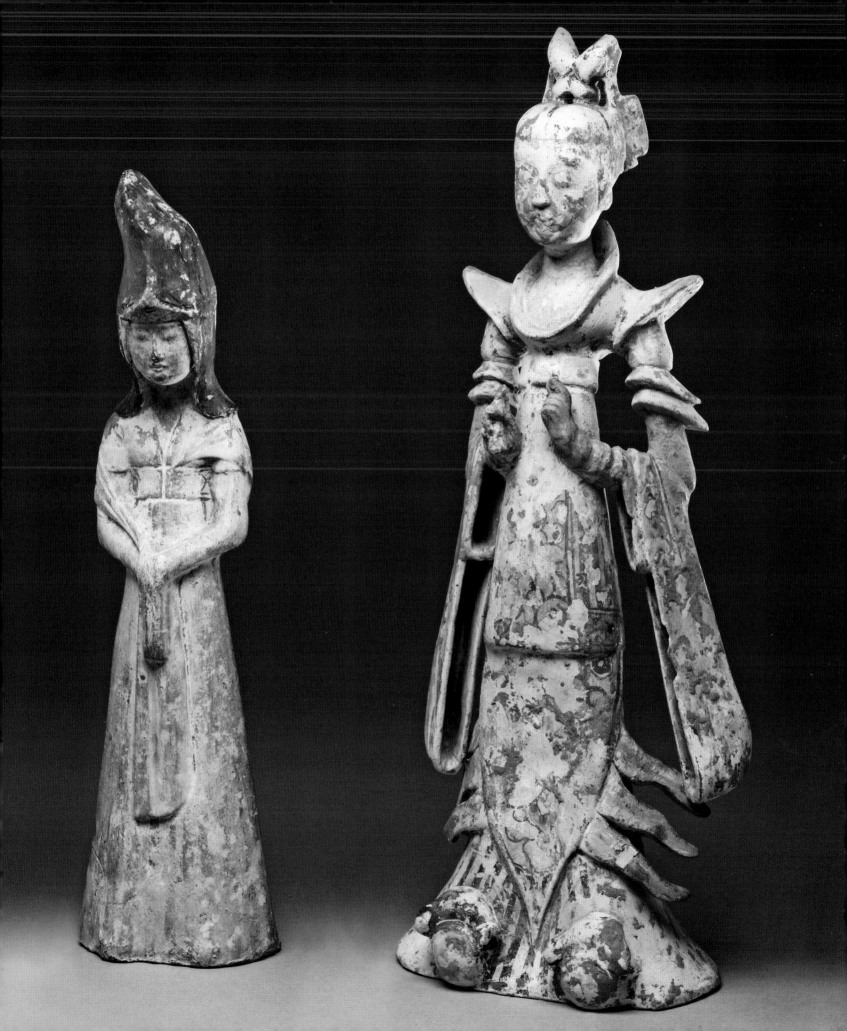

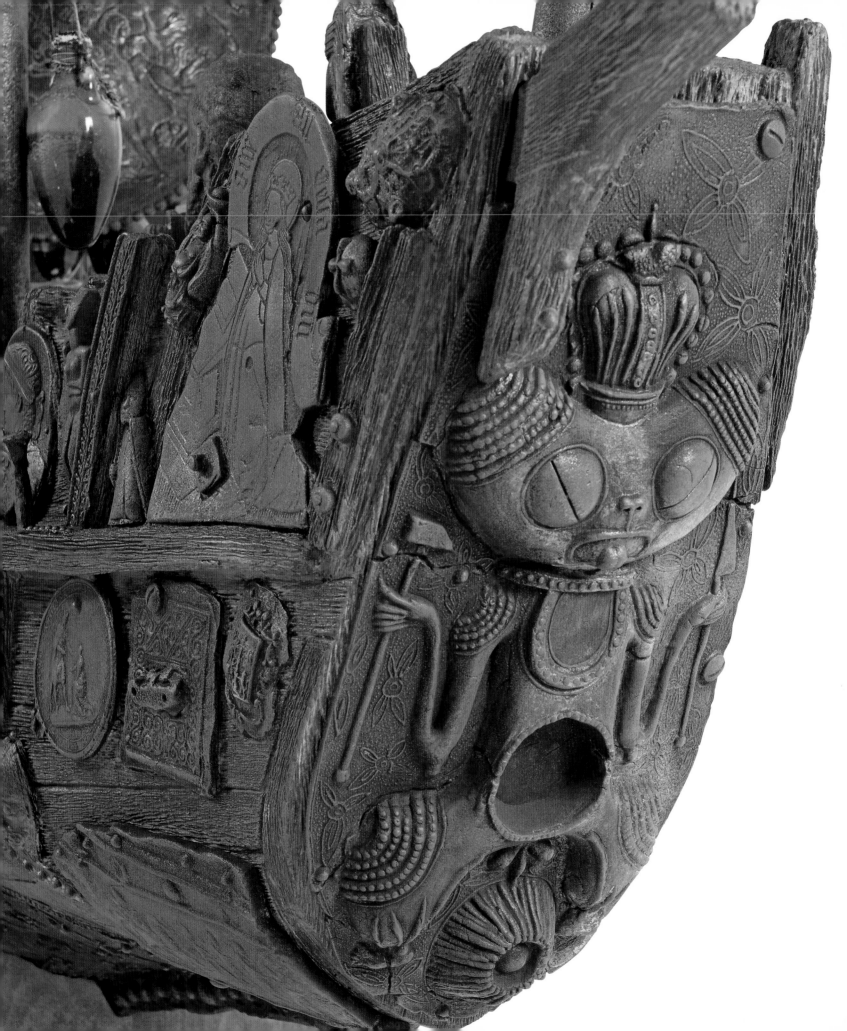

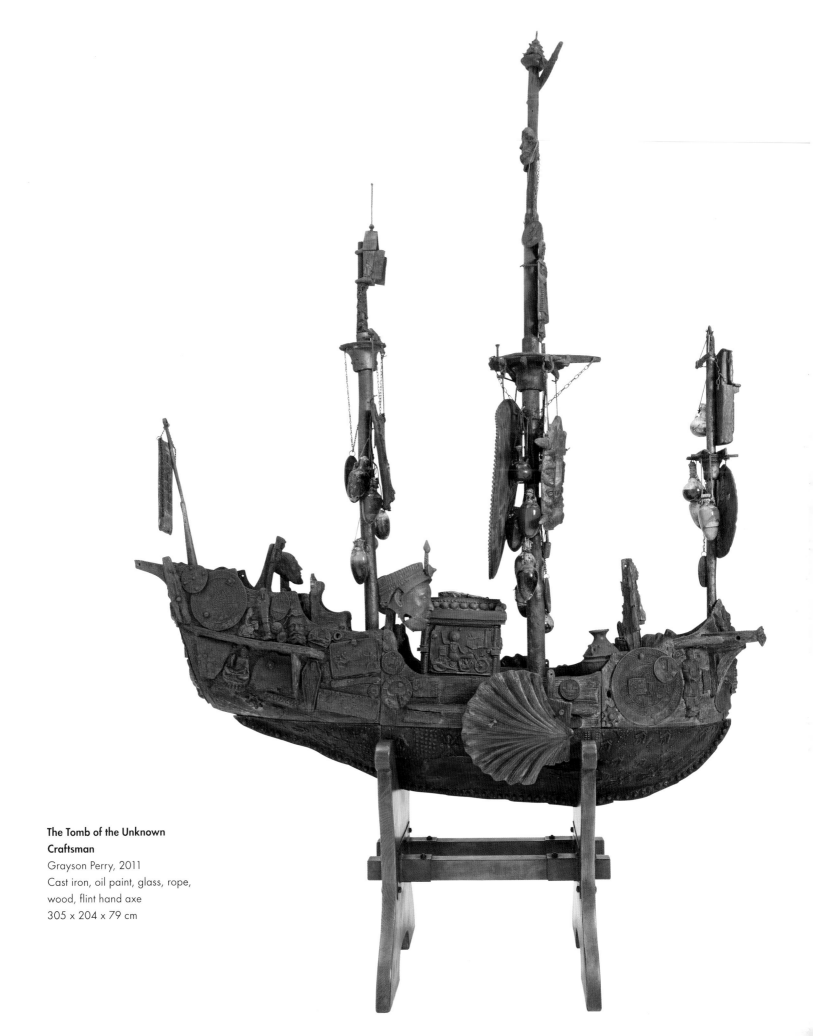

**The Tomb of the Unknown
Craftsman**
Grayson Perry, 2011
Cast iron, oil paint, glass, rope,
wood, flint hand axe
305 x 204 x 79 cm

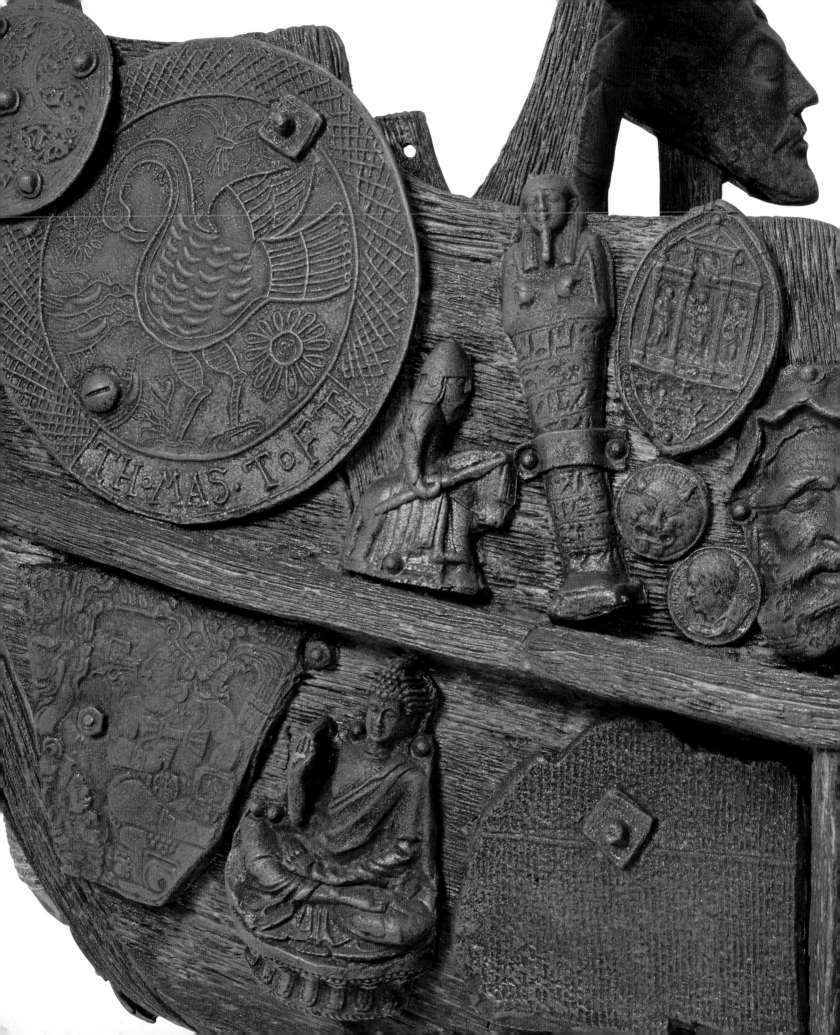

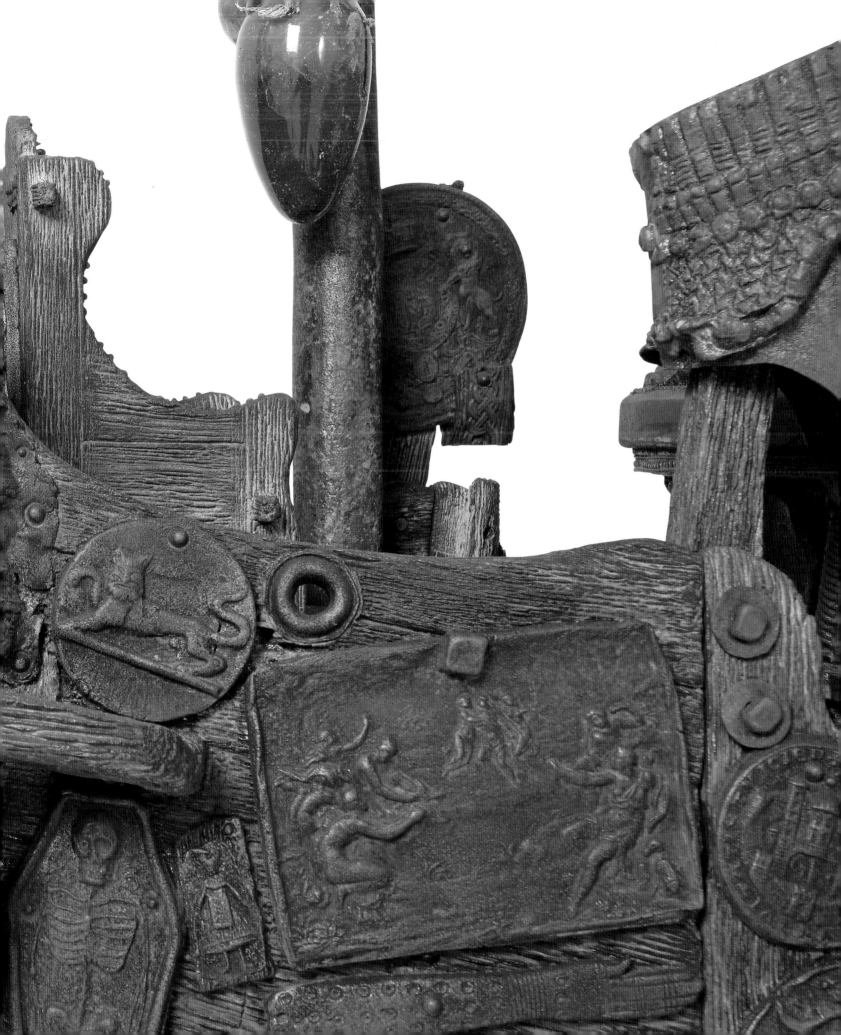

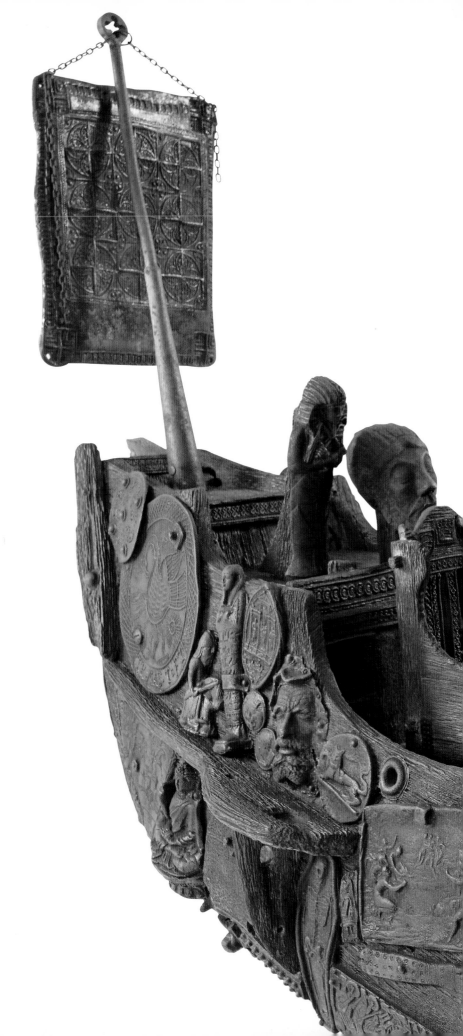

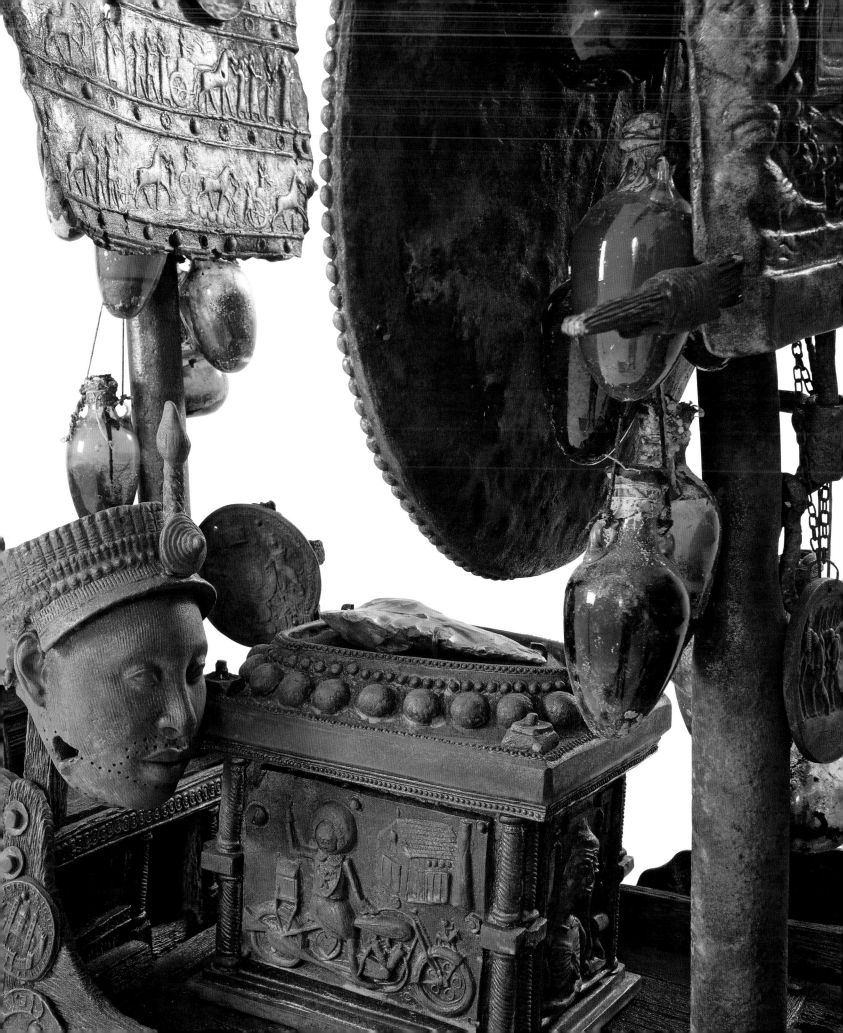

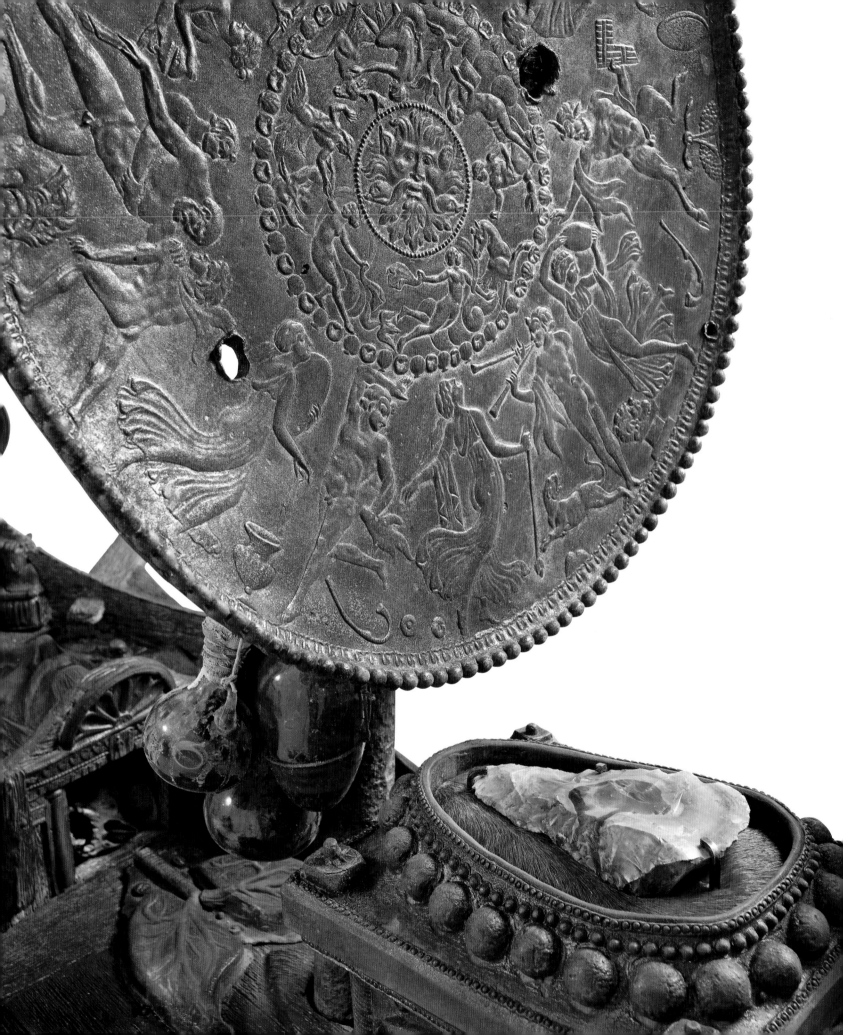

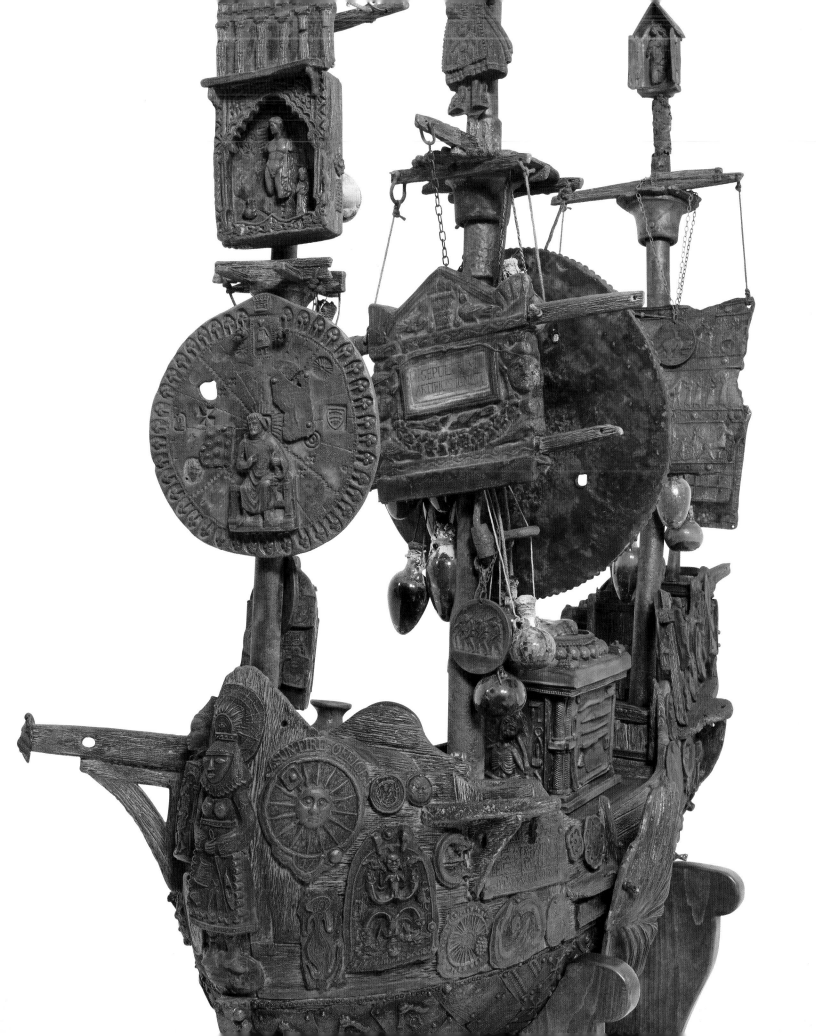

ACKNOWLEDGEMENTS AND CREDITS

Grayson Perry

All images © Grayson Perry, courtesy the Artist and Victoria Miro Gallery, London

Frontispiece and gatefold: *Map of Truths and Beliefs*, 2011. Edition of 7 plus 2 artist's proofs; courtesy of the Artist and The Paragon Press; woven by Flanders Tapestries from files prepared at Factum Arte (photo. Alicia Guirao, Factum Arte)

pp. 13, 15

p. 16 *Early sketch for AM1 motorcycle*, 2008

p. 17 *Untitled*, 2009

p. 18 (photo: Adam Scourfield)

p. 21 *Pilgrimage to the British Museum*, 2011 (photo. Kevin Smith, John Jones Art Centre Ltd)

pp. 28–9 *You Are Here*, 2011 (photo. Stephen White)

pp. 32–4 *The Near Death and Enlightenment of Alan Measles*, 2011 (photo. Stephen White)

p. 36 *Prehistoric Gold Pubic Alan Dogu*, 2007 (photo. Stephen White)

p. 37 *Alan Measles* (photo. Stephen Brayne)

p. 42 Detail of *Kenilworth AM1 horn cover* (photo: Grayson Perry)

p. 43 *Bodyguard's Jacket*, 2010 Costume by Phil Reynolds (photo. Stephen White)

pp. 44-5 *Kenilworth AM1*, 2010 Motorcycle built by Battistini's (photo. Adam Scourfield)

p. 46 *Bodyguard's Helmet*, 2010 Painter: Tom Fuller (photo. Stephen White)

p. 47 *Early English Motorcycle Helmet*, 1981 (photo. Stephen White)

p. 49 *Alan Measles on Horseback*, 2007. Cast by Tom Crompton (photo. Stephen Brayne)

p. 50 *A Family Tradition*, 2010 (photo. Stephen White)

52–3 Grayson Perry in Germany (photo. Eric Great-Rex)

pp. 58–9 *A Walk in Bloomsbury*, 2010 (photo. Stephen White)

p. 61 *I have never been to Africa*, 2011 (photo. Stephen White)

p. 62 *Hold Your Beliefs Lightly*, 2011 Programming by Tony Taylor Edition of 250 plus 10 artist's proofs (photo. Stephen White)

p. 64 *Shrine to Alan Measles*, 2007 (photo: Stephen Brayne)

pp. 74–5 *La Tour de Claire*, 1983 (photo. Stephen White)

p. 80 *Shrine to Alan and Claire*, 2011 (photo. Stephen White)

pp. 93–4 *Head of a Fallen Giant*, 2008. Cast by Tom Crompton. Edition of 5 plus artist's proof (photo. Anna Arca)

pp. 95, 97, 98 *The Rosetta Vase*, 2011 (photo. Stephen White)

p. 99 *Coffin Containing Artist's Ponytail*, 1985 (photo. Stephen White)

pp. 100–101 *The Frivolous Now*, 2011 (photo. Stephen White)

pp. 124–5 *Our Father*, 2007 Cast by Tom Crompton and Bjorn Fiskvaten. Edition of 5 plus 1 artist's proof (photo. Stephen Brayne)

Endpaper, pp. 128–9 *Pope Alan Stamp*, 2010 (photo. Stephen White)

p. 129 *Pilgrim's Passport* (photo. Stephen White)

pp. 130–31 *Our Mother*, 2009 Cast by Tom Crompton and Bjorn Fiskvaten. Edition of 5 plus 1 artist's proof (photo. Stephen White)

pp. 137–8 *Grumpy Old God*, 2010 (photo. Stephen White)

p. 140 *Tate Modern Reliquary*, 2009 (photo. Stephen White)

pp. 144–5 *High Priestess Cape*, 2007. Dressmaking by Sonja Verma; embroidery programming by Tony Taylor (photo. Stephen White)

p. 160 *Tomb Guardian*, 2011 (photo. Stephen White)

pp. 170-1, 202 *Pilgrim Bottle*, 2011 (photo. Stephen White)

pp. 186, 192–9 *The Tomb of the Unknown Craftsman*, 2011 Cast by Tom Crompton and Bjorn Fiskvaten; glassblowing by Mark Taylor and David Hill. Edition of 3 plus 1 artist's proof (photo. Stephen White)

The British Museum

Photographs © The Trustees of the British Museum (with special thanks to the Department of Photography and Imaging). Every attempt has been made to trace accurate ownership of copyrighted works in this book. Errors and omissions will be corrected in subsequent editions provided notification is sent to the publisher. Registration numbers of British Museum objects are as listed below. Further information about the objects and the collection can be found at britishmuseum.org.

p. 10 EA 9525; pp. 25–6; p. 35 ME 1933,0109.0.3; p. 36 EA 1992,0819.1; p. 38 CM 1919,1010.14, CM TWN, p. 89.18; p. 39 CM 1983,0738.2 (donated by Miss V. Hallam); p. 46 Af 1900,0427.1; p. 48 P&E 1852,0616.2; p. 51 (left) P&E 1887,0211.10 (donated by Sir A.W. Franks); p. 51 (right) P&E 1849,0926.7; p. 52 CM 1987,0651.4 (donated by Mr N. Jacobs); p. 53 CM 1986,1102.3 (donated by London Borough of Havering), CM 1994,1016.7, CM 1986,1102.4 (donated by London Borough of Havering); pp. 54–5 Asia 2008,3021.10 © Yoshinaga Masayuki; Little More Co. Ltd; p. 60 Af 1949,46.158; p. 63 Af1978,22.717; p. 65 As Franks.923.+A (donated by Sir A.W. Franks); p. 66 Am, De.22, Am, De.31, Am, De.23; p. 67 Af 1989,05.69, Oc 1841,0211.12 (donated by Queen Victoria); p. 68 Af 1954,23.1691 (donated by the Wellcome Institute for the History of Medicine), Oc 1931,0714.42 (donated by Lady Elsie Elizabeth Allardyce); p. 69 As 1934,0307.51 (donated by Charles A. Beving); p. 70 (top left) As 1980,0728.102 (bequeathed by P.J. Donnelly), (left) As 1980,0728.666 (bequeathed by

P.J. Donnelly), (above) Am 9392; p. 71 Am 1954,05.1000 (donated by the Wellcome Institute for the History of Medicine); p. 76 (left) EA 22783, (right) As 1894,1213.1 (donated by Sir A.W. Franks); p. 77 (left) P&E 1863,0120.1, (right) P&E 1883,0713.5 (donated by Rev. Grenville John Chester); pp. 78–9 As 2005,0614.4,2,3; p. 81 P&E 1889,0507.7 (donated by Sir A.W. Franks); p. 82 As 1974,0513.19 (donated by Sir Harry M. Garner and Lady Garner); p. 83 (above) P&E 1998,0605.48 (bequeathed by Sir Frank Kenyon Roberts), (right) As 1945,1017.488 (bequeathed by Oscar Charles Raphael); p. 84 As 1944,1017.1.a–b (donated by Major Charles Verner); p. 85 As 1997,1104.2; pp. 86–7 P&E 1998,0605.31 (bequeathed by Sir Frank Kenyon Roberts); pp. 88–9 As 1914,0512.1; p. 92 (nails) GR 1856.1226.886, (bequeathed by Sir William Temple), GR 1873,0820.146, GR 1873,0820.147, GR 1975,0902.8, (model of jawbone) Af 1874,0521.8; p. 96 Af 1905,0525.4; pp. 98–9 (ear and earring) P&E 1949,1008.1 (bequeathed by Mrs A. M. Favarger); pp. 102–3 Af 1940,23.1 (from Capt. Alfred Walker Francis); p. 104 ME OA+.2609; p. 105 (top) As 5068.a–b, (right) ME 1911,1026.9; p. 106 (engraving) PD 1934,0402.31, (tokens) CM J.3294 (obverse and reverse; donated by L.A. Lawrence), CM 1906,1103.5054; p. 107 P&D 1934,0402.26; p. 108 As 5068.a–b; p. 109 Af 1972,53.1; p. 112 As 2001,16.213 © Sanrio Co., Ltd; p. 113 P&E Eu1971,03.1-10, (apron) 2008,8009.1 (Sheila Paine Collection), (bag) Eu 1993,07.28 (Diane Waller Collection); p. 114 Oc 1904,0621.34; p. 115 As Franks.1220 (donated by Sir Augustus Wollaston Franks); p. 116 ME 1974,0617,0.1.35 (bequeathed by Sir Hans Sloane); p. 117 As

1898,0622,0.23; p. 118 ME As 1997,01.9; p. 119 PD 1975,U.1140 (bequeathed by Eliza Cruikshank); p. 120 (above) As 1880,304, (below) Am 2006,Drg.22070; p. 121 (above) As 2007,3014.45 (donated by Professor Dr Anna Dallapiccola), (below) As 2007,3014.6 (donated by Professor Dr Anna Dallapiccola); p. 126 P&E 1970,1001.1 (donated by J. C. O. Hill), P&E 1857,0718.3, P&E 1852,0930.2; p. 127 (above) P&E 1896,0501.76 (donated by Sir Augustus Wollaston Franks), (below) P&E 1904,0720.17; p. 132 PD 1933,0102.1 (presented by a body of subscribers as a tribute to Campbell Dodgson); p. 133 P&E 1905,0722.1 (donated by Charles Fairfax Murray); pp. 134–5 CM 2003,0509.2 (donated by Dr Barrie Cook), CM 1984,0505.3 (donated by Ian A Carradice), CM 1983,0125.5, CM 1997,1009.1, CM 1983,1220.1, CM 1988,0310.54, CM 1996,0829.1, CM M.4071, CM 1991,1213.4 (donated by Dr P. T. Craddock), CM 1993,0309.4 (donated by T. R. Blurton), CM 1978,0705.86, CM 1980,0408.16, CM 1981,0950.1 (donated by Miss C. M. Johns), CM 1978,0705.256, CM 1993,0125.14 (donated by Ms S. Darson), CM 1985,0625.1, CM 1984,1018.3 (donated by Miss L. Caygill), CM 1993,0127.35 (donated by Mr S. Cribb), CM 1992,0712.40 (donated by T. R. Blurton), CM 1986,0636.9, CM 1990,1210.28 (donated by Dr H. Swiderska), CM 1992,0712.35 (donated by T. R. Blurton), CM 1992,0712.34 (donated by T. R. Blurton), CM 1985,0114.5 (donated by Miss M. Randall), CM 1988,1117.1 (donated by Mrs M. Parlett), CM 1978,1218.3 (donated by J. Cribb), CM 1990,1210.29 (donated by Dr H. Swiderska), CM 1985,0933.5; p. 136 As 1923,0901.0.39 (donated by

Dr Oswald Siren); p. 139 PD 1845,0809.206; (top left) Asia 1905,0519.115, (moulds) As 1906,1228.27, As 1906,1226.26, As 1895,0209.9; p. 141 (plaques) As 1887,0717.147.17, 19, 24, 26, 29, 47, (stupas) As 1992,1214.119, As 1903,1017.14, As 1887,0717.93, As 2003,0702.1, As 2003,0702.3, As 2003,0716.1, As 2003,0226.1, As 2003,0704.2; p. 146 PD 1868,0808.4456; p. 147 As 2006,0210.0.1.1-55 (given anonymously in honour of Otsuka Takashi); pp. 148–9 As 2006,0113.0.1; p. 150 (top left) CM J.3251 (donated by L. A. Lawrence), (right) CM J.3243, (below) Af 1973,18.17.a-b (from Anthony Jack); p. 151 ME 1923,0106.1 (donated by Scott Bell & Co); p. 152 PD 2005,0429.39 (purchased with funds from the Arcana Foundation); p. 153 PD 2005,0429.38 (purchased with funds from the Arcana Foundation); p. 154 (top) P&E Witt.269 (donated by Dr George Witt), (below left) GR 1772,3014.34, (below right) P&E Witt.264 (donated by Dr George Witt); p. 155 (above left) CM 1918.05.06.1, (below) GR 1861,0425.38; (right) EA 1837,0714.41; p. 156 Oc1954,06.378 (donated by the Wellcome Institute for the History of Medicine); p. 157 PD 1871,0708.160; p. 161 Am 1907,0319.308; p. 162 Eu 1995,01.1 (funded by the British Museum Friends); p. 163 EA 1896,0511.35; p. 164 Af 1944,04.80 (donated by Irene Marguerite Beasley); p. 165 P&E Witt.258; p. 166 GR 1867,0507.96; p. 167 Am 1913,-212 (donated by L. F. Brady); p. 172 P&E 1887,0210.10 (Willett Collection); p. 173 P&E 1887,0210.4 (Willett Collection); p. 174 PD I,7.196; p. 175 (above) Oc 1884,0412.5 (Donated by the Lords of Admiralty), (below left) Oc1972,Q.61, (below right) EA

5601; p. 178 (above) P&E OA.5271, (below) CM 1916,0102.14 (donated by D. T. Harris); p. 179 (above) P&E OA5289, (below) CM 1930,0102.16; p. 180 (top left) GR 1890,0601.166, (top right) GR 1814,0704.1499, (below left) GR 1867,0507.178, (below right) GR 1890,0601.9; p. 181 (above left) GR 1872,0604.1301, (above right) GR 1872,0604.1317, (centre) GR 1814,0704.1497, (below left) GR 1868,0520.15; (below right) GR 1814,0704.1492; p. 182 (above) Af 1949,16.1 (donated by Miss Bella E. Le Butt), (below) EA 1921,1008.5 (donated by Egypt Exploration Fund); p. 183 Af 1933,-.3; p. 188 (above) Am 1978,15.859, (below) Oc 1981,Q.1393a; p. 189 Am 1986,06.254; p. 90 As 1947,0712.8 (bequeathed by Henry J. Oppenheim), As 1927,0521.2; p. 191 As 1917,1208.3 (purchase supported by The Art Fund), As 1936,1012.44 (purchased by public subscription from the George Eumorfopoulos Collection).

Other sources

pp. 8–9 © Topfoto; p. 20 © Getty Images; p. 22 © Getty Images; pp. 30–31 © Mary Evans Picture Library; pp. 40–41 © Mary Evans; Sepia Images Photographic Collection; pp. 72–3 © Time & Life Pictures; Getty Images; pp. 90–91 © Mary Evans; John Massey Stewart Russian Collection; pp. 110–11 © Mary Evans Picture Library; pp. 122–3 © Roger-Viollet; Topfoto; pp. 168–9 © Country Life; IPC Media Ltd; Mary Evans; pp. 176–7 © Henri Silberman; NonStock; Getty Images.

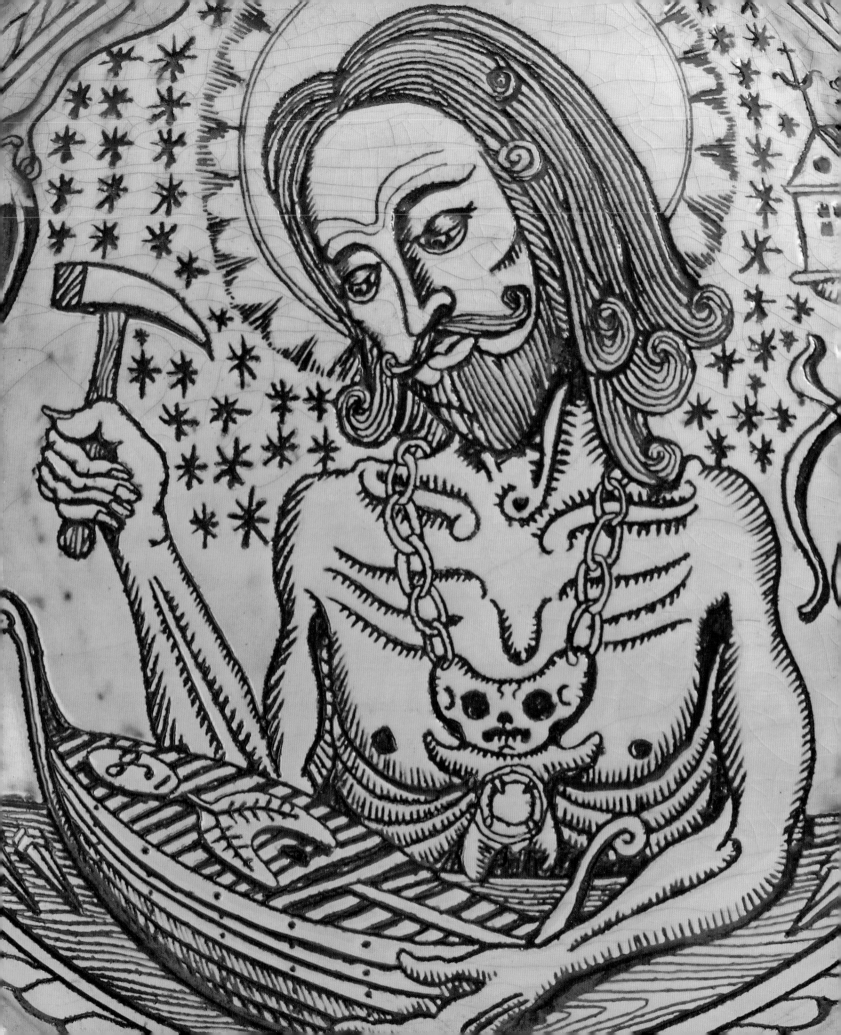

CRAFTSMEN CREDITS

Having conceived of an exhibition celebrating the Unknown Craftsman of history it seems appropriate to credit all the marvellous craftsmen and women who have helped me make some of my artworks. I would like to thank all those listed below as they are all skilled and dedicated people who have been a pleasure to work with, realizing my often technically challenging ideas.

The *Kenilworth AM1* motorcycle was built by Battistini's custom bike builders. The project team consisted of Nigel Green, Anthony Foy, Adam Smith, Alan Smith, Dan Smith and Tom Fuller.

The *Bodyguard's Jacket* and *Bodyguard's Helmet* were made by the team at Phil Reynolds Costumes. The matching boots were made by Natacha Marro. The helmet was painted by Tom Fuller.

The Tomb of the Unknown Craftsman, Head of a Fallen Giant, Alan Measles on Horseback, Our Father, Our Mother and several parts of the *Kenilworth AM1* were all cast at Tom Crompton's foundry. The team consists of Tom Crompton, Bjorn Fiskvaten, Gitte Crompton, Kabir Hussain, Tim Cross, Christopher Summerfield and Ian Crompton.

The glass vessels on the tomb were made by Mark Taylor and David Hill of Roman Glassmakers.

The *High Priestess Cape* was made by Sonja Verma.

Embroidery programming for *Hold Your Beliefs Lightly* and the *High Priestess Cape* was by Tony Taylor at Red Tape Designs.

The *Map of Truths and Beliefs* was facilitated, programmed and woven by Factum Arte, director

Adam Lowe and the team at Flanders Tapestries: Marcos Luduena-Segre, Roland Dekeukelaere, Joke Dekeukelaere.

Ceramic restoration by Bouke de Fries.

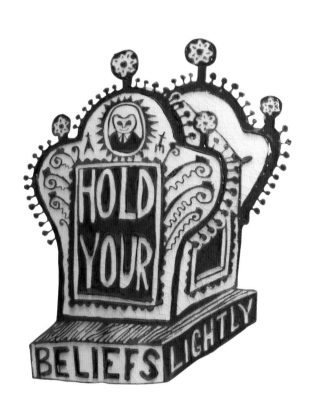